Secrets of the Serpent
In Search of the Sacred Past

PHILIP GARDINER

~ Special Revised Edition ~
Featuring Two New Appendices

Philip Gardiner

Best selling author of:

The Shining Ones
The Serpent Grail
Gnosis: TheSecret of Solomon's Temple Revealed
Proof: Does God Exist?

For more on Philip Gardiner visit: www.gardinersworld.com

Secrets of the Serpent: In Search of the Sacred Past
Special Revised Edition Featuring Two New Appendices
by Philip Gardiner
Copyright© 2008 by Reality Press
All rights reserved.

Reality Press
An imprint of Reality Entertainment, Inc.

For information contact:

REALITY ENTERTAINMENT
P.O. Box 91
Foresthill, CA 95631
ph: 530-367-5389, fx: 530-367-3024
www.reality-entertainment.com

ISBN: 978-1-934588-54-3

Printed in the United States of America

Dedicated to my wife, Julie,
who constantly brings me challenge and balance.

CONTENTS

Introduction

There is a world of mystery and wonder out there. Even today millions of people search websites, books and travel extensively to uncover the myths and history of our past. But we have to find the truth behind the diverse elements that rise up today as historical phenomena if we are to work out where we ourselves are going. Until we work out what our ancestors were trying to tell us, we will be missing out on a massive part of our own existence. Why did they build Stonehenge? What was that Holy Grail all about? What is the truth about tales of dragons and demons?

The answer to all these and more will not be found by watching Stargate or Star Trek. They will not be discovered in the lies perpetuated about reptilian royal families or bloodlines of Jesus Christ. They will not be found in false myths, newly created to fill in the gaps of our knowledge. The truths will be found instead in perfectly practical things. Why? Because regardless of how arrogant we think we are, our ancestors were intelligent people who were not engrossed in the art of paying off debt like we in the West are. In a similar way though they lived lives of survival and it will be in survival that the truths will be found. These truths may well be covered in glorious tales of magical wonder and hidden beneath coded Green languages, but it will be a truth that explains how they survived. This does not mean that what we uncover will not be exciting – it just means it will be real.

The journey upon which we are about to embark will be rough for some because previous perceptions and belief systems will be challenged and I would have it no other way. Often these new interpretations of our past will be ignored or sidelined because of the reader's current religious perception. However, I say to those people, try to understand that just because you are told a certain thing, does not mean it is true. Try to imagine a clock. The big hand is pointing to twelve. Well let's assume that the actual facts and reality of our planet are down at the bottom, at number six. If we were to take you to 6 o'clock immediately you would feel like something had been lost. This is mankind's current situation and this is why so many still search out the truth – because they feel as if something is missing. In this 'coffee table' book, we intend to take you on a journey, minute by minute until we eventually end up at where we ought to be – reality, number 6.

This book is the accumulation of knowledge. It is this knowledge that has allowed me to uncover the reality of our past. It is only by searching out knowledge that we can widen our perspective and not remain insular. Insularity is the position of having nothing but a belief system to back up our thoughts about life. While half the world hurries along believing themselves to be the chosen elite of a particular deity or nation, the other half do the same and we end up divided and at war. But what if the truth

of our diverse pasts were all related to one true core? What if the questions that we all asked had one answer based in fact? Would this undermine the belief systems of the globe?

In truth there is one definite thing we know about the religions of the world – they have all, at one time or another, been used as tools of manipulating mankind into action or indeed inaction. They have all been used to maintain and grow massive power bases that today appear unbreakable. They have all been used to increase the coffers of those in positions of authority. I'll give you a little, but disgusting example.

Recently I was on a trip to New York for various media appearances. It was a hell of a schedule and myself and my manager had a couple of hours spare. We had been in New York for several days and had not yet seen it properly, so we took advantage and ran off on a quick site seeing tour. During the break we went to St. Patrick's Cathedral, a large neo-gothic Catholic structure built in the 19th century. I was thoroughly impressed at the size and design. It reminded me so much of the beautiful medieval cathedrals of Europe, but with one distinct difference – it was perfect. There were no strange oblique corners or rooms added in over time as the many cathedrals of Europe were changed. This New York edifice was still perfect – the same as the day it had been built. The sheer amount of wealth that oozed from every quarter was a true statement of power.

I took some photographs and sat for a while, admiring the copy-cat nature of the clean building and absorbing the atmosphere that any structure so perfectly in-line with the ancient art of sacred geometry brings. And then I noticed a little girl at the side staring up at a beautiful religious icon of Mary. She stood holding her mother's hand and then I heard the little girl begin to pray. Her mother immediately stopped this innocent little act.

"We have to light a candle sweetheart. Here's a dollar." She said.

And with that the little girl bought herself a candle, lit it and resumed

her prayers. This whole sorrowful act struck me as being one of the saddest events I have ever seen. The girl was no more than seven or eight and in her unknowing youth she was suddenly inspired to pray to this mother goddess image that stood enticingly before her. In-order to do so she had to pay the priesthood who stood between her and her Goddess.

In this one little story we have a perfect example of the perpetuation of a cycle that refuses to be broken. The mother had at some time in her life probably been told the same thing, and now she too was passing on the knowledge. But this knowledge is based upon a lie and it simply fills the coffers of a religion that is as outdated as throwing spears at Bison. In the same way, we all buy in to one thing or another because that is the way we have been taught. We must get a mortgage and pay the financier; we must have a certain car and disappear beneath yet more dark clouds of debt; we must look like our modern superstars and so alter our appearance; we must know what others know and so rush out and snap up our copy of the Da Vinci Code. The only thing that brings all these things together is the lie and deceit of mankind, a bastardised version of evolutionary desires.

Money lending originated in a culture that had previously spent thousands and thousands of years bartering and surviving based upon family and group or socially oriented methods. But people, instead of actually bringing a product to market, started to promise they would bring a pig or an ox as payment and this was the lie and deception. The following week at market the pig or ox never arrived and so laws were brought in, but people evaded even these and so a new market stall was created by the Church and today we still refer to this stall with the same name – bank. This bank (from the Germanic route bancka or Italian banca, both meaning, table or bench) replaced the pig or ox with a new thing called money – the promise. The very word itself ought to have given us some indication of what was to come, for it is derived from the Latin word monere, which means 'to warn.'

It was backed by the wealth of the state or religion, which were intertwined anyway, and so people had trust in it. Eventually people used this

4

trust and started to borrow from the funds based upon future harvests. When the harvest didn't arrive the individual was suddenly under the subjugation of the authorities until the loan was paid off. In this way our modern capitalist state is based upon a lie and uses the individuals desires or even in the extreme, greed, to tie them up in ever increasing debt.

In the time before money, man offered the gods his goods and the priesthood accepted on behalf of their imagined masters. Today we offer the gods money and the priests do the same. If there were no gods, there would be no priests requiring us to make our offerings. I know that this is a massive over simplification, but yet again it makes a point – the priests create a 'value' called god and add to that – it is added value.

Look at it this way. A diamond is a lump of crystallised rock. The world is full of them, and yet somehow we have added value to it and now it is precious to us. It is actually of no worth other than what human's place on it and has no spiritual or practical value and the animals would walk past it without a care. It cannot feed you, it cannot save you and it certainly ought not to make you any happier than you already should be. And yet, people kill each other for them – based upon the value created by another man. An artist puts paint on a canvass and adds value – he is colouring up the mundane and charging us for it. Will it feed us? Will it save the starving of Africa or stop the brutal murder of innocents? I think not.

All of this is what Islam calls the kafir system. It is the unseen force that is behind many evils and is lead by the Dajjal – the anti-Christ. So, even the very dark side of religion is given 'extra value'. In this way, the system is actually at odds with what it is supposed to do – it is paradoxical and yet self-sustaining. Society is run on this system – but ask yourself, what does this system care for justice, love, need? It is, like the tale of that little girl in the Cathedral, feeding off the desires of man and at the same time subjugating him. It is adding value to the inner spiritual nature of man with a lie.

The truth is that we have a spiritual nature brought about by our own

consciousness and desire to understand the big questions. We have emotions, empathy and feelings about the world, people and animals around us. We look towards the heavens in wonder and then along comes a man in a religious frock and gives us explanations and all he asks in return for access to this wonderful new world of peace, harmony and heaven, is ten percent of your earnings. Not for him you understand, but for the gods. Today there are many lies and much deception. They are not always so obvious, in fact the majority are subtle. But they always tend to offer us something, which most of the time we could have done without or found within ourselves.

A lifetime of such deception turns a man dark. It weighs him down with fear, guilt, desire, lust, and in the end he forgets what he really wanted and needed in the first place. He is consumed by other people's ideas of what he should be. Only by understanding that these things are false - that he did not need to pay the priest in the first place, that he did not need that diamond ring or painting - will he free himself from the cycle of debt. But more importantly, he will free his mind of the false desires and understand his true self. It is this freeing of the mind with the knowledge of our, and other people's deceptions that is the route to true enlightenment. This is the real reason that the Catholic Church and other 'authorities' tried to stamp out decent. If we look back in time to those organisations that orthodoxy tried to eradicate we find one truth at the core – that those who would be free were gatherers of knowledge. One only has to look at that wonderful tale of the Egyptian city, Alexandria, with its millions of books and scrolls encompassing the wisdom and knowledge of the world and the ages past. It was burned to the ground by Christianity, afraid of the power of knowledge.

It is time to free ourselves of the bonds of ignorance.

Philip Gardiner, 2006, England.

tHE SErpEnt

In all my research over the past few years one little animal, both physical and metaphysical, has kept cropping up – the snake or serpent. There are literally thousands of interpretations given to the symbolism of the snake that we find in ancient texts, artworks, sculptures and structures and yet they can all be traced to one root source.

The following information may sound a little like an encyclopaedia. However, the information is vital to any serious investigator of our religious and cultural past. In short, I have discovered that a correct understanding of our own history cannot be fully comprehended without a firm knowledge of the worship of the serpent. In the first place we should understand that the snake is the physical slithering creature we see around the world, whereas the serpent is the mystical, mythological and metaphysical aspect of the same thing.

To begin we should also understand the root of the word and other related words that give us the various terms around the globe for serpent or snake.

The snake is known in the language of *Can*aan variously as Aub, Ab; Oub, Ob; Oph, Op; Eph, Ev. Amazingly in the Mayan language *Can* (Canaan) means serpent, as in Cucul*can* the bird serpent, and just as in the Ancient Sumerian A*can* and the Scottish *Can* for serpent (which is where we get the word *canny* like the wise snake.) Vul*can*, the Roman god of fire comes from the Babylonian *Can* for serpent and *Vul* for fire, showing an etymological link across thousands of miles. Indeed even the very centre of the Christian world, the Vatican, comes from the words *vatis* for prophet and can for serpent, making the Vatican a place of *serpent* prophecy.

The oracle that the biblical king Saul appealed to for prophecy was called "*one that hath Ob*" or the priestess of Ob – the snake. The snake worshippers of Moses time and area were known as Hivites, derived from *Hhivia* or serpent – the root of Eve. Hivites became Ophites, the early Christian Gnostic serpent worshippers who claimed affinity with the Christians in the second century AD. Indeed, the very children of Israel

intermarried with them and "*served their gods.*" They were also known as Baalim from Baal/Bel.

Baal was a solar god, thought by John Bathurst Deane in his, *Worship of the Serpent Traced Throughout the World*, to be an abbreviation of *Ob-El* – the serpent god or shining serpent. The 'shining' aspect of the serpent reveals a subtle clue. On the one hand the shining was the illumination believed to have been achieved when under altered states of consciousness and wherein one 'sees' serpents the world over. This is of course not true enlightenment, as our ancestors readily pointed out that true illumination derived from knowledge of ones own soul and knowledge of the greater work of the gods. This leads us to the other knowledge – the stars. In literal truth the serpent was indeed seen in the sky which shone down upon us. This is why in Egypt for instance we will see the sun (or Aten) wrapped with the snake and why the serpent was world-wide seen as a symbol of the sun.

Getting back to Baal, we find that the 20th century writer and historian Bryant, remarked that the Greeks called him Beliar, which was interpreted by Hesychius to mean "*a dragon or great serpent.*" Bel is the Assyrio-Babylonian version of the gods Enlil and Marduk – being the same as Baal – the same Baal seen throughout the Bible. So the Baal in the Bible is a Babylonian serpent god.

Could it be that *Bel*tane should be rendered Bel-Tan, both words signifying the dragon/serpent? – And showing again, a cross-continent link to Europe. Remember that this was a time of year associated with the sun and the serpent is again here being linked to these astrotheological concepts.

In fact 'Tan-it' or Tanit was the patron goddess of Carthage in Northern Africa, who was also associated with the 'Tree of Life' like Ishtar and Astarte, and she definitely crossed cultures into Europe.
Often the Tree is depicted with wavy lines said to represent serpents – a merging in symbolic form. The name Tanit means 'Serpent Lady' and she is found on many coins in Carthage associated with the Caduceus and

symbolising the role of Tanit in life, death and rebirth. She is basically the same as the 'Queen of Heaven' – Astarte/Isis/Mary. Here the serpent is associated with the cycles of the moon as the Queen of Heaven, whereas the male serpent is the King of Heaven – the sun. The one being the mirror of the other.

This relates the early Christian Gnostics right back to Babylonian beliefs of serpent worship, which in turn goes across to Egypt and Mesopotamia in general towards the African ancient serpent cults. Christianity then, is related to the most ancient serpent worship known and if it were not for the destructive covering up of huge amounts of historical data by the Christians, then this would have been all the more obvious, without such extreme measures of investigation. It is a fact that the Christians were ashamed of this link and did all they could to destroy it. Not least because it would reveal their own deity to be the sun itself.

A general term used for early Christian Gnostics, was Ophites as we have seen, although it is probably too strong to call them Christians in the modern sense. Epiphanius said:

"the Ophites sprung out of the Nicolatians and Gnostics, and were so called from the serpent which they worshipped."

They *"taught that the ruler of this world was of a dracontic form"* and *"the Ophites attribute all wisdom to the serpent of paradise, and say that he was the author of knowledge of men"* – linking him to the Taautus of the Phoenicians.

"They keep a live serpent in a chest; and at the time of the mysteries entice him out by placing bread before him upon a table. Opening his door he comes out, and having ascended the table, folds himself about the bread. They not only break the bread and distribute this among the votaries, but whosoever will, may kiss the serpent. This, the wretched people call the Eucharist. They conclude the mysteries by singing a hymn through him to the supreme father."

An amazing declaration, which speaks volumes. It tells us that, like the ancient Egyptians, the serpent was symbolic of the sun and must be constantly enticed to rise. Kissing the bread is the simple revelation that the sun indeed feeds us by giving life to our agricultural world.

The Eucharist mediator is the serpent, as Christ was the mediator on the cross, a symbol and act more ancient than Christ and rooted itself in serpent worship. The serpent was itself sacrificed on the 'sacred tree' or Asherah. This also relates to the rites of Bacchus, where snakes were carried in baskets of cakes and bread, the food then being given to the votaries. In these Bacchanalian rites there was also the consecrated wine, which was handed around. Remarkably, this ritual used a special chalice or grail object called the *Cup of the Agathodaemon*, meaning simply 'good serpent.' This serpent-consecrated cup of wine was handed around after supper just like at the 'Last Supper of Christ' and was received with much shouting and joyousness. The hymn sung via the serpent to the supreme father was just the same as the one sung in the memory of the Python at Delphi on the seventh day of the week. Now thousands of years later, Christians still take the Cup of Christ (called the 'good serpent' by the Gnostics) and eat the consecrated bread. This modern ritual is none other than the original, but renamed, 'Cup of the Sacred Serpent,' which gives the body, and blood of our oldest god.

A 3rd Century Persian teacher, known as Manes, who said that Christianity had got things wrong and he was here to put it right, attempted to revive these old ways. Regardless of the Christian attempts to kill off Manichaeism it survived until the 13th century. He is said to have revived Ophiolatreia (serpent worship), where he taught that Christ was an incarnation of the 'great serpent,' "*who glided over the cradle of the Virgin Mary, when she was asleep, at the age of a year and a half.*" But, the worship of the serpent was much more ancient than even Manes stated.

The chief title of the British serpent god was Hu the dragon ruler of the world, the title probably giving us Huas or Hyas, a name for Bacchus. The druid was known as 'a gnadder' (now known as 'an adder', having dropped the 'gn') as the adder was the symbol of the god Hu and Deane

believed that the Druids were "*Ophites of the original stock.*" They worshipped also Beli. So in this respect, the Druids were probably the last truly serpent worshipping priests in Europe.

A Bardic poem cited by Deane:

"With solemn festivity round the two lakes;

With the lake next my side;

With my side moving round the sanctuary;

While the sanctuary is earnestly invoking;

The gliding king, before whom the fair one,
Retreats, upon the veil that covers the huge stones;

Whilst the dragon moves round over;

The places which contain the vessels of drink offering;

Whilst the drink offering is in the golden horns;

Whilst the golden horns are in the hand;

Whilst the knife is upon the chief victim; Sincerely I implore thee,
O victorious Bel . . ."

Moving around like the serpent, sacred stones – all this sounds remarkably like the Avebury Serpent passage and others, and what is at the end, but a golden horn, a chalice offering. In all the research on the serpent worshippers there are some things we cannot deny – they were very real, they existed across the globe and they built huge stone structures everywhere. The Omphalos is an example of this.

According to Herodotus a sacred serpent was fed honey cakes once a month at the Acropolis in Athens. These honey cakes were marked with the Omphalos.

The superstition of the Omphalos was widespread like the serpent belief from India to Greece. It is a boss or orb with spiral lines (see chapter *Signs of the Serpent*) thought to represent serpents coiled. There are similar markings on ancient stone monuments across the world – especially at Newgrange in Ireland. Quintus Curtius also pointed out that in Africa there were such stones with spiral lines drawn, said to be a symbol of the serpent deity.

To the Etruscans the Omphalos was seen as a route to the Underworld. It was placed in a trench called a *mundus* (earth) and the first fruits offered into the trench, which was then covered by a huge stone. The entire city was centred on this spot with all roads leading to and from it.

Probably the most famous Omphalos is the one now in the museum at Delphi. In Greek history the Delphic Oracle was called Pytho (Python – snake) and she was active for over 1,000 years, getting involved in anything from mundane day-to-day prophecies to matters of state. Nobody really has any ideas how the Oracle managed to do her business.

There are suggestions that volcanic vents issued hallucinogenic chemicals up into the chamber and suggestions that sacred mushrooms were used. One strange vase however may give the clue. A 4th century Vulci Cup shows King Aigeus before Pythia (Themis) who holds a bowl and stares intently into it.

This is no vented drug or mushroom, this is the 'Sacred Cup' of the Agathodaemon in another form – the prophetic snake yet again. It may also be that this was a unique way of seeing the reflection of the sky and thereby 'predicting' events from astrological perspectives.

As throughout the history of the mystical serpent it has been associated with powers of 'future sight' – known to us today as 'Precognition.'

Around the decoration of this cup are the familiar spirals (movements of the sun and stars, spiralling because of precession) of the snake and Pythia herself is seated upon the tripod, sacred to the sight. Another indication that the serpent is associated strongly with prophecy is the stark fact that the words for 'divination' in Hebrew, Arabic and Greek all mean 'serpent' also. This alone indicates that Hebrew, Arabic and Greek are following the same beliefs, over a vast period of time.

According to Fergusson, the 19th century writer:

It was the symbol of other deities with likewise attributes. In The Serpent and Siva Worship, C. Staniland Wake remarks about the:

"Moslem saint of Upper Egypt is still thought to appear under the form of a serpent, and to cure the diseases which afflict the pilgrims of his shrine."

In the same book we hear of Ramahavaly, one of the four idols of Madagascar, whose emissaries are serpents. He is regarded as a Physician and thought to expel epidemic diseases, much akin to Aesculapius:

"as god, sacred, powerful, and almighty; who kills and makes alive; who heals the sick, and prevents diseases and pestilence; who can cause thunder and lightning to strike their victims or prevent their fatality; can cause rain in abundance when wanted, or can withhold it so as to ruin the crops of rice. He is also celebrated for his knowledge of the past and future, and for his capacity of discovering whatever is healed or concealed."

Ramahavaly has basically all the elements of the Agathodaemon, the sacred serpent, in one god. He is like many other serpent deities in charge of the weather, he has knowledge and wisdom, and above all he can heal, resurrect and disperse disease.

In the Epigraphic records of cures from Epidaurus there are many methods of healing. The 17th for instance states:

"A man had his toe healed by a serpent. He, suffering dreadfully from a malignant sore on his toe, during the daytime was taken outside by the servants of the Temple and set upon a seat. When sleep came upon him, then a snake issued from the Abaton and healed the toe with its tongue, and thereafter went back again to the Abaton." (Ab = serpent)

Valerius Maximus (1.8.2) also tells of a serpent which:

"through his arrival he dispelled the plague for the cure of which he had been summoned."

It is highly likely that these stories may relate to the healers and sages of the serpent worshipping cults and not the serpent itself, although it is likely that a snake was used in many cases for the cures.

In Islam the snake is always seen as being closely associated with life. In fact the word *el-hayyah* (related to Eve) meaning 'snake' is close to *el-hyat* meaning the 'life giving principle'. The Prophet Mohammed is said to have spoken of the Jinn (from where we get Genie) as being of three kinds, one of which was as a serpent. Muslims are thought to hold the opinion that Mohammed was sent not just for the people, but also for the Jinn (the words of Abu-Tha'labah al-Khushani Al-Khushati as related by Al-Tabarani.) Indeed the white Jinn are said to be formed from the irises of the serpent, Sakatimuna's eyes. The king of the Jinn was Jamshid who just happens to be famous for having a beautiful cup of Elixir. A golden cup full of the elixir of life, hidden by the Jinn and said to have been discovered while digging the foundations of Persepolis, which was Jamshid's capital.

"I know too where the genii hid the jewelled cup of their king Jamshid, With life's elixir sparkling high." Thomas Moore: *Paradise and the Peri.*

The Resplendent Jam, as he was known, was the first to organise society and was one of the first legendary and possibly mythical rulers of Iran (Persia). Wine and sugar were made for the first time. He was the first to construct roads and build ships, and he established the New Year's Day

festival known as Ruz on the vernal equinox, which is still celebrated in Iran.

During his long reign, Jamshid received a warning that in three severe winters heavy snowfalls would cover the earth and all creation would be destroyed, very much like the flood of Noah. Jamshid followed the divine order and constructed a *var*, which is a fortress, into which he took the best men, women, animals and plants to reproduce and replenish the earth after the snows had melted.

His reign was remembered for its great prosperity but also his pride. He became a sinner and he was defeated and killed by the serpent-king, Zohak. A later king of this dynasty, Fereidun, in turn killed the serpent-king. Fereidun is also credited with the discovery of the art of medicine and healing. It could be that Jamshid and Key-Khosrow from the 2nd millennium BC were mixed up, as Khosrow is often seen as a precursor to King Arthur, especially as he held the cup or grail of life. The whole story of Zohak and Jamshid is the struggle between the culture of Persia and the invading serpent cult from Syria, which was seen as the evil. I had hoped to be able to balance out this one sided history, but I could find no reference to an alternative story from the side of the serpent cult and so we left with a kind of anti-serpent propaganda.

SNAKE STONES

There are peculiar things known as 'snake stones,' which were said to impart healing and good luck. Called *gleinen nadroeth*, they are said to be small rings formed by snakes that join together; hiss; form a kind of bubble, which they blow on, and which then hardens resembling a glass ring. Quite often these 'snake stones' are said to be green in colour like the Philosophers Stone.

In Cornwall it was said that any beast bitten by a snake could be cured from the water infused by one of these 'snake stones.' Some of these

ancient bead stones were found on Hakpen (snake head) Hill in Avebury – thought today to be for purely ornamental purposes. In India the Brahmins convinced the Malabarians that they took these Pedra del Cobra from the actual hoods of snakes and this must surely be the same 'snake stone' spoken of by Pliny where he says of the Eastern Kings:

"It must be cut out of the brain of a living serpent, where it grows; for if the serpent die, the stone dissolves. The natives therefore, first charm the serpent to sleep with herbs; and when he is lulled, make a sudden incision in his head, and cut out the stone."

ADAM & EVE

Now we move onto the progenitors of the whole of the human race. Remarkably I found that both were related to serpent worship from their Sumerian origins.

Clemens Alexandrius said that *Heviah* – the root of Eve – means 'female serpent,' *"If we pay attention to the strict sense of the Hebrew, the name Evia aspirated signifies a female, serpent."*

It is connected to the same Arabic root which means both 'life' and 'serpent.'

The Persians even called the constellation, Serpens, 'the little Ava' or 'Eve.'

In old Akkadian, Ad signifies 'father,' and according to C. Staniland Wake in *The Origin of Serpent Worship*, Adam was closely associated in legend with Seth, Saturn, Thoth or Taautus, who were all associated strongly as serpents.

Hercules, himself a serpent deity, is titled Sandan or Adanos. Adonis and Osiris were Azar and Adar – and even St. John's devilish, *Abaddon*,

includes the term. No wonder that Abel, the son of Adam and Eve, means 'serpent shining' and that Cain was thought to be of serpent descent. The other and important point to note is that Adam and Eve were initially immortal and Eve gained her wisdom via the serpent on the Tree of Knowledge/Life.

As for Cain and Abel: According to Hyde Clarke and C. Staniland Wake in Serpent and *Siva* Worship, Abel (Mbale) and Cain (Kane/can) are names given to elder and younger brothers.

Abel resolves into Ab (Snake) and El (God/shining) and therefore he is a 'snake god' or 'shining snake.'

According to Rabbinical tradition Cain was not the son of Adam at all, but rather the son of Asmodeus, the 'serpent spirit' who is Ahriman in Persian Zoroastrianism.

Astronomy

The motion of the planets was seen as serpentine by many cultures. Calendars from Eurasia show representations of the celestial pathway with cycloid movements and serpentine features. The eclipses are shown as one serpent eating another. (*Snake Patterns in Eurasia/Japan and Their Implications*, a 2001 paper by Szaniszlo Berczi, Osamu Sano and Ryuji Takaki from Eotvos University and Tokyo University of Agriculture)

Similar serpent formations for the celestial pathways are shown across the world and so it is not surprising to see the serpent represented on the ancient stone monuments of the world, which are aligned to various celestial motions such as Midsummer and Midwinter.

In Greek legend the father of Aesculapius, Apollo – the sun god – asked his sacred crow (or raven) named Corvus, to go to earth and bring him a cup of fresh spring water. Corvus flew down with a chalice in-order to fol-

low his master's instructions.

However, by the edge of the water grew a fig tree. The fig is thought to be the tree from the Garden of Eden.

The temptation was too much for Corvus to eat the fruit. But it was not ripe and so the bird waited. When the fruit was ripe Corvus ate his full until the last of the figs had gone. Then he remembered why he was on the earth in the first place and quickly filled his goblet. However he suddenly had a thought, that he would need an excuse for taking so long. He grabbed a water snake and together with the cup flew back to Apollo.

He told Apollo that the water snake had attacked him, but Apollo saw the tiny snake and refused to believe the bird. He punished Corvus by turning him black (hence sent him into night time), where he had once been a beautiful silvery white. He gave the bird a raucous crow and then threw Corvus, the snake and the cup into the sky.

Now we can see the cup as Crater and the snake as Hydra in the stars. The snake was told to keep the cup on his back and never to let Corvus near it – the snake becoming the protector of the cup of the waters of the gods.

Ophiucus stretches from east of the head of Hercules to Scorpio and is partly in the Milky Way and divided by the celestial equator. Ophiucus, the 'snake handler' and Serpens the snake are seen together – the handler holding the snake. The classicists see Ophiucus as Aesculapius the healer.

To others, Ophiucus is one of the Libyan Psylli who were noted for their skills in curing snakebites and to still others he is Aaron or Moses with their serpent staffs or St. Paul with his Maltese Viper.

Again, the word Ophiucus comes from *Ophis* for snake and *cheiro-o* for 'to handle' – sounding remarkably like Chi-Ro, a supposed name for Christ, but a symbol which has much older origins.

There is a legend regarding Orion and Scorpius, which involves this snake

handler. Orion in a fit of anger swears to kill all the animals on the Earth, but Gaia, the Earth's Goddess is angered and sends Scorpius after him. Orion falls wounded from the sting of Scorpius, who sets in the west and rises in the east to gloat over his victim. But along comes Ophiucus who is above Scorpius and tramples on him. Then, using his Elixir of life, Ophiucus restores Orion to life and he is seen again once more on the horizon. This story is similar to the ancient Egyptian, Osiris, (Orion) Set, (Serpens) and Horus, (Ophiucus) myth.

Serpens however is the most unusual constellation in the sky. It is the only one that is split into two parts. The two parts themselves are very telling as they reveal a distinction between the tail or body and the head of the serpent.

Serpens Caput is the head of the serpent and Serpens Cauda is the tail of the serpent. Even though the two are separated, they are still, and uniquely, classed as one. The other important point to remember, is that Ophiucus and Serpens thousands of years ago were actually much larger in the sky than they are today – they had more importance to the ancients than we realise. It is a springtime constellation – it is therefore the constellation of new life!

American Snake Tribe

This American indigenous people call the snake *anida wehi* or 'supernatural.'

They possess influence of the rain and thunder gods, over other animals and plant tribes – much like the 'Horned Man' from the Gundestrup Cauldron, who appears to be of the snake tribe and has rule over animals.

The most revered snake is the Rattlesnake, called *utsa nati* ('he who has a bell.') However, all snakes are treated with respect, fear and awe.

The Rattlesnake was, according to legend, once a man – alluding to the ancient, incoming serpent worshippers of antiquity. This man was transformed into a Rattlesnake in-order to bring salvation to the human race and save him from the power of the sun. Even the Cherokee Indians are afraid of killing the Rattlesnake and will ask for pardon from the snake's ghost should they do so.

The snake is said to be afraid of a plant called *Silene stellata* or 'Rattlesnakes Master,' which is used by medicine men to counteract the venom. The teeth, skin, flesh and oil of the Rattlesnake are greatly revered for their medicinal value, although pardons from the ghosts of the snakes have to be sought by the medicine man for their use. This of course leaves the secret of the preparation to the power of the priesthood, who therefore earn a living from it.

There are sacred preparations, which we can only see in part, as the secrecy is closely guarded. We do know that firstly the snake's head has to be cut off. The teeth are used basically as a visual device to scare the patient into believing in its power. The rattles are worn about the head and the flesh eaten to make warriors 'angry.' The most important part is the lower body and the oil, which is held in great estimation by the Snake Tribes and the early white settlers for its effect upon joint problems.

In seasons of epidemic a roasted snake was hung in the house for the father of the family to bite off a small amount each day. He would chew it, mixed with water and then spit it upon the other members of the family to protect them from disease. The *gule gi* or blacksnake was used to prevent toothache and there is indeed a tradition that if the snake is hung on a tree for three days it will bring rain . . . remarkably similar to the Christian tale and even a link with Yahweh the rain god.

CIRCUMCISION

There is a peculiar practice, which links the worship of the serpent with

the Hebrew nation of old – circumcision. Still today, Jewish boys are circumcised – that is, they have their foreskin removed from their penis. Why? And how does this strange practice link with serpent worship?

There are wall carvings in Egypt showing circumcision being practised. The Egyptians held the belief that when the snake shed its skin it had undergone rebirth, it was symbolic of attaining new life . . . of being born again.

The Egyptian priest in a mock ritual of the 'serpent shedding his skin' therefore removed the foreskin of the male and so the male was 'born again' like the snake. This practice then spread to the Semitic peoples, Arabs and Jews in later times – most probably via the emerging serpent worshippers. There is some thought that this practice may even go back to ancient Sumeria.

GLAUKOS

"O Glaukos, guiding the revolutions of innumerable years, if it be lawful leave the abyss of the barren sea, and show me the life-sufficing plant, show that which you tasted once with your lips, and now enjoy life incorruptible, circling with the course of time." Dionysiaca 35:72.

Two generations before the Trojan War a child named Anthedon was born to King Minos of Crete, who had come from Scythia. This is the same Scythia from where I traced the influence of the serpent and dragon aspects into Britain during the period of King Arthur and thereby into the legends of the Grail. (See The Serpent Grail, Philip Gardiner with Gary Osborn, Watkins, 2005)

Anthedon crept into a cave used for storing mead and drank himself to death. Minos sent for the seers who informed him that whoever could describe his sacred cow the best would be able to restore the child. The problem was that the cow changed colours every four hours, like the peri-

ods of the day. From black of night, to white of day, then red of sunset and back to black again. The only one who could describe the cow was Poluidos ('much knowing') who said it was like a mulberry ripening, which went through similar colour changes. Poluidos was the son of Koiranso, the son of Abos who was the son of Melampous the Egyptian. He was the most famous iatromantis (like a shaman) in Greece and was said to know the language of snakes.

Poluidos found the boy and brought him back to Minos who refused to be satisfied, as he wanted the boy alive as promised by his seers. Poluidos and the boy were locked into a beehive-shaped tomb and were refused escape until the boy lived again. Poluidos was unable to do Minos' bidding but prayed to the gods for help. Soon, after growing accustomed to the dark he saw a snake approaching the corpse – presumably to enact the gods will. However, terrified, Poluidos killed the snake – only for a second one to emerge.

This second snake saw the dead remains of the first and slithered off to fetch a twig of an herb called the Flower of Zeus, which it used to bring the first snake back to life. Poluidos took the hint and stole the twig using it to resurrect the boy. A blue-grey scar emerged on the boy where the twig had touched him and from that day forth he was known as Glaukos meaning 'blue-grey.' He was also known as Antitheos or god-like and with his fashioned serpent staff he had power over serpents until the end of time. His hair and beard turned green after becoming Glaukos or 'old man of the sea' and there are tales of him acting very similar to the Quinotaur of the Merovingians. Glaukos helped Jason build the Argo, so that he may find the 'Golden Fleece' and it is believed his myth came to the British shores under the guise of Gathelos, the husband of Skotia, whom he had married after helping the Pharaoh (possibly Akhenaton) in battle against the Ethiopians.

The myth goes that Gathelos (Glaukos) travelled to Europe and brought the Druid faith with him. On the way they visited Carthage, found a

colony in Galicia, Spain, called Brigantia after the goddess Bridgid and then went on to Ireland.

Gathelos became king and Skotia his queen. The tribe took on the name *skotioi* and eventually moved to Caledonia giving their name to Scotland ('dark land.') Glaukos then moved back into the sea and the people of Scotland still call his descendants blue men (*Na Fir Ghorm.*) All of this is wonderful folktale, and yet it hides the distinct belief that serpentine tribes and Egyptian type religions did indeed come to the islands of Britain.

A similar tale of snakes bringing the elixir is found in the story told by Nonnos. When a venomous serpent killed the Lydian, Tylos, his sister Moria requested help from a giant called Damason. This giant killed the serpent with a tree. However, the serpent's wife brought a herb known as the 'flower of Zeus,' put it to the nostrils (like the Ankh) and brought the dead husband back to life. Moria then picked the same herb to bring her brother back to life. Firstly, note how the serpent is killed or sacrificed with a tree. Secondly, note how the 'herb' is placed to the nostrils. This is the same process when using the Egyptian Ankh, the life giver and the Ankh is made up of the symbol of the tree and the snake. It is the symbol of ultimate treasure.

The internal energy or serpent fire is the gift of the gods and gives all things life. It rises upon the Tree of Life and Knowledge, which are representations of the spine. The pinnacle of this tree is the skull and so life is drawn and given via the portals of the head.

MINOAN SNAKE GODDESS

According to Dr Alena Trckova-Flamee Ph.D. the snake goddess of the Minoan culture is closely associated with the more general snake culture of the period (approx. 1,600 BC). It was Sir Arthur Evans who linked this goddess with the Egyptian goddess of the Nile, Wadjet.

From Evans point of view the snake was a form of 'underworld spirit' with a domestic and friendly aspect. She was the Mother Goddess, although some doubt is now being cast upon the assertions of Evans and his archaeological validity. There are various representations of the Minoan Snake Goddess, mostly supposedly found in temples, although some are said to have been found amongst grave goods. The most famous however are the two faience snake goddesses from Knossos and from around 1,600 BC. Simply they are bare breasted, female figures, holding aloft snakes. The snake is believed to emerge from Egyptian influence. This influence can be seen when we consider that Mut (mother) in Egyptian texts is the 'mother of mothers' "*who gives birth to every god; the wonderful snake who wounds herself around her father Re and placed him on earth as Khons." (Hathor Rising: The Serpent Power of Ancient Egypt* by Alison Roberts.) The Minoan Snake Goddess symbolises rebirth, resurrection and the renewal of life – the very aspects of the serpent we have been discovering in pure form. In fact, the tale of Glaukos we have just seen, is a Cretan myth.

PANCHATANTRA

The Panchatantra are five books of animal and magical tales and one of India's most influential contributions to world culture. Said to have been compiled between the 3rd and 5th century AD, however it is believed, not without reason, that they were already very ancient by then. These stories substantially influenced Western Europe via Arabic translations and oral trade. In it we can see the links between the Brahman culture and the idea of serpent descent for the royal families. Devasarman, a Brahman, lived in Radschagriha and had a childless wife who wept constantly for children. This indicates the sterile nature of the Brahman at this stage, much like the lack of fertility in the Arthurian Fisher King tales. One day Devasarman said to his wife *"Stop your grieving. Behold, I was offering a sacrifice for the birth of a son when an invisible being said to me in the clearest words, 'Brahman, you shall be granted this son, and he shall surpass all men in beauty and virtue, and good fortune shall*

be his.'" The Brahmans wife was overjoyed at this tale, however in the course of time she gave birth to a snake. All her servants cried, "*throw it away*". However, the doting mother picked it up and cared for it lovingly.

One day she got upset when watching the wedding of a young couple, saying to her husband, "*You treat me with contempt, because you are not making any effort at all to arrange a wedding for my dear child.*" The Brahman replied "*I would have to go to the depths of hell and beseech Pasuki, the King of Snakes, for who else, you fool, would give his daughter in marriage to a snake?*" But wives can be very convincing sometimes and the Brahman ended up travelling far and wide to seek out a bride, ending up in a place called Kukutanagara (note Naga in the name meaning serpent). He spent the night there and in the morning told his host why he had come. Amazingly the host had the perfect daughter and the Brahman returned home gleefully with the girl and her servants. After an initial shock at the thought of marrying the snake the girl eventually came around and promised to marry him. She showed the snake respect during the early days, serving him milk and food. But one night the snake left his basket and crept into bed, but the girl thought it was man and she was terrified, until she realised it really was her husband who had changed shape. The Brahman had seen everything and early in the morning before the snake could creep back into his snakeskin he stole it and burned it and never again could the son take the form of a snake.

Although there is much Gnosis in this story it is a tale indicating the descent of the Brahman from the earlier serpent worshipping cults. The Brahmin replacing the serpent skin and therefore having superior power. There are hundreds more like it across the world, relating to the descent from serpent worshippers. There is little wonder when these serpent tribes were spreading their belief around the world before Egypt had even been thought of.

So there we have a few tales of the serpent in the history and mystery of the human mind. In altered states of consciousness modern science has proven that snakes or spirals and waves are seen internally and so this

becomes a universal archetype. There are reasons for these perfectly nat-
ural shapes appearing in our unconscious or subconscious world – not
least of which is because energy is a wave. These internal and religious
impulses were then externalised, just as man has done so for thousands of
years and still does. Art itself is a distinct method of externalising the
internal world of emotion and thought. And so the serpent was sought on
the earth. It was used for medical purposes. It was worshipped as a sym-
bol of the inner wisdom and it was placed in the greatest of all human
mental playgrounds – the sky.

My reason for beginning this collection of articles and thoughts with this
information is simple. I believe that the history of the world cannot be
complete without the mythology of the serpent. As we can see from just
this small collection of information almost every culture on the plant has
origins in the worship of the serpent and especially the healing and
enlightenment aspects of its symbolism. The greatest gods, the greatest
saviours seem to have origins in this amazing lost knowledge. Now think
about this for a moment. How many history books have you read that
point out these incredible tales? The answer will be relatively few. What
occurred is simple. In the Victorian age many historians discovered a lot
of these links and wrote about them in isolation. Others even played
down or re-wrote this history because it offended their Christian delica-
cies. We have to remember that many of our 19th and 20th century histo-
rians were actually Christians and they did their level best to explain any-
thing they found to be anomalous in terms of their faith. At the end of the
day, history is history and we cannot bend it to our own belief system.
Belief, faith and emotion are quite separate from truth. The facts are stark
and care little for your opinion or mine, they just are. Whatever we wish
to think we know, whatever we have been told to know, we must check
and check again.

The problem has been that a lot of this information was there, but hidden
in fusty old peculiar books. It was never collated, at least it was never
brought together in one place in an unbiased way. Now, we are in the
21st century and we have the opportunity to set the record straight again.
Now we have this information we must decide what to do with it. I have

decided to use this, and more besides, to question the many mysteries and myths we still seem to have and the answers that it throws up are startling. Those questions and answers are the subject of this book.

SPIRALS, SYMBOLS AND SNAKES

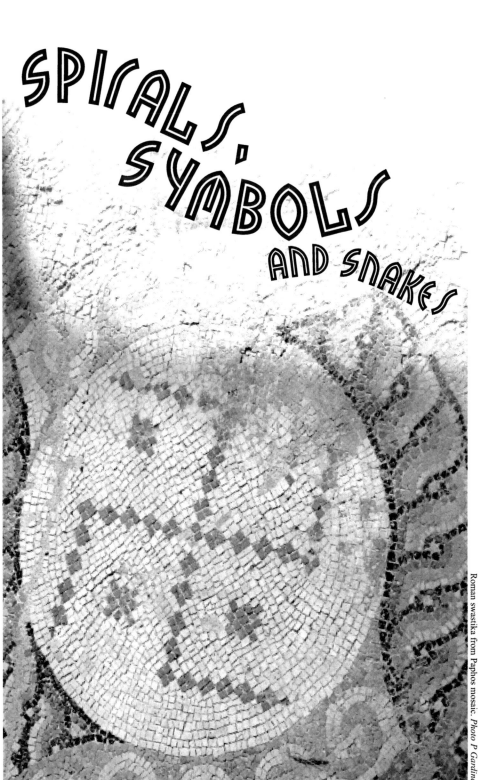

Roman swastika from Paphos mosaic. *Photo P Gardiner*

In the last chapter we went through the history and mythology of the snake in the world. What we saw was that history is not as we thought. We saw that underlying almost every concept was astrotheology or the planets as gods – the sun, moon and stars. We saw that internal experiences are externalised and that the myths and religions of the globe all revolve around a unique symbol – the serpent. It is seen in the sky, on the ground, hidden in language and glaring at us from the pages of our most profound books. In this Article I want to extend that now a little and for us to journey around the world of symbols. By understanding what many of these symbols mean and just how universal they are we will be guided into this lost world of our past. We will begin with a symbol of life itself from the world's greatest ancient civilisation.

ANKH

The Ankh is the Crux Ansata. A simple T-Cross, surmounted by an oval – called the RU, which is, simply put, the gateway to enlightenment.

This enigmatic symbol of Egypt represents 'eternal life' and was often found in the names of Pharaoh's such as Tut-*ankh*-amun. The symbol is often depicted being held by a god to a Pharaoh, giving him life, or held by a Pharaoh to his people, giving them life – this basically set aside the immortals, from the mortals, for anyone wearing or carrying the Ankh had gained or hoped to gain immortality. In truth also, the pharaoh was God on earth and so he held his own symbol of the sun and the serpent to his people – he was the sun, giving us life, just as it does in nature.

It is the loop (the RU or gateway) of the Ankh, which is held by the immortals to the nostrils (as in the Biblical god breathing life into the nostrils of Adam.) If indeed these 'immortals' are the sun, moon and stars, then this Ru device is indeed a gateway to the stars – or basically a gateway to what we were believed to return or become following death. The Ankh though outlived Egyptian domination and was widely used by the Christians as their first cross, but in this symbol holds a clue to the

secret of the serpent.

Thoth (see *Taautus* below) was said to have symbolised the four elements with a simple cross, which originated from the oldest Phoenician alphabet as the curling serpent. Indeed Philo adds that the Phoenician alphabet "*are those formed by means of serpents . . . and adored them as the supreme gods, the rulers of the universe.*" Thus bringing to mind the god Thoth, who again is related to the worship of serpents and who created the alphabet. The "*rulers of the universe*" are indeed the planets and stars.

Bunsen in the 19th century thought, "*the forms and movements of serpents were employed in the invention of the oldest letters, which represent gods.*" This symbol of the four elements was altered slightly and became the Egyptian Taut, the same as the Greek Tau, which is where we get the name Tau Cross from – a simple T.

The T or Tau cross has been a symbol of eternal life in many cultures and gives its name to the Bull in the Astrological sign of T*aur*us – note here the two elements of the Tau and the RU being brought together. In fact the Druids (or 'adders' after the snake) venerated the tree and the snake by scrawling the Tau cross into tree bark.

In the Middle Ages the Tau cross was used in amulets to protect the wearer against disease.

Amongst the modern Freemasons the Tau has many meanings. Some say that it stands for *Templus Hierosolyma* or the Temple of Jerusalem, others that it signifies hidden treasure or means *Clavis ad Thesaurum*, 'A key to treasure' or *Theca ubi res pretiosa*, 'A place where the precious thing is concealed.'

It is especially important in Royal Arch Masonry where it becomes the 'Companions Jewel' with a serpent as a circle above the cross bar – forming the Ankh with the Hebrew word for 'serpent' engraved on the upright and also including the Triple Tau – a symbol for hidden treasure and significantly made up of 8 right angles.

It was also the symbol for St. Anthony – later to become the symbol for the Knights Templar of St. Anthony of Leith in Scotland. St. Anthony lived in the 4th century AD and is credited with establishing Monasticism in Egypt, and generally the story goes that he sold all his possessions after hearing from the Lord and marched off into the wilderness to become a hermit. On his travels he learned much from various sages in Egypt and grew for himself a large following. He was sorely tempted by the devil in the form of 'creeping things' and serpents (chaos). In one episode he follows a trail of gold to a temple, which is infested with serpents and takes up residence, needing little food for sustenance other than bread and water. He is said to have lived 105 years and due to this longevity he is credited with protective powers. His secret treasure was the balance between the *chaotic* serpents and the *order* of his belief.

The Order of the Hospitalers of St. Anthony, who would later take much of the Templar wealth, brought many of Anthony's relics to France in the 11th century, although they were said to have been secretly deposited somewhere in Egypt just after his death and then later to have found their way to Alexandria.

The Taut or Tau symbolises the creating four elements of the universe. Next the symbol of the sun / serpent was added, a simple circle or the oval RU. This loop above the T cross-created the Ankh, the symbol of eternity. The snake in a circle eating its own tale is symbolic of the sun and immortality – the perpetuation of the cycles.

The symbol of the crescent moon was added to this, turning it into the sign for Hermes/Mercury and showing the Caduceus/Serpent origin. No wonder that this, the most perfect and simple of symbolic devices became the symbol of the early Christians; no wonder that, even though there were no cross-beam crucifixions, Christ was never the less symbolically crucified on a symbol of eternal life, a symbol of the serpent.

This symbol became the mark or sign, which would set the believer aside for saving. In *Ezekiel* this is the mark that god will know, the mark on the forehead. As Deane points out the *Ezekiel* passage (9:4) should read, "*set*

a Tau upon their foreheads." or "*mark with the letter Tau the foreheads.*" The early Christians baptised with the term *crucis thaumate notare*. They baptised with the symbol of the sun-snake (*sun-ake*). And St. Paul himself in *Galatians* 6: 17 states "*let no-one cause me trouble, for I bear on my body the marks of Jesus.*"

Is this the original mark of Cain, who we have found to be of the serpent tribe?

The idea of this sign or mark is widespread once discovered. In *Job* 31:35 we read in our modern Bibles "*I sign now my defence – let the Almighty answer me*" which should properly read, "*Behold, here is my Tau, let the Almighty answer me.*" He then goes on and says "*Surely I would take it upon my shoulder, and bind it as a crown to me.*"

This remarkable idea of wearing the Tau cross on the shoulder as a sign would later become part and parcel of the crusader Templars markings, the very same Templars who are instigated in the worship of serpents. Also the Merovingians (said by some to be descended from Jesus and a sea serpent or fish god – the Quinotaur or Quino-Tau-rus) were supposedly born with a red cross between their shoulder blades. The Tau cross is also strangely used by those practising sacred geometry as a 'marker' for buried treasure, whether physical or spiritual.

In shape, the Ankh is very similar to the Egyptian musical instrument, which is shaped like the oval RU – the Sistrum.

SISTRUM

An Egyptian musical instrument closely associated with female gods – especially Hathor the serpent/cow goddess and Isis – the consort of Osiris. In form, very much like the Ankh with a loop at the top – also representing the egg – and three serpents striking through the loop with

small square pieces of metal, which rattle. It's possible these three serpents represent the pingala, ida and sushumna nerve channels and which are said to converge and fuse together within the centre of the brain – which in the individual was also thought to represent the 'cosmic egg.'

During the ascent of these serpent energies up the spine to the centre of the head, the individual while going through this supposed enlightenment process, will hear sounds similar to the sounds the Sistrum makes – i.e., rattle sounds like tambourine bells and sounds like a bell-tree being stroked. One will also hear sounds like a 'rattle snake' and also whistles and flute-like instruments. Underlying these sounds is a very low and strong rumbling sound which fades-in at first and gets louder and louder as the process proceeds culminating in the bright, white light explosion in the centre of the head. The Sistrum then may have been a symbol of this experience.

The Sistrum was used in pictures and carvings to show the various gods and Pharaohs subduing the power of a particular god – and mostly because the god holding the Sistrum had the 'power' and 'energy' to do so representing the solar power on earth.

BIRDS

The association between birds or wings and the serpent seems to go back in time many thousands of years and across the world. To quote John Bathurst Deane:

"The hierogram of the circle, wings, and serpent, is one of the most curios emblems of Ophiolatreia, and is recognised, with some modifications, in almost every country where serpent worship prevailed . . . It may be alleged that all these cannot be resolved into the single-winged serpent once coiled. Under their present form, certainly not; but it is possible that these may be corruption's of the original emblem which was only preserved accurately in the neighbourhood of the country where the

cause of serpent-worship existed; namely, in Persia, which bordered upon Babylonia and Media, the rival loci of the Garden of Eden."

Deane relates these many thousands of images of the 'winged serpent' to the Seraphim of the Bible, the 'fiery' and 'flying serpents.'

These could also be the origins for the flying dragons and why Quetzalcoatl was the 'feathered' or 'plumed serpent' amongst others. The reason given by Deane for this symbolism is for proof of deity and consecration of a given Temple. If this is the case, then it was certainly believed that the ancient serpent had consecrated Temples across the world. And if the serpent was a true symbol of the sun (external) and the inner light (internal) then it was a perfect fusing of our ancestors belief in one location at one time (temple).

The real reason for the wings is that the serpent enlightenment aspect gave the adherent wings, symbolically making him/her higher in aspect and part of the 'heavenly' chorus.

DOVE

The dove is an important element in symbolism and for some reason was seen in the New Testament as a symbol of the Holy Spirit or feminine aspect of God. It came down upon Jesus as he was baptised, giving him that famous 'born again' element or 'touched by the spirit.'

It descended upon the disciples. But why was the Dove chosen?

The Mesoamerican god Quetzalcoatl is the 'Feathered Serpent,' so are there any links between the dove as a feathered bird and the serpent? Eurynome was probably the most important Goddess of the Pelasgian myths. These Pelasgians were a people who arrived in Greece from Palestine over 5,500 years ago, although it also became a term for "real" Greeks later on.

Eurynome was the creator, the Mother Goddess – the ruler of all things. She was born from chaos; she separated the water from the sky and then danced across the water in-order to create.

Whilst dancing she created wind or breath and taking hold of it between her hands she rubbed and rubbed until she had created a snake. The snake was called Ophion and he was filled with desire for the 'dancing goddess.' Wrapping himself around her *seven* times he impregnated the goddess, who had now taken the form of a Dove, and created an egg.

From the egg came forth all animals and plants and so Eurynome ascended to Mount Olympus and watched as her children developed. The snake Ophion bragged about his creation and so Eurynome kicked out his teeth, from where came all the people, including the first man Pelasgus, (like Adam) and from where the tribe derived its name. Ophion was then kicked out of heaven. The creation of the world and all that is in it was therefore again due to the snake and a goddess. But how does this goddess relate to the bird?

By the Sumerians, one of the most ancient of civilisations, she was simply known as Iahu, the 'exalted Dove.' This Eurynome cult had spread across the Mediterranean and became a base for many other myths and religions, including the Hebrew god Yahweh taking on elements of the name Lahu. She was an original Mother Goddess, the feminine aspect and was seen as a dove – and united with the serpent seed, she gave birth to creation. She skirted between the world's at the point of creation – she danced across the water. This is the place between the world of consciousness and unconsciousness. It is the hypnagogic state, of being aware of the unconscious world of imaginative creation. The snake wrapped around her seven times and this indicates the chakra points of the Hindu kundalini or coiled serpent. It is the creative force energised by the serpent fire. It is control, balance and power of the individual to bring about the new you.

The Dove of Christianity is the feminine aspect and brings new life; she was known as the breath – the same breath that emerges in the beginning

of creation and from the Egyptian Ankh (see Ankh) into the nostrils, bringing new life and immortality. The Dove is therefore true knowledge and wisdom in balance and unity.

Celtic Knotwork & Other Symbols

Due to the prevalence of the serpent in the Celtic world and surrounding cultures, it is my understanding that Celtic Knotwork is derived from the images of the snake and the movements of the planets.

We can see influences of this in the spirals and other serpent shapes seen upon many of the world's ancient monuments. In Scandinavian literature and stone art we can also see how the serpent appears, looking remarkably like Celtic Knotwork. In Roman and Greek wall paintings there are running spirals thought to be symbolic of the protective snake.

A Neolithic vessel, now in the museum of Henan in China, shows a distinct correlation between the idea of the snake and the Knotwork. The idea of the Knotwork coming from the snake was probably discontinued due to Christian influence.

Another symbol that is related to the snake is the Ivy leaf, a symbol of Bacchus/Dionysius and of immortality. The reasoning behind this symbol is simply that the leaf is similar to the snake's head and it entwines around pillars and trees as the snake is shown to do in images across the world.

Related to this Ivy leaf image is the shape of the heart and we can see in two Japanese clay statuettes from the Jomon period that they have these snake-heart heads.

Many images of the Buddha also incorporate this Ivy/Heart shape head – a softening and hiding of the earlier images of Naga deities who had snakes heads. These Ivy and Heart shapes were thought to protect the

person wearing them or the building adorned with them, and they are therefore no different to the concept of the protecting or guarding snake from folklore and legend. They are just basically symbolic of the original snake – and remained so until Christianity demonised them. Of course the Ivy, along with that other serpentine symbol, the grapevine, are to be seen across the world's Christian buildings, as Jesus claimed that we should be grafted onto the vine. Did Jesus really mean that we should be part of the serpent cult? Part of the family, which he was himself a creation of? In truth this was a statement of Oneness, unity through wisdom and knowledge – a distinctly Gnostic concept.

SPIRALS & OTHER ROCK ART

Marija Gimbutas in *The Goddesses and Gods of Old Europe* says:

"Compositions on the shoulders of cult vases reveal pairs of snakes with opposed heads, making the world roll with the energy of their spiralling bodies."

Spirals and carvings of this snake energy are seen all over the world, much like the cult of the serpent. And, it is always found to be in association with the serpent worship. According to J.C. Cooper in *An Illustrated Encyclopedia of Traditional Symbols*, the spiral *"typifies the androgyne and is connected with the caduceus symbolism"* which is of course the symbol of serpent healing. In Australia Robert Layton in *Australian Rock Art: a new synthesis*, (Cambridge University Press) points out the serpent origins of these images – images, which are always seen with other serpentine shapes. Figure three in Layton's book shows these images clearly as *"a snake entering a hole,"* *"a snake leaving a hole."* Remembering that the Ouroborus, the circular image of the snake eating its own tail, is an image of immortality, we should also remember the antiquity of the device. Alongside spirals are circles – like the Ouroborus – often called cup and ring marks. There are also zigzags, thought by many to be the fiery aspect of the serpent, and waves, showing the fluidity of the serpent

- something also related to the symbolism of Water. It is no surprise that such images of the snake, in all its relative forms, should be seen on the most ancient of rock art. In the cup and ring marks there are many images of what appears to be a serpent entering the cup and rings. Some have put this down to a serpent entering a hole, others that it is eating an egg; nobody is sure. What it does show is a serpent head towards a cup! If, of course, the snake is also the symbol of the macro sun, then these spirals and serpentine patterns may also reveal the pathways of the sun at various times of the year and the greater years – such as those of the precession of the earth.

The spirals have been associated with astronomical alignments. This can especially be seen in the work of N L Thomas in *Irish Symbols of 3500 BC* where the spiral running right to left is seen as the winter sun; the spiral running left to right is the summer sun and the double spiral as the spring and autumn equinox. There is little doubt from the work carried out by Thomas that this is true, but the fact also remains that the ancients were using symbols of the serpent in their astronomical alignments. This is matched by the fact that the serpent was seen in the sky, in various constellations and by the serpent encompassing the heavens. The two elements cannot be split apart – this was a unified theory of life and it was created by, given life by and kept fertile by the snake and the sun.

In Eurasia and Japan there are definite images of snakes as spirals. In earthenware from the middle Jomon period (approx 2000 BC) of Japan these can be seen quite clearly, and are said to be there to protect the contents of the jar from harm; something important was obviously in them. Clay figures from the same period also show wound snakes on the heads. These spirals became part of family crests and transformed over time into the Yin and Yang symbol of duality so popular today. These family symbols are called Kamon and one class of them particularly is called Janome, which basically means eye of the snake. Characters for snakes in Chinese became part of the alphabet over 3000 years ago. Another interesting point about the snake in China is that the Rainbow is said to be the snake elevated into the sky much like the Australian Rainbow Serpent. Indeed, the Chinese character for Rainbow reflects this position as it has

the symbol of the snake within it.

In Peru there is pottery with spirals ending in snakes heads. In Taiwan there is a sculptured door with spirals ending in snakes heads. In many Celtic stone monuments there are similar images – all leading to the now beautiful and ornate Celtic Knotwork.

SWASTIKA

The ancient symbol of the swastika is simply a stylised spiral as can be shown from the many depictions across the world of swastikas made up of spirals and snakes. It also shows up in the spiral fashions of the labyrinths and mazes. The word labyrinth comes directly from the ancient Minoan Snake Goddess culture of Crete, where the swastika was used as a symbol of the labyrinth and is linked etymologically with the 'double headed axe' – the Tau Cross. Similar labyrinthine shaped swastikas have been found in the ancient city of Harappa from 2000 BC. As the labyrinth is viewed as a womb of the Mother Goddess, and a symbol of the snake, there is little wonder that these two symbols became fused. However, labyrinths were also seen as places of ancient serpent initiation. In ancient Egypt the labyrinth was synominous with what was called the Amenti – the snake like path taken by the dead to journey from death to resurrection. It was Isis, the serpent queen of heaven who was to guide the souls through the twists of the Amenti. The path towards the centre leads towards treasure. The snake adorning Athene in ancient Greece is shown with a swastika skirt. The same is true of Astarte and Artemis. There is Samarran pottery dating from 5000-4000 BC from Mesopotamia showing a female swastika, where the hair swirls with Medusa type serpents. The swastika is also shown as two serpents crossing each other.

In Norse myth, the hammer of Thor (note that Labyrinth means double headed axe just like the Hammer of Thor!), Mjollnir, is closely connected with the swastika and is found to be a prominent motif in Scandinavian art from the Bronze Age to the Iron Age. It is found on swords and

Anglo-Saxon cremation urns and on numerous Viking items. It was seen as a protector against thieves, reminiscent of the fact that serpents were known to guard treasure. As Thor's hammer was also seen as a Tau cross (See Taautus) it is certainly related to the secrets of the serpent. It was used by Thor to lop off the head of the sacred ox, which he used as bait to catch the Midgard Serpent, which encircled the globe in the symbol of the Ouroboros, eating its own tail. This was Thor offering a head as sacrifice to the serpent to try and gain immortality in the mead – the drink of the gods. Thor's aim was to gain a cauldron big enough to take the mead for the immortals and he needed to prove his worth by fishing for the serpent. He had power over the serpent as the slayer, with the swastika or Tau cross. There is evidence to prove that the myths of these Scandinavians and the Hindus are related, as the story of Thor and the Midgard Serpent closely resemble the battle between Indra and Vritra, showing a common origin. Vritra is the great serpent, which lies at the source of two rivers (the positive and negative or male and female), as the Midgard Serpent lies beneath the sea (of the mind and the other side of the planet where the sun goes each night). Indra slits open the belly of the serpent to release the waters and therefore fertility back to the land. Both gods, Indra and Thor, are related to the weather, both are warrior gods with a thunderbolt as a weapon and both slay the dragon. The swastika of the serpent is a common motif in both cultures. Eventually the Christians steal both pagan myths and place St. Michael and St. George in their place – both having the red serpent cross to replace the swastika.

The swastika is also the symbol of the movement of the earth fixed on one spot.

TAAUTUS [TAUT, THOTH]

Taautus was said by Eusebius to be the originator of serpent worship in Phoenicia. Sanchoniathon called him a god and says that he made the first image of Coelus and invented hieroglyphs. This links him with

Hermes Trismegistus, also known as Thoth in Egypt. Taautus consecrated the species of dragons and serpents; and the Phoenicians and Egyptians followed him in this superstition.

This Taautus could very well be a memory of the first group who originated the worship of the serpent after the flood or end of last ice age 12000 years ago. The idea of Taautus links precisely with the stories of Thoth, who later became a great sage of Gnostic and Alchemical beliefs. Thoth was deified after his death (a time that nobody knows) and given the title 'the god of health' or 'healing.' He was the prototype for Aesculapius and identified with Hermes and Mercury. All healers, all wise, all teachers, all saviours and all associated with the serpent for their powers and all individuals who could map the stars and movements of time. However, it was as the healing god that Thoth was symbolised as the serpent - whereas he is normally represented with the head of an Ibis and Baboon.

The Letter or Symbol 'Tau' is the first letter of Taautus, Tammuz and Thoth and is thought to be the 'Mark of Cain'.

So there we have many symbols and many references to the sun and the snake. There are often confusing elements at play here, which often seem to mislead us and appear 'hidden' because we have simply forgotten the real truth. In essence we can reduce all of this down into three simple and distinct parts to help us on our journey.

We must remember before we do so that the very word, snake, is derived from both the animal and the sun – *sun-ake*. Now we can see clearly that the serpent was often but not solely used as a symbol of the movements of the great god in the sky – the sun. Secondly the snake was a symbol of the internal 'sun' – what people know of today as enlightenment within and thirdly the real and literal snake did indeed offer up its body for our use. We created an Elixir of Life from its venom and blood, healed our skin with its skin and brewed wonderful concoctions from other parts.

All in all, the serpent or snake has been a very powerful literal and physical element, let alone a useful symbolic part of our history. We can now use our new knowledge to move forward and through some of the mysteries of mankind.

Spiral vase. *Photo P Gardiner*

The saviour of mankind is a recurring motif. It has, like the sun, risen in every part of the world for thousands of years. It has cast its light upon every civilisation and every culture. But the light of this ancient sun has also cast dark shadows and today we wander around in the shadow of deception. You see, as civilisations grew so too did the power base of those who claimed authority from their saviour and great cultures began to move physically closer and closer, eventually crossing over into each others domain and the rest is history. There can only be one saviour, so went the cry, and for hundreds of years mankind has fought over the difference they perceived. But these differences are a phenomena and this study will highlight just how similar the various saviours of the planet are and how they are all based upon the same original ideals and belief systems – that of the original serpent worshippers and the motions of the planets.

BUDDHA

According to Albert Churchward in *The Origin and Evolution of Religion*:

"*The first Buddha was called Hermias, and can be traced back to Set of the Egyptians; he originated in the Stellar Cult. Later, however, the Solar Cult was carried to India, and the Buddha is there representative of Ptah of the Egyptians.*"

So, what we have here is a non-historical god-man based upon the sun and finding origin in Egyptian religion. He follows certain patterns, which as we will see, relate entirely to the idea of the later Jesus Christ. These patterns are the same the world over and follow a distinct astrotheological perspective. It is interesting to note that Buddha is seen as emerging from Set or Ptah of Egypt, especially when we consider the serpentine relationships of both deities.

The serpent was an emblem of the sun and of Buddha the messiah

45

(Squire, *Serpent Symbol*, p 195). According to Hindu oral tradition and legend, Gautama (Buddha) *"himself had a serpent lineage."* Not surprisingly trees are sacred to Buddhists, as Gautama was 'enlightened' beneath the Bo Tree. In *Ophiolatreia*, Hargrave Jennings quotes Captain Chapman who was one of the first to see the ruins of Anarajapura in India "*At this time the only remaining traces of the city consist of nine temples . . . groups of pillars . . . still held in great reverence by the Buddhists. They consist first of an enclosure, in which are the sacred trees called Bogaha*" or Trees of Buddha.

The basis of the Tibetan healing arts comes from Bhaisajya-guru, Lapis Lazuli Radiance Buddha – the 'master of healing.' The begging bowl is made of lapis lazuli and contains the very elixir of life.
An indication of what this Elixir is that resides in this bowl is found in a story related about the Buddha when he passes the night away at the hermitage of Uruvela.

The leader, Kashyapa, warned Buddha that there was only one hut available, and that a malevolent Naga (see Naga below) occupied it. Buddha was not phased by this and went to the hut regardless. However, a terrific struggle ensued culminating in the hut bursting into flames. The onlookers drenched the flames, but they had to wait until morning to find that Buddha had survived. The Buddha emerged with his begging bowl in his arms and inside was a peaceful, coiled snake. The Buddha had slain the dragon of its fiery notions and emerged with a beneficial result.

Now, to invoke the healing power of the snake, it is thought to be sufficient to simply call on the medicine Buddha. The serpent and Buddha are associated in symbolism because Buddha turned himself into a Naga (cobra) in-order to heal – that is, Buddha probably became a member of the Naga serpent cult in-order to learn their healing ways, just like Apollonius of Tyana and many others. This Apollonius himself was worshipped widely at the time of Christ. He did many miracles that were reminiscent of Jesus and indeed the very worshippers of Apollonius were later known as Christian Gnostics.

The coming or future Buddha is said to currently reside near, under or even in the Naga tree, where he learns wisdom from the Nagas.

Buddha as the god-man:

Born December 25th to the virgin Maya – announced by a star, wise men and angels.

Pronounced ruler of the world at birth and presented with costly gifts.

He 'crushed the serpents head' and was tempted by the 'evil one.'

He was baptised in water with the Holy Ghost present.

He fed the poor, healed the sick and walked on water.

According to some traditions he even died on a cross and was ascended physically to heaven (Nirvana).

CHRISHNA

Chrishna, Christna or Krishna is the Hindu god Vishnu in human form, like Christ is Yahweh in human form. And as all other healers, saviours and preserving gods, he was represented as a serpent. The serpent was a symbol of Vishnu as a preserving god and saviour.

The orthodox and post Christian position of his death is that he was shot in the foot while under a tree. However, as always with Hindu gods there are many variances. One states that the body of this 'god-man' was suspended on the branches of a tree – that is, he was crucified.

The disciple, Arjuna, came to take the body away, but it had already disappeared. The use of many arrows to 'pin' him to the tree is reminiscent of the crucifixion of Christ. As Doane points out in *Bible Myths and*

Their Parallels in Other Religions:

"The Vishnu Purana speaks of Chrishna being shot in the foot with an arrow, and states that this was the cause of his death. Other accounts, however, state that he was suspended on a tree, or in other words, cruci- fied.... The death of Chrishna is very differently related. One remarkable and convincing tradition makes him perish on a tree, to which he was nailed by the stroke of an arrow.... We find that Chrishna is represented hanging on a cross, and we know that a cross was frequently called "so cursed tree." It was an ancient custom to use trees as gibbets for crucifix- ion, or, if artificial, to call the cross a tree . . . In earlier copies of Moor's Hindu Pantheon, is to be seen representations of Chrishna (as Wittoba), with marks of holes in both feet, and in others, of holes in the hands."

Many of the images of Chrishna have been destroyed or removed by Christians. In the 19th century the British Parliament sent a Christian Bishop to find out about the Hindu religion. The result was forwarded back to England for investigation and the history of Hinduism was there- after found to be "horribly mutilated" and to be "scarcely recognisable." The Hindu crucifixion was completely removed. Indeed the Reverend Simpson, an erudite religionist noted that the *"subject, a crucifix, is omit- ted in the present edition, for very obvious reasons."* These obvious rea- sons were the Christian sensibilities, who, when they discovered such instances came up with the excuse that:

"These crucifixes have been introduced into India, I suppose, by Christian missionaries, and are, perhaps, used in Popish churches and societies." (Moors Pantheon)

There were several other points of discussion, which startled many; namely the Coronet, which was probably of Ethiopian or Parthian descent and looked incredibly similar to the crown of thorns and even the halo's seen around the gods. These coronets are associated with most saviour deities because it mirrors the corona seen around the sun when it comes into union with the moon in a solar eclipse – thus creating the 'son' of the sun and moon. The fact however remains that *India had its crucified vic-*

tim long before Christianity.

With the travels of people such as Apollonius into the mysteries of India, there is little wonder that the idea of a crucified god got back to Greece, Italy and the pre-Christian world. Indeed Apollonius is connected with bringing back the ideas of Chrishna. Yet again we have a line drawn back towards the serpent worship of antiquity directly from Christianity. Christianity has 'borrowed' extensively from the numerous, but singular, serpent cults and pagan beliefs of the ages. The relation of Chrishna in his various forms as a serpent deity, and being hung upon the cross, has remarkable similarities to the 'Brazen Serpent' of Moses, which according to the Christian writer Barnabas, was set up on a cross, and which Lundy says was a simple sign of salvation; and Moses himself makes the sign of the cross at Exodus 17:12. It is basically the serpent upon the T or Tau cross. It is life, immortality and rebirth; a universal image seen across the Atlantic even with Quetzalcoatl and one that mirrors the process of the sun.

There is wide usage of the crucified form, being seen even in Assyrian Monuments of Nineveh, which predate and were the progenitors of the Christian cross. They were symbols of the resurrected serpent god; the serpent god entering a ritualistic rebirth on the sun symbol of the cross; a symbol, which would take on the symbolism of the serpent because of this very fact. The fact that, according to Tertullian, the Christians were accused of worshipping an ass-headed god points simply to Set or Seth, the Egyptian god, who is the twin to Horus, as Christ is the same as John the Baptist.

The Brahmans represented Chrishna as a crucified god-man; the Romans revered Sol crucified on December 25th; Zoroaster was born by immaculate conception and his soul suspended 'a lingo' or from the wood or tree of knowledge; Prometheus was crucified, even nailed to a cross; Tammuz was crucified around 1160 BC according to Graves; and Julius Firmicus said that Tammuz was raised from the dead for the salvation of the world, the same Tammuz who is represented by the Tau cross; and the Assyrians had their sun god Baal with outstretched arms in the cruciform. The fact

49

that this 'sign' of the god-man or serpent on a cross was a symbol of salvation, which is basically 'immortality,' is seen even by Christians such as Reverend Cox who said "*the Egyptian the cross . . . became the symbol of immortality, and the god himself was crucified to the tree which denoted fructifying power*." The snake brings immortality and the tree, as the vegetation or solar power gives it 'life.' This Egyptian god crucified was none other than the twin of Set, Horus (Osiris too as the 'father'.) In fact Horus was even seen crucified between two thieves as we shall see later. But we must for the moment remain in the Hindu culture and turn now to India's greatest – the serpentine Naga.

NAGA/NAAGA

A Sanskrit term meaning literally Serpent (especially cobra); also holds the meanings – a tree; a mountain; the sun; the number seven; wisdom and initiate – all symbols and emblems we are familiar with in the worship of the serpent and amazingly also familiar motifs surrounding Christ. These Naga are said to reside in Patala, however this has a meaning similar to antipodes, the same name given by the ancients to the America's.

Naga is a similar term to the Mexican *Naga*ls, the medicine (healers) and sorcerers who always kept a god in the shape of a serpent. In Burma they are *Nats* or serpent gods. Esoterically Naga is a term for wise men. There is a folk tradition that Nagas washed Gautama (Buddha) at his birth – the wise men visiting the deity on Earth. They are also said to have guarded him and the relics of his body after his death. The daughter of the Naga Ulupi, the king of Patala, married Arjuna who is the same as John and was the disciple of Buddha.

According to H. P. Blavatsky in *Theosophical Glossary*, the Naga were descended from Rishi Kasyapa who had twelve wives (therefore he is the sun), by whom he had numerous Nagas (serpents or wise-ones) and was the father of all animals. Rishi Kasyapa can therefore be equated with or be a progenitor of the Green Man, who is the god of animals the world over.

The Naga of Kashmir instructed Apollonius of Tyana. This is the same Kashmir where the serpent tribes became famous for their healing skills. There is a theory that the Nagas descended from the Scythic race and when the Brahmins invaded India they found a race of wise men, half gods, half demons (snakes). These men were said to be teachers of other nations and themselves instructed the Hindu's and Brahmans – no wonder that Apollonius visited them.

In the Bhagavata Purana there is a description of the Bila-svarga or the regions of the Nagas said to be subterranean. Some of the names associated with this place relate remarkably to the Mesoamerican and South American terms such as Tlaloc.

"My dear king, beneath this earth are seven other planets [seven is important in Atlantean myths – seven islands like Atlantis], known as Atala, Vitala, Sutala, Talatala, Mahatala, Rstala and Patala… the residents are known as Daityas, Danavas and Nagas . . . brilliantly decorated cities . . . wonderful houses, walls, gates, assembly houses, temples, yards and temple compounds . . . The houses for the leaders of these planets are constructed with the most valuable jewels, and are always crowded with the living entities known as Nagas and Asuras . . . Many great serpents reside there with gems on their hoods, and the effulgence of these gems dissipates the darkness in all directions. Since the residents of these planets drink and bathe in juices and elixirs made from wonderful herbs, they are freed from all anxieties and physical diseases. They have no experience of gray hair, wrinkles or invalidity." (See *Mahakala* below)

There is currently a lot of debate about the original inhabitants of India – whether Aryan or Naga, but the fact remains, whether the Nagas were Aryans or not, they were an ancient inhabitant. The very fact that they were mentioned in the ancient Rig Vedas shows this to be true. They also intermarried with the Royal families, hence the popular myths of serpent kings.

"Then come the Naaga, the Siren serpents, whose worship has been so

important a factor in the folklore, superstition, and poetry of India from the earliest times down to-day. Cobras in their ordinary shape, they lived, like mermen and mermaids, more beneath the water, in a great luxury and wealth, more especially of germ, and sometimes, as we shall see, the name is used of the Dryads, the tree-spirits, equally wealthy and power-ful. They could at will and often did, adopt the human form and though terrible if angered, were kindly and mild by nature. Not mentioned either in the Veda or in the pre-Buddhist Upanishads, the myth seems to be a strange jumble of beliefs, not altogether pleasant, about a strangely gift-ed race of actual men; combined with notions derived from previously existing theories of tree worship, and serpent worship, and river worship. But the history of the idea has still to be written. The Naagas are repre-sented on the ancient bas-reliefs as men or women either with cobra's hoods rising behind their heads or with serpentine forms from their waist downwards." Rhys Davies, *Buddhist India*, p.223.

These tree deities were Nagas anyway as Rhys Davies continues on page 223:

"The tree-deities were called Naagas, and were able at will, like the Naagas, to assume the human form and in one story the spirit of a Nunyan tree who reduced the merchants to ashes is called a Naaga-raja, the tree itself is a dwelling place of Naaga. It seems that they also left behind myths of healing as a story in the Journal of the Bombay Branch of the Asiatic Society demonstrates. When there was an epidemic among the children, it seems the only answer was to bring them to a snake skin which was hung on a pole and allow them to touch it – reminding us of the idea of the Brazen Serpent of Moses, which was upon a pole and for the healing of the "children" of Israel. This may explain why it is that the tree-gods are not specially and separately mentioned in the Maha Samaya list of deities who are there said by the poet to have come to pay reverence to the Buddha."

The history of the Nagas that we do have, textually beginning around the 7th century BC is an amazing history of ups and downs. It parallels the rise and fall of the serpent worshipped by the Semites, with the Brazen

Serpent being raised in the wilderness and then broken up in the temple. Added to this the influence it had upon the Greeks and we may also see in it the origins of the myth of Atlantis.

NAGAJURNA

A hermit and wise teacher and who scholars relate to John the Baptist and who is said to have visited China in 3rd Century BC, converting many to Buddhism. He is often called the second Buddha as he established the Madhyamika School of philosophy. Most interesting however is that he is said to have received his wisdom and Tantric empowerment with the help of the 'Nagas in the lake' beside which he meditated. In Tibet he is known as Lu-trub (snake in Tibetan is Lu). Nagajurna was from the wealthy background of a South Indian Brahmin family. By tradition he is said to have obtained the title of Naga by visiting Patala, the home of the Naga. The texts or twelve volumes that the Naga gave him called *Prajnaparamita Sutra* are still said to be kept in the temple dedicated to him in Kathmandu.

Another strange story relates Nagajurna with the Philosophers Stone:

There was much grief and famine in the land, which was affecting the monks as they could only survive from the generosity of the surrounding villages. Nagajurna went off and visited a distant planet, bringing back with him the Philosophers Stone, which could turn lead into gold. However, even after supporting the monks for six years with his new venture he was eventually found out and expelled as handling gold was forbidden.

An allusion to the sacred architectural skills of the serpent worshippers is shown by the legend that Nagajurna built many Temples with special clay that the Nagas had given him – presumably from their underwater home and therefore indicative of the 'good building source' to be found in the mind. In this instance Nagajurna is the builder of the mind Temple with

the aid of the power of the otherworldly serpents – wisdom.

Toward the end of his earthly days, Nagajurna was patronised by King Ativhana as he supplied him with his serpent elixir of life. However, one of the king's sons wanted this opportunity to rule the kingdom and plotted Nagajurna's death. This Prince Shaktiman crept up on Nagajurna and struck him with his sword. However the sword failed to decapitate the sage. Nagajurna said, "*Don't be worried that your plot will fail. Many life times ago, I accidentally cut an insect in half with a sharp blade of kusha grass. The present situation is a direct outcome of that act. Although no weapon can harm me, let me tell you that you can easily sever my head with a blade of kusha grass. And in this way, the law of karma will be fulfilled.*"

Also, Nagajurna's remains are said to still be preserved at Shri Pravarta in southern India – everything except his head! His head had been severed by a blade of kusha grass, struck by Prince Shaktiman, and is said to be kept in a walled enclosure in the Swayambhu complex. As soon as Prince Shaktiman had decapitated Nagajurna he heard the headless voice "I will now depart for *Sukhavati* heaven, but will soon repossess this body." The prince fled in fear and a female spirit took the body several miles away. The body lay in the 'wilderness' for many years until miraculously the head found its way back to the body and Nagajurna returned to life. Estimations of up to 600 years life span have been put forward for Nagajurna after this; however there seems to have been a mixing of other individuals to make up his legend and this may account for the longevity. His real name was Siddhipada and he acquired the name following the saving of the life of the king of the Nagas, Mucilinda, who had fallen seriously ill following a fire set by an angry yogin. After this Siddhipada then went to the realm of the serpents and acquired great teaching. Arjuna (white) was a warrior of ancient times and Naga is serpent, so Nagajurna became his title – the white snake.

NAGARAJA

Nagaraja is a name given to the guardian spirits of the lakes and rivers in India and means literally dragon or serpent king. They became Arhats and were textually converted into Buddhists. Is this the origin of serpents and dragons in lakes and seas?

NAGAYUNA

Strangely the Indian branch of alchemy is known as Nagayuna, just as Western alchemy is also smothered in the images of serpents. The symbol of the entwined serpents is seen all over India looking virtually the same as the Western caduceus, another symbol of Western alchemy. These stone votive tablets are known as Nagahals or Nagakals. The idea of Indian Alchemy is purely the production and preservation of the Elixir, both physically and spiritually.

MAHAKALA

A very popular god and Naga King who was tamed by Majusri and Avalokitesvara and turned into a protector of Buddha. He helps beings overcome negative elements, especially spiritual ones. In depictions of him he stands over a lying corpse holding a vajra chopper and skull in front of him. The skull is full of the blood and guts of dead demons (Naga) that have been churned into the elixir. He has a serpent on his pot-belly and is adorned with serpent bracelets and ear ornaments.

This is a remarkable image of a Hindu god holding a chalice containing the Elixir, which is made from churned snakes – it is blatant in its symbolism. One on level it reveals the Elixir of Life to be manifestly derived from the snake and on another level it reveals the wisdom within the skull.

HORUS

It's now time to shift angle slightly and look sideways at India's close cultural and historical neighbour – Egypt. Many people fail to realise that as Egypt was once a great and powerful Empire, so too was India and both shared similar time-scales for their growths.

In the myths of the Egyptian deity, Horus, we have starkly given to us the real reason behind the use of the Uraeus snake symbol by the Pharaohs. Horus is said to have recovered the eye of Osiris, his father, and to have placed over the wound the divine serpent Uraeus in-order to cure him. In fact his father then made Horus king of Egypt. He was therefore the saviour-king.

There are parallels here with Jesus in that he too healed the eye, but this time it was with clay. However, he spat into the clay, and it was this act, the 'spit' of the serpent king, which cured the eye. Jesus then went on to become spiritual-king like Horus. He was paired with Set, as Jesus was with John the Baptist or against Satan (Set) and he even had Set decapitated as John is beheaded.

Set later returned, taking the form of a serpent. Horus was crucified between two thieves and then resurrected, just like Christ. His earthly father was known as Seb, which is the same as Joseph. He walked on water, delivered a 'Sermon on the Mount' and was said to reign for 1,000 years. So, if Horus is the Egyptian equivalent of Jesus then what does it tell us about Jesus? And furthermore, what does it tell us about the Grail?

Well, in the 1st dynasty of Egypt there was a king called Djer. He was the third king and he had a son named Djet, although evidence of this relationship is sketchy. Djet was also known as Wadjit the uraeus snake. Djet's tomb is at Abydos in a location known as Umm el-Ga'ab.

First excavated by Flinders Petrie it was later redone by Kaiser and Dreyer in 1988. There were steles found at the sight indicating the early

names of this enigmatic pharaoh. It was a snake with a falcon above and a palace below the snake. Simply, this inscription means 'Horus the snake.' Remembering that this is one of the Pharaohs from the 1st dynasty then we have here an indication that very early on in Egyptian history the god Horus was seen in relation with the healing snake. Even as a child there are images of Horus holding aloft two snakes, as if in dominion of them.

If Christ is seen as Horus, then he too is associated with the 'healing snake,' and no wonder that the early Christians called him the 'good serpent.' But there is yet a more revealing element of the names given to Jesus, which in the light of this new outlook is most revealing. Jesus is called the carpenter, but what is the root of this word and why was it used for a man that plainly did not have the inclination or time to sit and carve out wood?

The word carpenter contemporaneously was 'naggar' meaning wise man and serpent. Mark 6:3 "*Is not this the carpenter?*" now reads "*Is not this the serpent?*" The blood that therefore flowed from Jesus into the Grail, and the spit that came from his mouth to heal the eye, were elements of the snake.

MITHRAS

The Roman and earlier Persian god Mithra or Mithras was represented encircled by serpents, as seen especially at Modena where he is entwined by the serpent whilst holding a staff and encircled by the Zodiac. In his rites, customs were observed similar to those of the mysteries of Sebazius – that is, a serpent was thrown into the chest of the initiated and then withdrawn from the lower body.

Mithras often has a lion's head, a human body, and a serpent coiled around him. The lion's head is thought to signify the sun and the snake the 'cosmic path.'

A stone found at Lyons has "Deo invicto Mithir" under a raised figure of a large serpent. Mithras was often depicted as a young man. In the Roman mysteries and traditions of Mithras he is seen killing or sacrificing a bull, another symbol of the sun and yet in the Iranian stories there is no association with the bull at all. It was in fact Ahriman who killed the bull in the Iranian stories and it could be that this simply passed over with the Mithras that the Romans re-created.

One of the strangest mysteries of Mithras is the famous rock-birth. The scene shows Mithras emerging from the top of an egg shaped rock, normally depicted entwined with a snake-like symbol of the 'Orphic Egg.' Mithras is born from the egg of a snake as an immortal god. Yet again, the snake's egg is associated with immortal birth. Mithras was seen as the redeemer and saviour in that he was able to transcend the ego, which can halt one's spiritual progress. The 'bull' to be sacrificed is the ego – one's 'present personality.'

The ego is the source of division and duality – being divided as it is between the 'objective,' 'conscious' male/positive aspects and the 'subjective,' 'subconscious,' female/negative aspects, and these two divisions are symbolised by the two horns of the bull.

It is the ego that has to be 'sacrificed' before one can become enlightened and become a 'god' or avatar like Mithras and the other gods and avatars he is associated with – like Horus or Jesus for instance.

This 'sacrifice of the self' implies that the ego must be 'killed' or 'dispensed with.' But the real process is that this division in one's consciousness be 'healed' – i.e., the two divisions of the ego are to become united and so reintegrated so that the ego can then become one with the source. In other words, it is the division in consciousness, which must be 'sacrificed' – by being Neutralised. This division within the ego reflects the same division between the ego and the centre of one's consciousness, which is symbolised by the 'cosmic egg.'

As we can see, Mithras is born from the egg of a snake as an immortal

god and yet again, the snake's egg is associated with immortal birth. Mithras was seen as the redeemer and saviour. Like Mithras, one being 'born' or 'reborn' from the egg or 'cosmic egg' conveys the meaning that one has become enlightened by this reintegration or fusion in consciousness and therefore one is 'reborn' anew – i.e., illumined – possessing a profound knowledge of oneself and one's reality. One's division has been 'healed' by the serpent energy – the neutral life force – and this spiritual, psychical, 'healing,' also extends into the 'physical' healing properties of the snake.

OSIRIS

This Egyptian sun/earth-god as the saviour is associated with the snake. He enters the tail of the snake, to be reborn from the mouth – like the egg emerging from the mouth of the snake, as in Irish and Celtic tales and the Ohio Serpent mound in America. Amazingly this 'being' born again from the serpent is widespread. Was it an ancient concept? Was this one of the first rituals of the serpent cult?

Australia is one of the oldest remnants of the serpent cult as it was split off thousands of years ago. In the Western Desert of South Australia there is a ritual called 'the making of the medicine man.' The ritual begins with the prospective medicine man (shaman) being mourned as if dead. He then goes to a water hole where two medicine men cover his eyes and throw him into the jaws of the serpent. The prospective medicine man remains inside the belly of the serpent for an indefinite time until the other two medicine men bring rats to entice the serpent as an offering and the born again new medicine man is ejected from the mouth of the serpent. He falls alongside a 'rock hole' indicating that this was no real snake; instead it simply must have been seen as a serpent mound. This is reminiscent of the serpent rock or egg from which Mithras is born. The shaman has also been reduced to the size of an infant – which shows that he is young again in new life.

Mircea Eliade in *Rites and Symbols of Initiation* points out that, "*what characterises all forms of this dangerous return to the womb is that the Hero undertakes it as a living man and an adult – that is, he does not die and he does not return to the embryonic state. The state involved in the enterprise is sometimes extraordinary – nothing less than winning immortality.*"

Others, such as James Campbell (*Hero with a Thousand Faces*) point out that now the postulant becomes not only the father, but also the son. The father and the son are one and this makes complete sense because Osiris is in fact the father of Horus, but he is also Horus himself. This is no different to the fact that Jesus was the Son of God, but also God on earth. Mary, the mother of Jesus is therefore also the mother of God. She is in fact Isis, the mother, sister and wife and in this she is the mirror of God the sun, just as the moon is the mirror of the sun. The three aspects are the full moon, the waxing moon and the waning moon. They are in fact mirrors of human relationships, mother, sister, wife for the female and father, brother and husband for the male.

zoroaster

Supposedly born around 1,500 BC or 660 BC (depends upon whom you believe) in Iran, there is evidence that this saviour-style figure or title had actually been in existence for at least 10000 years. According to some historians there have been up to seven different Zoroasters over time, making him not a single person but an ancient god humanised.

His teachings are to be found in the *Avesta* and *Gathas*. Zoroastrianism did not really take off until around the 6th century BC and lasted until it was taken over by Islam in the 7th century AD, although there are still some who cling on even today. These Zoroastrians are believed to have been the wise men or Magi of the Christian Bible, who brought gifts to Jesus at his birth, as a born god. If these Magi saw their gods as serpents, then there is little wonder that they should see and be associated with this

serpent saviour born in human form.

According to Eusebius in the ritual of Zoroaster the great expanse of the heavens and nature were described under the symbol of the serpent (*Ophiolatreia*, Hargrave Jennings). This was doubly mentioned in the *Octateuch* of Ostanes and even to the point that Temples were erected across Persia and the east in veneration of the serpent deity. The serpents were esteemed the "*supreme of all Gods and the superintendents of the whole world.*" The worship is said to have begun yet again in Chaldea. That the city of Opis (*Op* = serpent) was built on the Tigris is a testament to this fact.

Zoroaster in essence is a god-man archetype like Osiris. We can see this element of him when we run through some of the similarities between Zoroaster and Christ.

Zoroaster was born of a virgin via the immaculate conception.

He was baptised in a river and tempted in the wilderness.

He began his ministry at thirty (30 degrees is the measurement between the Zodiacal signs).

He baptised with water, fire and 'holy wind' (ghost). It was said that one would follow who would baptise with the Holy Ghost.

He was 'the word made flesh.'

He revealed secrets of heaven and hell – the resurrection, salvation, judgement and apocalypse.

He was slain and his followers had their own Eucharist.

He even had a sacred Grail or Chalice!

MESSIAH [COMPARISONS]

So there are many similarities between the various 'messiahs' that the world has known and it is my view that they all emanate from one original and serpent cult source. We have seen above some groundwork from the realm of Hindu and Buddhist belief. We can see the beginnings and origins even of some of the more peculiar and even profound things we find in our Christian Messiah in the West. Let's just take a look at some comparisons now and see what sticks out like a sore thumb!

Buddha was born of the virgin Maya who was known as the 'Queen of Heaven' on December 25th.

Jesus was born of the Virgin Mary, also known as the 'Queen of Heaven,' on December 25th in a cave or manger.

Horus was born of the virgin Isis-Meri on December 25th. Isis-Meri is also known as Mata-Meri or Mother Mary.

Mithra was born to a virgin on December 25th and in a cave or manger; also announced by a star and three wise men.

Chrishna was born of the virgin, Devaki (shining one). This goddess or 'Queen of Heaven' is known as Isis, Astarte, Asherah, Marratu, Marah, Mariham. In fact the Semites knew her as Mari-El or Mary God or indeed shining Mary.

Chrishna's most beloved disciple was known as Arjuna or Ar-jouan (John.)

In Egyptian myth, Anup or Aan (John) the Baptiser also baptised Horus, and in Christian myth John baptised Jesus. Both Anup and John the Baptist were decapitated.

Buddha performed miracles and healed the sick, as did most of the oth-

ers. Horus had twelve disciples like Christ and Mithra. Buddha was trans-figured on a mountain like Christ and Horus. They all ascended into heaven.

Buddha was sacrificed for three days and was then resurrected like Jesus. Horus was crucified, buried in a tomb and then resurrected.

Mithra was buried in a tomb and then resurrected three days later. Chrishna was crucified between two thieves on a tree, then rose from the dead and ascended to heaven – as did Prometheus.

The idea of being resurrected after three days has strong links to astronomy. The stone monuments of the world are also linked to astronomy and the serpent. The 12 disciples are the 12 zodiac signs and months and of course, the snake, seen as the Ouroboros is in control of the signs – just like Christ, who controls and guides the disciples. But the snake is seen, not just in control of the stars, but also as the sun and the moon – basically, the serpent is seen as the most powerful of the cosmic entities.

In December the sun makes a descent southward until 21st or 22nd December, which is then termed the 'Winter Solstice.' It stops then for three days and begins to move back again northwards – it is resurrected. As the serpent and the sun are linked together in symbolism of new and regenerative power then there is no surprise to find this correlation.

Being born of a virgin implies the knowledge that the calendar began whilst in the constellation of Virgo. As the sun, the various messiahs are the 'sun' of god and are the 'light of the world.' The Hindi word 'Kris' actually means sun and it is from this root that the word Chrishna and Christ are derived. In fact Chrishna was known as 'Jezeus' or 'pure essence' and centuries before Jesus Christ.

The sun has a corona or horned crown, like the horns and the crown of thorns of Jesus and Chrishna. Most of these remarkable and ritualistic 'sons of god' are come of age at 30 and there is no surprise to find that the sun enters into each zodiacal sign at 30 degrees.

Even the language barrier is overcome when we find that Buddha was considered the good shepherd, carpenter, saviour and light of the world. Horus was known as 'the way, the truth and the light' – again, like Jesus.

Also as God's anointed, 'the messiah,' the 'lamb of god,' 'the word,' 'the good shepherd,' 'the fisher,' 'the son of god' – Horus was also known as the 'KRST' or Christ. (There are in fact many depictions of Horus at his virginal mother's breast, looking exactly like Jesus and Mary.

Horus also raised 'El-Azar-us' or 'El-Osiris' from the dead, just as Christ was to raise 'Lazarus.' This story in itself is an allegory of the sun god Osiris being reborn.

There are others who match those similarities seen above. Dionysius for instance, rode on a triumphant ass. He was sacrificed as the Dendrite or Young man on the tree and eaten in a sacred Eucharist. He turned water into wine; given the title king of kings and rose from the dead. His cult actually entered Jerusalem around the time of Christ and was indeed thought to have been worshipped by the Jews. His symbol was IHS, a symbol still used by Christians. He was called Iasius in Crete, which is an equivalent to Iesu or Jesus.

Mithra, like Jesus, has his principal festival at Easter when he was resurrected and he had a Eucharist like Jesus.

In Phrygia the god Attis was crucified on a tree – a day known as 'Black Friday.' He was born on December 25th to a virgin named Nana. He had a Eucharist of bread as his body and was called the Son of God. After three days in the 'underworld' of hell he ascended as god.

They are all basically descended from royal lineage and were generally wealthy. We know from looking around the folklore as well as these religious similarities that this royal lineage generally meant that they were descended from serpents or dragons. Jesus was of the line of David; Buddha the son of a Raj, and Chrishna descended of royal stock. They all are involved in some kind of trinity, as are many other faiths.

Chrishna, Buddha and Jesus all are 'dragon slayers' – they all 'crush the head of the serpent.' To all, the serpent is an emblem symbolic of 'wisdom.' To all, the serpent is intricately linked to their entire myth as a symbol of healing and is highly beneficent. And to all, yet again, the serpent is linked to the Elixir.

The Christian Church, which has destroyed much of our history over the past 1,500 years jealously guarded most of this information. The very messiahs of the globe were written over. Even Buddha became a Christian saint as St. Josaphat, taken from the Buddhist title, Bodhisat. Christianity as a literal truth is now so heavily entrenched in the culture of the West that there is almost no attempt made to put the record straight. Recent television documentaries prove that the idea of the Christian story is still seen today as being literally true, and these are documentaries made by Journalists! The fact remains that the story is widespread and is an astronomical, serpent-oriented device for symbolic immortality and realisation of the self.

What we have seen here in this quick study is that India and Egypt, to name just two, are full of stories and religious texts that perfectly parallel the Christianity of the West and especially, pre-date it. The incredible stark reality of these facts are often fought over on the internet and in books and magazines and yet the force of faith is blind to the logic of reality and evidence. The battle will rage for a long time yet, but what we have today is a little more freedom of speech than our ancestors. I will use that freedom to the best of my ability and to constantly question what I am told and so should we all.

Aesculapius with his serpent Rod, Rome. *Photo P Gardiner*

The crucified solar deity Apollo. *Photo P Gardiner*

DAGOBERT

AND THE MEROVINGIAN MYTH

And so we have seen the history and mythology of the serpent past. We have seen the serpentine saviours rise and fall across the world. Today there is one particular saviour myth that has crept into popular folklore through various best selling books, documentaries and films – the Merovingian dynasty.

The Merovingian dynasty has been romantically depicted by both the regional writers in France and international best selling authors such as Dan Brown and Baigent, Leigh and Lincoln. There are tales of mystery and magic, of wisdom and light and last but not least of all, descent from God himself via His Son, Jesus, and His supposed wife, Mary Magdalene. Some (Tracy R. Twyman and Boyd Rice) even go so far as to say that the Merovingian's were descended from an ultra-ancient race of fallen angels that spawned the globe taking wisdom and knowledge with them as Atlantis sank, and we can see in the last few chapters how this absurdity has arisen.

Well, I shan't comment upon that one, or the nonsense that they were descended from Jesus, but what I intend to do is give a burst of information and then draw some conclusions at the end and hope that the reader has managed to get to the same place as myself by then. That place I hope to get to will be found nowhere else on this planet than in your own mind.

It all started with the leader of the Salian Franks known as Merovech (Latinised as Meroveus and hence the line became known as Merovingian) in the 5th century AD. Both he and his son, Childeric I were great warriors and fought bravely against the Visigoths, Saxons and Alemanni. Following Childeric came his son Clovis I who went on to unite most of Gaul and the Loire and defeated the Roman ruler, Syagrius, to the joy of almost everybody – or so the propaganda goes. It was Clovis I who adopted the Roman Catholic religion for his nation. Eventually by the early 7th century we end up with the infamous Dagobert II. Also known as Dragobert – coming from the words 'Dragon' and 'Bert', which in turn comes from Bara or Para, which means Pharaoh. So Dagobert simply means 'king' or 'Pharaoh of the dragons.'

Dagobert is said to have visited Ireland, a home of serpent worship, and is also said to have married at Rennes Le Château, where incidentally, a ritual skull was found which had a hole in its forehead. Still today, Masons worship the head or skull of Dagobert calling it Mahomet (much like Baphomet of the Templars.) It is kept in the convent of the Black Sisters at Mons. The cup that was formed to hold the skull was made into the shape of a chalice. Hence we have the head of the dragon pharaoh in the chalice.

But who is Dagobert and where did he come from? What makes him so important that his skull should be turned into a Grail and then worshipped by the Masons – the modern Templars?

The year 469 AD and the Roman Catholic Church makes a pact with Clovis I, King of the Franks, giving him the title, 'New Constantine' as a 'thank you' for becoming Christian. This was the beginning of the Holy Roman Empire, which was hoped to last forever. But it did not, and by the year 800 AD, the Empire was threatened.

Dagobert II, was a French king from the supposed 'Grail,' Merovingian bloodline, and was the last of the Merovingian kings to hold the title of 'Holy Roman Emperor.'

These Merovingians are said to be a dynasty of Frankish, priest-kings, with magical powers, derived from their long red hair and the special birthmark between their shoulders of a red cross (see below). Obviously the Christians spread rumours of witchcraft, and various other misdemeanours, because Dagobert was seen as a threat. After several years spent away from his Frankish Kingdom, Dagobert returned from Ireland in 679. But there were problems with the Mayors of the Palace.

Three years later the Catholic Church plotted a conspiracy against him due to their displeasure with Dagobert's lack of allegiance to the Roman church.

While on a hunting trip, Dagobert was lanced through the eye by his own

godson as part of the ploy. Now power was passed to Charles Martel, beginning the famous Carolingian dynasty. This basically ended the Merovingian bloodline and its run of power. From that day, the Merovingian kings were powerless and were officially thought to have died out with Dagobert's grandson, Childeric III.

Charles Martel's grandson, Charlemagne was anointed Holy Roman Emperor.

The Catholics had wiped out the troublesome Merovingians once and for all – or did they? Some still claim today that they are descendants of this special bloodline, however my researches have only gone to prove that this is pure propaganda, fuelled by books such as *The Holy Blood and the Holy Grail* and the blatant lies of Pierre Plantard.

Thousands of books have sprouted in the last few decades with 'new' evidence, none of which is verifiable and based upon legends only.

The Merovingians, 'born of the sea,' with kings connected etymologically with the snake, as well as ritualistically where simply descendants of the 'serpent bloodline;' the Royal line descended from serpent priests, as we have seen across the globe in India and China, in Britain and America. Their connections with the Grail are simply via the secret of the snake and their obvious pagan past brought down the Christian might of Rome.

RED CROSS

One of the most striking images in Christian history is the Red Cross. Whether a strict Latin or a Templar *croix pattee*, it is a memorable symbol, especially seen on a stark white background. Seen in relation to the 'mark' of Cain or the Merovingian birth-mark, or even the Templar cross, they all seemingly relate in one way or another to be a symbol of the snake. Indeed, the Red Cross is an almost universal symbol of the snake,

and therefore to wear it one is branding oneself. The reason for this is quite simple. The serpent and the snake were intertwined - the snake was a symbol of the sun and the cross a symbol of the seasons.

The 'Rosicrucian's' – obviously meaning the 'Rose' or 'Red Cross' – were a strange esoteric secret society of Alchemists and spiritualists. Linked inextricably to the Masons, Templars and others in the story of the Grail, they have been greatly debated and researched.

A term for Rosslyn could very well be Rose (Ross) Snake (lyn – also line, both being the same (snake-line)). Many places involved in the story are associated with this terminology. Whilst there recently filming for a documentary I found that even the iron fence surrounding the chapel was adorned with a rose and a cross.

The island of Rhodes could also be from the Syraic term for 'serpent,' *Rhad* – although the standard terminology comes from *Rhoda* the 'rose goddess.' Either way this place was once overrun with the cult of the serpent and was once called 'place of the serpents.' Many places in France have in fact been named after Rhodes – Rouen was Rhodom and Rennes (as in Rennes le Château) was Rhedae.

BULL

In the mysteries of Ceres and Proserpine the great secret is communicated to the initiates "*Taurus Draconem genuit, et Taurum Draco.*" Meaning, "*The bull has begotten a serpent and the serpent a bull.*"

The bull is a symbol of the 'generative force,' - the power. It is a symbol of the sun in Taurus and emerges from the sea. As the Quinotaur he supposedly spawned the Merovingian bloodline with his son being called Merovech, after the sacred bull of Heliopolis, Meroe.

It was this King Merovech, the first in the line of Merovingian kings,

who was said, to have been spawned by the Quinotaur. This is a giant sea monster with a bull or goats head. So the *mer* part of Merovee becomes obvious in that *mer* means 'sea' – born of the sea. The word 'Quinotaur,' if broken down, resolves into Taur for Bull, and Quin/Kin for King. He is the 'King Bull of the sea' – the sun in Taurus. This 'bull king' goes back a very long way in history – right back to the days of Mesopotamia and kings such as Sargon and Menes. But this goes back yet further to an association between these kings and their legendary genesis from ancient sea-born gods such as Oannes and Dagon who were serpent gods.

The sun as a serpent would sink beneath the horizon and become a fish. Dag means 'fish' and On means 'sun,' Dagon is therefore the 'night-time serpent sun' – otherwise known as the 'Black Sun' in various esoteric traditions. The 'black sun' is a symbol of the Underworld and the Unconscious – the 'Collective Unconscious' attributed to psychoanalyst, Carl Jung. Could it be that these legendary creatures are archetypes from the unconscious – or represent man's 'collective unconscious?' This is the element Gnostics believe to be the true self.

These myths are those of invading 'serpent worshippers' or migrating snake cults, coming into the land; bringing with them all the skills associated with the coming of these ancient gods such as metallurgy, architecture and medicine – not to mention a distinctive psychology. These deities are half-bull, half-fish or serpent-figures, revealing their belief systems in their strange images - not what they were physically. It reveals a belief system of a duality between the sun (bull) and the snake (dragon/dagon.) Oannes is Dagon and this is related to the word for dragon. This god is the Biblical Leviathan, the great serpent of ages past who encircles the world as the Ouroborus, the symbol of immortality and eternity. This is the same symbol, which attracts the phrase 'my end is my beginning' like the words placed into the mouth of Christ 'I am the beginning and the end . . . the Alpha and Omega.' In fact the Christians of later times went on to use the image of the Ouroborus as a symbol for the Alpha and Omega elements of their Christian faith. The Levites of course derive their name from this Leviathan, their name meaning 'Sons of the Leviathan.' Oannes is also the same as the Hindu Vishnu who is

linked with the serpent. However, there is another interpretation of equal worth for the Quinotaur as we shall see.

Heracles wrestled with the snake, which transformed itself into a bull. Heracles tore off one of the horns, which the nymphs tossed into the river where it turned into the Cornucopia or 'horn of plenty.'

In Scotland there are hundreds of Pictish symbols found on rocks and ancient Neolithic monuments. There are many that are in the image of the snake and also with the snake in association with the bull – thus revealing the widespread nature of the bull/serpent association.

QUINOTAUR

The Quinotaur has the root 'kin' being possibly from Cain and therefore showing the Quinotaur to be descended from the serpent race of Cain. Kin is also related to 'serpent' and 'king.' But what is the Quinotaur? Quin as we can see could be from king; Taur is obviously from Taurus the Bull or indeed the Tau. Quin could also come from the Babylonian Qunigu who was the greatest amongst the children of the dragon goddess Tiamat.

According to Babylonian legend in the beginning there was "*neither land, gods nor men.*" There were only elements known as Tiamat and Apsu. Tiamat was the female and the spirit of salt water and primal chaos, and Apsu the male, the spirit of fresh water and void. Tiamat is depicted with scales and a serpentine body and legs, with horns on her head. The union of these two gods produced all the other gods, including the greatest among them, Qunigu.

The Quinotaur was a mythical sea beast, said to be half bull and half fish or dragon/serpent. This could very easily be an indication of Taurus going into Pisces and a message of the stars. However, according to author Crichton Miller the sign Aries has been deliberately removed or left out

of the name in-order to claim that their bloodline stretched back to the end of the age of Taurus.

"The god Amun or Amen covered the period from the design of the Great Pyramid to the death of Christ the Shepherd of the sheep (Aries), before that it was the Golden Calf or Taurus. The process is Taurus, Aries, Pisces.

They then make a statement in their name (kin/quin) that they are the rightful Kings (rulers) of the Age of Aries and can lay claim to the throne of Rulers in the name of God for the new age of Pisces." Crichton Miller, author of *The Golden Thread of Time.*

The Quinotaur is also said to have sired the Merovingian bloodline as we have seen. The same Merovingians said by several authors to be descendants of Jesus – the sun-deity – and so he is the sun or ruler in each sign. Quinotaur traced backwards through Greek and into Phoenician legend is none other than Zeus, the very same god who impregnated his own daughter with Dionysius. But how is Zeus related to the Quinotaur? Well, Quinotaur is Dagon, the half fish/serpent linked with Oannes and Odakon and giving us the Dragon title. Elsewhere Dagon is known as Daonos and Zeus was Dyaus. As we know, Zeus was known to have taken the form of the serpent to procreate, just as the Quinotaur sires a race of sacred kings – and in the Orphic legends it was the son of Zeus, Dionysius, who was to be the fifth ruler of the world. The Phoenician legend involves him in the disappearance of the daughter of Canaan, Europa. Europa was a princess or the daughter of a god and was said to be very beautiful. One day a servant told Europa that a white bull had appeared on a local beach. This tame bull allowed Europa to wrap garlands of flowers around its horn and to climb on for a ride. But the bull ran off with Europa into the sea; she was never seen again. Now we have an entire continent named after a missing girl, stolen by a bull.

All of this is beginning to sound very strange and on the face of it, none of this ought to relate, but please stay with it a while, as all will become clear. We must now move into an area that at first glance will also appear

unrelated – the Wandering Jew.

WANDEⳆING JEW

A myth mainly from the Middle Ages, of a Jew said to have lived at the time of Christ and to live forever. Apparently, according to the Christian additions to the myth, he offended Christ on his way to the cross and was therefore cursed to walk the earth alone until the end of time. It does indicate that Christ had the power to give immortality on this earth, not just in heaven.

One of the most interesting things however is not the later Middle-Age myths, which were attached to the character, but the origin. The Wandering Jew is literally an amalgamation of hundreds of supposedly separate characters, all immortal. However it is my view that they all originate from the source of serpent immortality.

The modern myth probably comes from a character called Malchus (Macco, Malco) who strikes Jesus in John 18:20 and gets the curse of immortality.

However in Matthew 16:28 there is also the disciple, who Jesus infers immortality upon: "*There be some standing here, which shall not taste of death.*"

Note that Jesus, however, says "some." There were indeed several characters that Jesus bestowed earthly immortality upon, and not as a curse, but as a gift.

There is also one named Sameri – who, in the Koran is cursed with immortality by Moses – the wielder of the serpent Caduceus; and not forgetting that Jesus is likened to Moses, "*who lifted the Brazen serpent in the wilderness.*" There is a remarkable astrotheological reason for this. Jesus was an adept, he could 'fix' time because he understood the motion

of the planets and the sun – being a sun-deity himself. Fixing the motion is symbolic immortality, for it escapes the cycles of life – Nirvana. It is in essence, piercing or lancing the dragon, which is the sun passing over-head. The Wandering Jew, therefore, must be somebody who understands this power and has 'fixed' time – albeit symbolically. And this explana-tion will now open up another truth of the Green Man and much more. But there is also more to this character. There are always more levels of understanding – many levels of heaven.

The Grotto della Sibilla, which is said to be in the Umbrian Mountains, and was mentioned in the Medieval period romance *Guerino il Meschino* by Andrea da Barberino, Macco, is mentioned as having been turned into a serpent by an enchantress called Sibillia, who is connected with the healing serpent. This Macco is the Wandering Jew in serpentine form – the same Wandering Jew who 'sheds his skin.'

Malchus was also known as Ahasverus or Buttedaeus and in the myth it was as a porter that Ahasverus struck Christ and mocked him for walking slowly. Jesus told him to wait for his return, which of course never hap-pened and so Ahasverus lives still.

Later Christian additions indicate that he repented of his sins and became a Catholic, which is obvious propaganda. However, and what is most extraordinary, he is said to grow old in the normal way, but when he reaches the age of 'one hundred' he sheds his skin and rejuvenates to the age of thirty! What can be more like the tale of the rejuvenating snake? – And to the sacred age of thirty, which is the age of illumination and the same as the degrees between each and every zodiacal sign.

The Wandering Jew is also likened to Cain, the father of the serpent race – whom it is said, wanders the earth as an immortal – as the Lord put a 'mark' upon him so that none would hurt him.

The Quinotaur is also implied here with the root 'kin' being possibly from the same root as Cain and therefore showing the Quinotaur to be descended from the serpent race of Cain.

There is also an amazing legend about the linking of Herne or Cernunnos, the 'horned god,' with the Wandering Jew, in that they are one and the same. It is said that Herne told Jesus to drink water from the indent of a horse's hoof, telling Jesus therefore to subjugate himself to the old ways.

Horned God

From Pashupati to Pan, the 'Horned God' is seen throughout history in connection with the secret of the serpent. It is Pan who kicks open the cista of the Bacchus, revealing the serpent from within. Dionysius (Bacchus) is often depicted with horns and the Bacchanals of Thrace were said to wear the horns in imitation of their god. Even Zeus, who transformed himself into a serpent to bring Dionysius to life, was often depicted as having horns.

The horns are thought to signify the solar aspect of the god, the life giving aspect. They are also symbolic of the bull, which is again a solar symbol or the sun in Taurus. The goat is also associated in terms of animals and horns with the serpent, as Dionysius is often manifested as a goat.

Indeed the awakening of Moses is symbolised by horns or shining forth; this, the same Moses who wields the Caduceus staff and raises the Brazen Serpent of healing for Yahweh in the wilderness – a point not lost on 1st century AD medallions which show Jehovah as a serpent. The horns then emerge as the enlightenment aspect of the serpent – the shining or illumination one gains from the processes known as Kundalini or other similar methods. They are the symbolic representation of what occurs inside the head.

HEADS

Heads are central to the story of the serpent cults and there are many instances, which prove this point.

Hydra was the Greek water dragon, said by Alcaeus to have nine heads (nine is the number of the sun, the immortal one), one of which was immortal.

Appollodorus tells us "*For his second labour Herakles was instructed to slay the Lernaian Hydra. The beast was nurtured in the marshes of Lerna, from where she would go out onto the flatland to raid flocks and ruin the land. The Hydra was of enormous size, with eight mortal heads, and a ninth one in the middle that was mortal. With Iolaos driving, Herakles rode a chariot to Lerna, and there, stopping the horses, he found the Hydra on a ridge beside the springs of Amymone where she nested. By throwing flaming spears at her he forced her to emerge, and as she did he was able to catch hold. But she hung onto him by wrapping herself round one of his feet, and he was unable to help matters by striking her with his club, for as soon as one head was pounded off two others would grow in its place. Then a giant crab came along to help the Hydra, and bit Herakles on the foot. For this he killed the crab, and called on his own behalf to Iolaos for help. Iolaos made some torches by setting fire to a portion of the adjoining woods, and by using those to burn the buddings of the heads, he kept them from growing. When he had overcome this problem, Herakles lopped of the immortal head, which he buried and covered with a heavy boulder at the side of the road that runs through Lerna to Elaios. He cut up the Hydra's body and dipped his arrows in its venom.*" Appollodorus 2.77-80. (The Library – Greek Mythography 2nd Century BC.)

Strabo gives an even more telling tale of the usefulness of this poison, as he points out that the Anigros River of Elis, "*emits an offensive odour for a distance of twenty stadia, and makes the fish unfit to eat . . . this is attributed by some writers to the fact that certain of the Kentauroi here*

washed off the poison they got from the Hydra . . . The bathing water from here cures leprosy, elephantiasis, and scabies." Strabo, Geography 8.3.19.

A strange affect for poison to have, that it should, diluted in the waters of the river, have medicinal benefit. It has to be related to the equally, peculiar concept that the Hydra has one immortal head. This of course relates to my discovery that our ancestors used venom and blood of the snake as a unique medicinal substance or Elixir. Could this be a clue to the dilution ratio of venom to blood? An eight to one ratio?

According to the *Argonautica*, the arrows dipped in the blood of the Hydra were used to kill the Dragon of Hesperides, which lay by the trunk of the apple tree.

There is another hint that maybe the diluted poison should be mixed with the horse. Heracles shot his poisonous arrows into Nessus, "As he died, Nessus, knowing how poisonous the arrows were, since they had been dipped in the gall of the Lernaean Hydra, drew out some of his blood and gave it to Dejanira, telling her it was a love charm. If she wanted her husband not to desert her, she should have his garments smeared with this blood." Hygnius Fabulae 34, Latin Mythography, 2nd century BC.
This is not obviously linked with the horse at all, until we discover that Nessus was a Centaur and therefore half-horse, half-man, like Chiron, the teacher of the snake god, Aesculapius. Let's just sideline a moment and look at the horse.

The etymology of the horse is strangely linked with the snake and it is an amazing trip through the mythologies of the world to discover the secret of this association.

The word *nag* is now synonymous with the horse, but it comes from the Middle English *nagge* which itself is a derivation of the word Snag, Snagga or Snekka, which is snake. This relates strongly back again to India, where the word used for snake was naga. Here, alone in language, we have this peculiar mixing between the snake and the horse, which has

occurred over a vast period of time and yet is still observable today.

The horse without doubt is not only linked with the serpent but also the sun, as we would expect. In Gaulish coins there are representations of the serpent under or over a horse, said to be a symbol of the sun god. In fact, in the Bible we have Jesus, the son god, riding or 'on top' of the Ass or Horse as he rides triumphantly into Jerusalem - to death and then new life – the pattern of the sun each day. However, there is a remarkable scientific reason for this association.

In-order to produce anti-venom, non-lethal doses are injected into horses and over a period of time the horse naturally builds up antibodies specifically designed to neutralise the venom. Eventually the horse's blood is collected and the antibodies extracted to produce anti-venom. This amazing 'coincidence' is not new; it has been known about for centuries and is as old as oral tradition can be.

This idea of the ancient concept of the horse is also seen in the peculiar images of horseshoes seen on rock art in Australia, from before there were even horses in Australia (horses arrived in 1878). (See the book *The Sign of the Serpent* by Mark Balfour, Prism)

At Newgrange the horseshoe again is mixed with the spirals and images of snakes.

Getting back now to the concept of the head and its association with the serpent, we find the Greek god Pan. Seen by many scholars as one of the pro-genitors of the 'Horned God,' found in so many places around the world. According to many sources his father was Hermes, the wielder of a Caduceus. Other sources have him as the oldest god of all, older even than Zeus.

At Cirencester, England, this Horned God is depicted with two snakes rearing up, replacing his legs in a similar fashion to images of Dagon. In fact, I have travelled the length and breadth of Europe and found these images at hundreds of sites.

In Greek legend there is Dionysius, who is equated to the other horned gods as the 'god of animals' and 'hunting' – the same Dionysius who I found elsewhere to hold the chalice or elixir.

There is also a female version of the 'horned god' in Amaltheia, the goat nymph goddess. She was the glorious nurse of Zeus and Pan. Zeus took one of Amaltheia's horns and gave it to the nymphs; it became the 'Horn of Plenty,' a precursor to the Holy Grail. Upon Zeus becoming the 'Lord of the Universe' he set Amaltheia's image among the stars as Capricorn, which has a fish, or serpents, tail. On frescoes in the Roman catacombs the ancient pagans drew images of the 'Sea Goat' carrying the Caduceus – therefore linking the 'horned god' with the 'healing' and 'wise' elements of the serpent. This image alone as the Goat of Mendes was to move in Alchemical and Cabalist circles much later on.

The Wandering Jew and the Horned God, Osiris and Dionysus, all are synominous with the now infamous Green Man.

GREEN MAN

The Green Man or indeed Woman, can be seen across the world in medieval and even modern cathedrals and churches. Many will now be familiar with the chapel at Rosslyn and the many hundreds of Green Men depicted there, peering from their foliage hideaway's. However, take a trip to Southwell Minster or Lichfield Cathedral in England and you will find many more. In fact there are thousands of Green Men and Women across Europe. These depictions are ancient and have distinct pagan origins and now that we understand our diverse pagan heritage included the worship of the serpent and the many things that this entails we must also understand that Christianity adopted it. The Green Man is the fertile god of nature, the god of life and it is therefore only fitting that he has a consort and a female version of equal status. The fact that there are less female Green deities pocking out of stone trees from the church wall is simply because Christianity took on the paternal aspects of the Jewish

religion. In truth, a rich, fertile and active nature simply had to have a dual nature of male and female and mirror the life of those on our plain of existence. But what are the origins and meanings behind this peculiar little character?

Keating explained that Gaedhal, who is said to be derived from Gadelius (husband or son of the daughter of Akhenaton, Scota,) actually got the name from Glas or green. This could be from the idea in the time of Moses, that the area of snakebite turned green. The Green Man or Woman was therefore not necessarily green due to the foliage, but may have been due to the idea that he/she was immortal due to the healing venom of the snake.

El Khidr is the Arabic term, meaning 'green' and is said by some to be linked to the infamous Sumerian Gilgamesh. Gilgamesh, in one epic tale, tried to find the herb that brings eternal life – the Elixir – but a snake steals it while he is taking a bath.

Gilgamesh is also the one who cut the chuluppu tree, which is surrounded by serpents at its base. He takes the tree to Inanna but keeps the rootstock where the snakes had been and makes the magic wands Mikku and Pukku, said to be progenitors of the serpent rods of Moses and Aaron.

El Khidr is also equated with St. George; the Wandering Jew, Elijah; Moses – the one with the serpent staff; Melchizedek – the longest lived person in the Bible; Dionysius – said to be the Greek, 'Green Man' before he took on the role of wine and ecstasy; and the Druze say that El Khidr is John the Baptist – which is interesting when we consider that Lady Raglan and Sir James Frazer pointed out that human representations of the 'Year King and Queen' (Green Man and Woman) were usually decapitated and then hung on a tree, as John is decapitated and Jesus is hung on the tree. This of course makes John and Jesus two aspects of the same thing.

El Khidr is said to be immortal, as he drank or fell into the well of the water of life. He is wise as a serpent and several Sufi Orders claim

descent and initiation via him. With connections to Islam we have to ask, did the Templars have any idea about El Khidr? Was he Baphomet? El Khidr is also linked by some to Al Qaid, the Muslim star on the tail of Ursa Minor behind the head of Draco.

The colour green is something seen often in folklore, myth and legend and strangely it always seems to have some relationship to our tale here. Guinevere, the serpent-connected Queen of Arthur, is said to have green or emerald robes. Sir Gawain is the green knight. Wolfram von Eschenbach's Parzival, linked strongly to the Templar tale, has the hermit Trevrizent with a green reliquary. Even the sword used to behead John the Baptist is said to be emerald. Ancient druids, neophytes and the fairies were said to wear green. And as we know, green, is a distinctively fertile and vegetative colour across the world. For all these reasons, the secretive and ancient languages and symbols of alchemists, mystics and even Gnostics is said to be the 'green language.'

Now, just a quick mention of Rosslyn. Although the Sinclair who built Rosslyn was not a Templar, he was linked to the Templars indirectly, and Rosslyn has hundreds of Green Men images, as well as Templar symbols; namely two brothers on a horse, the Agnus Dei; the 'five-pointed star' or pentacle; the Head of Christ image or Baphomet, as well as the floriated cross and the dove in flight with the olive branch. Split up and most of these images are purely Christian symbols or motifs stolen from other more ancient religions. However, put together in one place with historical links to the Templars, we are left with little doubt that there must be a Templar and esoteric link. But inside Rosslyn one is always overcome with the sheer scale of the vegetation, it is simply like bringing the outside in. In fact, this is almost exactly what was happening. The Garden of Eden with the tree of life and the tree of knowledge were brought to this place. It was a place of knowledge and eternal life and there is little wonder the Green Man should be in residence.

Also, a few miles away from Rosslyn is Temple, the modern-day name for Balantradoch, the ancient headquarters of the Templars in Scotland. I visited Temple in the summer of 2002, just to see for myself what was

left – if anything – of the Templars. I was not disappointed – and if anything, was surprised to see so many symbols, that in fact were related to the modern day Masons; further linking the Masons to the ancient Templars.

After having walked around the graveyard of the old chapel for some time; enjoying the beautiful sunshine and the total silence of this wonderful and sleepy village, I heard the Iron Gate open and saw three large dogs come charging in, and straight towards me. I tried to see who had let them in as I stumbled backwards over the old stone tomb stones, only to see the back of a man running off up the hill, laughing as he went. After fighting off the dogs with my camera bag and coming away unscathed I began to wonder why I should seemingly have been set on in such a way. There was no way I could catch the laughing man and as I looked around there were no witnesses. It was a sleepy, quiet little place where you could sit down and die and nobody would notice. I made my way back to my hotel and inquired of the owner about Temple. "*Sit down*", he said, as if it was a long story.

We had a pot of tea on the lawn under the clear sunny sky and the owner informed me, that Temple was an unusual place. It seemed that the 'locals' where no longer 'locals.' Instead, rich outsiders had been buying up property in the area – even to the point of taking over the small town hall. It was somewhat of a touchy point to the locals, I was informed. All the owner could suggest – and from what he had heard – was that they were rich Masons, coming 'home' and settling, from all over the world.

"*But*," I asked, "*Why should I have been set upon?*" The owner simply said that the locals believed they guarded their secrets well, and that he was far from the first 'researcher' to have been cleared off in such a way. I decided that none of this was relevant to the current research and did not follow it up. But I will one day.

Other things close by Rosslyn and which link to the Templars includes the infamous Templar Wood. Nothing can be seen from ground level, which links this wood to the Templars; but take to the air and a wonder-

ful sign meets you with some surprise. It is a wood, planted in the forma-
tion of the Templar Cross and even though it was planted after the disso-
lution of the Templars – the fact remains that the Templars in Scotland
did not die out; they just changed and went 'underground' . . . hiding
their signs so that nobody could prove their existence.

However that Rosslyn-Templar diversion out of the way we have to try
and make sense of what we have learned and I apologise for bombarding
you with lots of seemingly unrelated information. We began this tale with
stories of the Merovingians. This now infamous royal family has even
found it's way into the film the Matrix because of the perception that it
has spawned secrets and secret societies around the world, as if protect-
ing something. This whole mythos has in fact become one of the best
money-spinners in the literary and film worlds. We are fed little bits of
information, most of which is an outright scandalous set of lies created to
bolster theories that simply do not hold water and all the time we are
forced away from the simple historical truths which underpin the balder-
dash spoken.

There is no relationship between the supposed lineage of Jesus and Mary
to shape-shifting reptiles; there is no lineage, except that created in the
mind of man. In fact, it would be a far stretch of the historians imagina-
tion to accept that a real Jesus Christ existed at all in the form that is con-
stantly rammed down our throats. Jesus, as we can clearly see was the
culmination of a great many pagan deities and all of them, without excep-
tion, are linked in one way or another to the worship of the wise serpent
and to the power of the sun. It is therefore no stretch of the imagination
to understand that the character of Jesus was in-part based upon these
serpent deities. Just look at the shedding of skin, whereby the snake
crawls into a dark place and leaves behind its skin and then emerges born
again. The same thing happened to Christ as he died on the tree, was
placed in a tomb and once risen to new life, left behind his old skin or
shroud. In Africa and elsewhere the snake is still pinned to the tree as a
votive offering or sacrifice for the health of the tribe – in some places it
is even pierced on the side. Christ was equated to the Brazen Serpent of

Moses and we are told to be "wise as serpents". In truth, the ancient and pagan worship of the wise serpent has slithered unseen into our so-called modern religions.

What there is in fact, as we can see from the disparate evidence presented above, is a whole host of clues, laid bare before our very eyes. All we have to do is eradicate the pre-conceived thoughts that are in our minds. These thoughts were placed there at Sunday School, in text books, from the silver screen or indeed from the now imposing internet.

Try to break a boundary here with me for a moment. Imagine if you will, a world that holds no mystery. No this isn't the beginning of a John Lennon song, it is a serious attempt to alter our perspective. Imagine that there are no ghosts, no aliens, no Loch Ness Monster or Big Foot. Just imagine that man has simply evolved over vast periods of time and to a point where he suddenly or slowly became conscious of the world around him and his own place in it. It's like looking at a monkey and watching it as it looks around, picks up a few things and then something comes into its mind and its startled. We can see in its eyes and actions that it is scared to death. It has suddenly realised that it is sentient and quite separate from the world around him. He looks at the other monkeys now with an austere gaze and pities them, but he is also very different now and so takes himself away from nature and begins to use the world around him for the products it can supply. Gradually, like a baby, his mind tries to work out how everything is put together and how to take them apart. He wants to know what those points of light are in the sky, what that big yellow round thing is and the white one that changes shape at night. He'd never spotted that before and so he analyses everything. A few thousand years pass by and the descendants of our little monkey are losing their hair because they have covered their bodies in the skin of other animals for the cold and wet times. They are using their minds, working out how to kill bigger and bigger quantities of animals for meat, which they have found gives them more satisfaction than eating vegetable and fruit matter all day long. Now they have more time on their hands – a concept they had no idea of before they became conscious.

Time passes slowly and the mind develops. Some in the growing groups want to know more and as they question they become fearful of the dark night, the deep waters and the burning summers. Noises come from the woods that they no longer know – because they have been too long away from that level of nature and so they wish to understand. The new world of the stars, sun, moon, raging waters, reflections and death all must be explained or avoided. For thousands of years these new men experiment with the natural world and discover all-kinds of cures and even mind altering drugs. Then one crippled little monkey-man takes some strange looking mushroom and in his own mind he disappears into another world – a world that the new consciousness becomes aware of as the unconscious world of the imagination. But these concepts are not yet borne and so this other world is real, very real and when the monkey-man returns he tells the others of his vision trip. He is so adamant in his belief that others try the process too and experience archetypal visions and so also believe the process to be real. They see spirals and strange serpentine shapes that modern research has proven to be at the deepest level of our psyche and so when awake they spot these shapes all around them and see the snake disappear into the other world and emerge with new life – it is a special animal – more special than all the others.

Years pass and we now see large wooden buildings, circles of trees and pathways, all mirroring these other worlds. Pictures are painted on these structures and inside caves of the wonderful otherworldly visions. Men and women have been chosen to access these worlds for the rest of the growing tribe and they become healers and guides, medicine men and priests. All around they paint and carve images of snakes and folklore erupts with tales of their ways. These new priests take a name – serpent priests and shining ones – and very soon they are even forming their own child's head into the elongated shape of the snake. This is not fanciful imagination. This is not aliens or beings from other dimensions. This is hard archaeological and historical fact – the evidence is there.

We zoom forward now to the 21st century and what do we find? Modern myths of saviours and Christ men who can access other worlds; tales of Green Men and immortal shaman-like semi-deities and now stone build-

ings with beautiful depictions of myths that stretch back in time to our ancient monkey-man who sat one day and almost fell off his perch when he realised what the hell he was. We also see another myth forming...
"These Merovingians are said to be a dynasty of Frankish, priest-kings, with magical powers....."

ROSSLYN AND THE SINCLAIR'S

In the last chapter we touched upon Rosslyn Chapel due to its links with the Templars and thereby the newly created bloodline myth. But there is much more to this little place that is missed and more also to the family that created it, the Sinclair's.

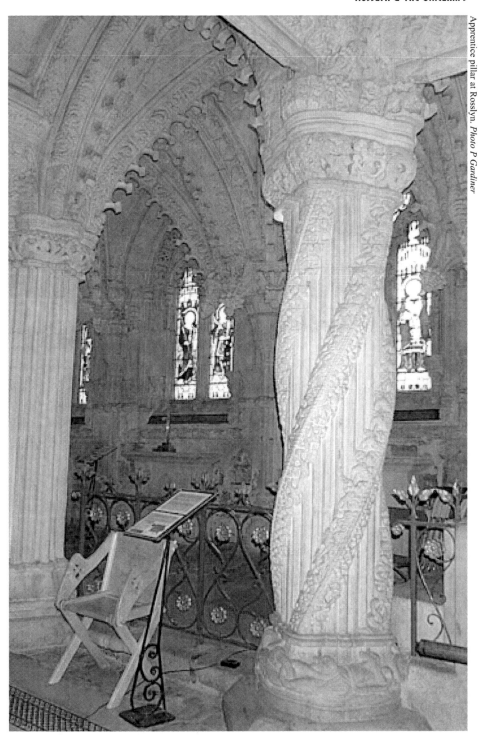

Rosslyn Chapel, just south of Edinburgh, is a wonderful experience and today is being swamped by tourists from across the known world due to the publicity it has received from the now infamous *Da Vinci Code* book of Dan Brown. I have now visited it extensively and can highly recommend it to anybody. I was recently up there to film a documentary for a Canadian television company. It was midday and the spring wind and rain battered the side of the sloping hill whereupon is situated Rosslyn or as the sign states, Roslin. I parked the car, which I noted had grown extensively since my last visit and I also noted how at even this wet and dismal time of year the car park was nearly full. The first time I ever visited this place it had been a desolate, empty, grey place that suffered from a lack of funds. Almost nobody outside of the Gnostic and Masonic loop had heard of the place, but now, thanks to Dan Brown et al, it was like Disney Land. I ran through the horizontal rain and shot into the new entrance, with its new paint work and impressive pictures on the wall. I was to meet the crew inside and so I waited patiently in line behind two Americans who were discussing the *Da Vinci Code* with the ticket salesman. They bought a guide book and mentioned how busy the place seemed and the response came from the ticket salesman that it was due to all these books and documentaries and in fact there was yet another being filmed today with yet another author. Suddenly I felt about two inches tall as I, next in line, said "I'm this author you just spoke of, would you mind telling me where the crew was?" We had a laugh and it was a fun day filming while half the world watched.

Started, it is claimed, in 1446 by Sir William Sinclair it was 'completed' in 1486 by Oliver Sinclair, William's son. The word completed is a problem, because according to orthodox history it was never completed and forms only part of a much greater design. However, there are those who believe that it is how it was meant to be and others still who believe that the chapel we see today is in fact in the wrong place and indeed there is physical evidence to prove this. We shall however concentrate on what is actually there and tangible.

There are images of Green Men, snakes, pillars, trees, Grails and much more of interest to us and all of which relate. There are fourteen pillars,

12 for each sign of the zodiac or tribes or disciples and two main 'others.' One for the sun and one for the moon, or Christ and John, or Horus and Set or Jachin (also known as Tsedeq by the Nasoreans) and Boaz – basically the twins.

The pillars in the east form a Triple Tau cross, which is the badge of the Royal Arch of Freemasonry. This Triple Tau has many meanings, among them "a key to treasure", "the Temple of Jerusalem" and "a place where precious things are kept." If "thou knowest" these things, then nothing is wanting, says the Royal Arch Degree. It also has the meaning *Templum Hierosolyma* or Temple of Jerusalem, indicating that, just as the Jerusalem Temple held secrets, so too did Rosslyn, and possibly the same ones. The layout was not within the normal Christian boundaries and was certainly made to hold key secrets. Just what those secrets are remains a mystery because that is actually the whole point. There is no altar like a true Christian chapel, indeed in 1862 the Chapel had to be consecrated, as it was believed that it never had been. Many believe that it is a copy of Herod's Temple and there is evidence to support this in the carvings of the building of Herod's Temple. Today, as I know from my own visits, Masons from across the world come to pay homage at this shrine of Templar and Masonic secrecy.

Probably the most written about element of Rosslyn is the Apprentice Pillar – a stunningly beautiful work of Masonic art. Its symbolism is thought to represent the Norse world tree Yggdrassil, which is constantly gnawed at by the Midgard serpent. It represents the tree of knowledge or wisdom and the tree of life; it is the fountain of immortality and is richly adorned with the entwined serpentine image with dragons biting each other's tails at the foot. Yggdrassil also has a secret beneath its roots – the head of Mimir who had been decapitated in battle and was therefore powerfully endowed like the Tantric Skull cups of India. The serpent and the Tantric head seen together in Norse myth and found in Scotland at Rosslyn Chapel. It is not surprising to find these elements in a Sinclair building, as their roots are Norman (north man) and Norse. There are many things that are thought to be hidden within the pillar, including the Grail and the head of Christ, but scans have revealed nothing spectacular.

The story of the pillar is interesting and is distinctly an ancient initiation myth. The Master Mason did not want to complete the pillar until he had visited Rome and seen the original, whatever that was. So off he went, leaving behind the Apprentice who went ahead and completed the pillar in his absence. The Master returned and was so envious that he struck the Apprentice with his mallet and killed him; the work was complete. This story or myth points to one thing; the importance of the secret hidden in the pillar, a secret that does not lie within the pillar but is seen all over it; the immortal promise of the serpent. I went to Rome, to the Vatican (meaning city of serpents!) and I saw the great pillars in St Peter's – each one of them was topped by a serpent.

But the truth does not lay with any of the pillars at Rosslyn for they only point the way. We cannot enter the Temple until we have walked between them.

EIGHT

One of the most important numbers involved in the tales of the Templars, the Sinclairs and of course Rosslyn Chapel is the number eight. To quote from Tim Wallace-Murphy and Marilyn Hopkins in *Rosslyn*:

"a number of great importance to the ancient Egyptians and the Knights Templar. Including the preparatory Temple at Buhen, there are eight sacred sites in the Egyptian system. There are eight doors depicted in the allegorical symbolism of the Temple of Philae. Eight occurs frequently in European esoteric symbolism, especially that associated with the Templars. There are eight steps on the scala philosophorum, or "philosopher's ladder," depicted at Notre-Dame de Paris; there are eight points to the croix patte, the main badge of the Templar Order; the octagon is the basis for much of the geometry used to construct the round Templar churches as well as playing a significant role in the sacred geometry of Gothic architecture. Eight is also the symbolic number for resurrection,

an important concept for initiation."

Without doubt the secret knowledge of the early Christian (and Islamic) and oriental Gnosticism took root within the Templars, as well as other Christian monastic orders. The number 8, therefore becoming of paramount importance to the sacred geometry and architectural structures that erupted around Europe. The Dome of the Rock, built by the Islamist's had eight equal walls within the boundary of the dome, holding it aloft. The Templars guarded this sacred building for ninety years and simply must have been influenced by Islamic Gnostic beliefs.

Anybody who has done a study of the Sufi's and the Christian Gnostics will know that their beliefs were not simply similar, but that they were rooted in the same Hindu, Egyptian and even Greek concepts. And equally anybody who has researched the Knights Templar will know that they were heavily influenced by the Sufi's and the Christian Gnostics. Indeed my own research has shown that the origin of the Templars goes back into the mists of time well before the 11th century and to the time of the early Essene, from where much of Gnosticism is derived.

From Jerusalem, the Templars went back to Europe and built. They influenced thousands of buildings incorporating the number eight. These buildings were erected by *compagnonnages (Les Compagnons des Devoirs du Tour de France)* or early Masons, who would later on become the Freemasons and in Provence actually erected many of the Templar churches. Tim Wallace-Murphy and Marilyn Hopkins in Rosslyn state that these 'Children of Solomon' were instructed in sacred geometry by the Cistercian Monks – the same Cistercians who helped set up the Templars in the first place. Many, including the great Fulcanelli, believed that the Gothic architecture which came with these 'new' Templar and Cistercian inspired building techniques, actually contained a three dimensional language known as 'la langue verte' or the 'green language.' Green, as we have seen before is the 'special' colour of the serpent world. It is the Emerald Tablet and the Green Man; it is the language of initiation. No wonder then that Rosslyn Chapel has this green language from top to bottom. No wonder that Rosslyn also has the language of immor-

tality in the symbol of eight and the snake.

According to Hargrave Jennings in *Ophiolatreia*, the Egg is used as the phonetic sign for 8 and "*when combined with T, is the determinative of the female gender… placed close to a serpent in hieroglyphical legends.*"

There is though, another reason for 8 being symbolic as eternity. It is in fact, when placed on it's side the *lemniscate* or symbol of infinity. Ancient man saw this as a symbol of the entwined serpent, eating it's own tale like the images of the Ouroboros. However, as my good friend Crichton Miller showed me recently on his wonderful home-made globe, there is another reason. Crichton has created a globe which not only spins but which precesses and therefore actually holds the whole cycle of the earth, not just the solar cycle. He told me to place my finger directly on the great pyramid of Giza and to hold it firm whilst he precessed the globe around a full 25920 year cycle. What actually appeared was the figure 8. It is then, much more than a symbol on a piece of paper, it is a symbol of the very heavens themselves for the longest of all cycles and begs the question – how on earth did our ancestors work that out? The answer to that will be very much found in Crichton's own book, The Golden Thread of Time, which reveals exactly how this process was discovered. One thing is true though – images of this wonderful astronomy are all over Rosslyn and it was the Sinclair's who built it and it was the Sinclair's who were involved heavily in navigation and the search for new land and countries.

SINCLAIR

And so we find ourselves back with the builders of this peculiar little chapel – the Sinclair's.

The origin of the Sinclair family so intrinsically involved in the Templar/Grail myths are in Scandinavia. This great northern group of countries cannot escape from its serpent past. Whether Vandals or

Lombard's, they were all "*addicted to the worship of the serpent.*" Olaus Magnus informs us that snakes ate, slept and played with ordinary people in their own houses. Overtly this serpent worship became obvious when seen on the dragon standards of the later Danes and Vikings. The same dragons brought to Wales and into the Arthurian myths by invaders like the Scythians who came with the Romans. Deane also lets us in on the Danish sacred vessel of this primitive idolatry. The relic is a "*celebrated horn found by a female peasant, near Tundera in Denmark, in the year 1639.*" It is said to be of gold and embossed in parallel circles, seven in number. In circle one there is a naked woman kneeling with extended arms - on each side, the figures of serpents. Circle two has the figure in prayer to the serpent, the next in conversation with the snake. This has to be a Grail, a horn of plenty, of offering and then receiving from the sacred snake.

It is said that the women of the Vandals who worshipped the flying drag-on, kept snakes in hollow oaks and made offerings of milk. They prayed to them for the health of their family - which may be an indication of a deeper use of the snake. Keeping them imprisoned, feeding them and then requiring healing from them. The Lombard's similarly worshipped a golden viper and a tree on which the skin of the "*wild beast was hung.*" The Bishop of Benevento suppressed this belief by cutting down the tree and melting the golden viper into a sacramental chalice!! The Norman's were descended from Vikings and held the Yggdrassil tree to be impor-tant, with the serpent as the Ouroborus around the heavens. They incised dragons and snakes on their sword hilts and shields. This was often with the symbol of the Tau cross before they were Christian.

The crest of Henry St. Clare (1st Earl of Orkney) from the 14th century was the head of a great serpent and the engrailed cross now seen all over Rosslyn Chapel also has some remarkable connotations. The engrailed cross is now a Sinclair symbol, but to engrail something, in the symbol-ism of the day implied 'generation.' The Sinclair family - the 'Holy Light' - was the Holy Generation – the keepers or protectors of the Grail and strangely at the centre of the engrailed cross is the Templar cross. This element of the Templar cross is there regardless of whether the

97

Sinclair's claim not to have been connected to them or not and as it begins the almost eternal outward journey from the centre in its horse shoe like curves it becomes symbolic of immortality.

The tomb of Sir William Sinclair inside Rosslyn Chapel depicts a chalice and octagonal cross and a rose. The chalice is the Grail, the cross is the number 8 for immortality and the rose is the blood of the serpent (Christ) and symbolic of the mother goddess Ishtar.

The name Sinclair comes from the hermit St. Clare or St. Clere who lived in the town, which is now known as St. Claire sur l'Epte and is located to the north-west of Paris. The area is now known as Normandy, after the Norse invaders, some of which would later become the actual Sinclair's.

Clare was born in Kent, England, to a noble family in the ninth century. It is said that his father wanted him to marry a rich heiress. But Clare was austere and aloof. He was too holy to be considered for such things. The lady however took no notice and pursued him with her wily charms. Finally Clare escaped her clutches, but she promised revenge and he had to run to Neustria (Normandy) where he began to live as a hermit.

Eventually the healing abilities of this Buddha like character made him famous and people flocked to him from far and wide. Moving his hut from first 'this place' and then 'that,' there was no escaping the people seeking cures, in a tale almost 100% reminiscent of tales of Buddha.

Clare's past was about to catch up on him however, as the rich heiress, seeking her revenge sent her agents to France to track him down. On the 4th November 884, Clare was found in his hut at the side of the River Epte. He had been beheaded. This became the symbol for St. Clare, as it was for St. Denis – the figure of a man with his decapitated head in his arms. And St. Clare's head and bones are said to reside in the local church, separated by the Altar.

It is said that the blood flowed from his neck in gushes and that a new spring emerged from the ground where the blood had flowed. The hut

was transformed into a chapel, the chapel into a church and eventually the quiet, remote hermits dwelling place became the town of St. Clare sur l'Epte. Now the Salle de Fete (Town Hall) at St. Clare sur l'Epte is built entirely of wood from Norway, with the gables being marked with *dragon's* heads.

The whole idea that a spring should emerge from where the blood of the dead healer fell is obviously nonsense. It is just not possible, and so, it must be a creation of symbolic element. The wells and springs of the day, and as far back as man can go, have been seen as places of healing and associated with the serpent. That this holy healer, who resided sometimes in caves, had his head chopped off and his blood creating holy water is full of clues. It is not, however, an unusual occurrence – indicating that a secret truth is being given in the telling of the tale.

St. Julian of Brioude in the Auvergne was beheaded at the side of a spring, and later this very same spring was said to be able to cure. St. Juthware's Well at Halstock in Dorset was created where the head of the saint came to rest – strangely right beside a sacred and so called miraculous Oak Tree. St. Thomas's Well at Windleshaw was risen where the priest was decapitated during the persecution of Catholics, and there are many more.

So let's divert for a moment and take a look at water and see if there are any interesting pieces of evidence we can find.

Water

Geoffrey Ashe in *The Ancient Wisdom* says:

"According to one theory, all primordial serpents of myth are derived from a Sumerian Arch-Serpent in Subterranean waters, whose name was Zu."

99

'Water' – as we have seen – is the home of the serpent spirit. And water serpents are generally healers. For instance in a lagoon near Gimbo Amburi in Africa there was a serpent, which would cure 'madness,' and in an Algerian well there was a serpent deity taken over by a Muslim Saint, which was said to cure sore eyes. This links with the ideas once prevalent in Palestine and Syria that the waters were often associated with the annual Rajab festivals, which honour the serpent that resides in the holy waters.

The Naga of India were also said to live beneath the waters in Patala, and they were expert healers. And springs such as Ephca in Palmyra were named after the serpent deity residing there. In Greek myth, the serpentine god Poseidon, and the serpent Typhon, were water and spring deities with many watery places taking on their names. Even in the Temples of Aesculapius we find the pools of healing; a healing which is directly associated with the serpent.

This element of the 'healing serpent within the water' simply crossed over into the water itself, and thereafter the water became the healing element. Added to this the concept that water was seen as the portal (hence Patala and Atlantis) to the otherworld and we have an association of the "water of the gods" healing mankind.

Beneath the Temple in Jerusalem there is the 'Serpent Pool' or 'Dragon Pool.' What it was for nobody is quite sure. It may be that here lay the Hebrew secret of the 'healing water' in the name 'serpent.' This is the 'upper pool,' called today, the *Birket-el-Mamilla*. It is the "*dragon well*" of *Nehemiah 2:13* and the "*serpent pool*" of Josephus War V. 3 & 2.

This pool, which lies in the north west of the city (although the exact location is heavily debated,) was later renamed the 'pool of Hezekiah' by the serpent-bashing king himself.

The Essene were said to have used pools to heal and they are connected to the healing serpent in many ways. It may indeed be that Baptism has its root in this idea of the serpent healer – being 'born again' to new and

eternal life by being submerged into the waters of the serpentine other-world. An indication that this may be true is found in the fact that baptism has its roots in other ancient societies such as India. Here, the initiate was dipped three times (like the 'three day death of the sun') into the sacred waters. The dove aids baptism as well as it comes down on the hierophant and adds the regenerative aspect as the Holy Spirit. Where 'full submersion' was impossible due to arid climates, then sprinkling of either water or blood would suffice.

In Greece they even kept a Holy Vessel, which carried the sacred waters of the healing serpent.

The Egyptian Horus was baptised by Anu the Baptiser and so the origin of Baptism is much older than we previously understood. And as we can see it is firmly rooted in civilisations, which are central to the development of the serpent-worshipping cult – namely Egypt and India.

A larger version of this basic 'truth' is seen in the story of the flood.

In Indian lore the many-headed serpent, Vishnu, tells Manu about the coming deluge and so saves mankind from certain death – only to be symbolically reborn again after the deluge and from the waters. It is the serpent, which has the powers to create the chaos of the flood, and the serpent, which can save – in the same way that it has the venom to kill, and the venom to cure.

Surely, associating the serpent upon sarcophagi and funeral items brings the idea out, that it is the power of the serpent, which will once again bring new life, whether in this world or the next and to the person contained within.

In Bali the Naga serpent worshippers even burn a snake with their dead to give him or her new life after death. The place that many great legendary figures go to after or near death is often across the waters to a place where the fairies or 'serpent spirits' reside. They are given life eternal via the snake. It is only after the power of the snake has left you that

your life ends, as Porphyry related that when Plotinus died, a snake emerged from beneath his bed – the snake had left and taken his protection and energy away.

So, water holds the portal to the world of the serpent. It holds the keys to immortality. It is the fluid of the mother earth from where emerges wisdom and new life. And it is the stream of life or essence that flowed from the ground where St. Clare's blood was spilt.

The person said to be responsible for the death of St. Clare was a woman and it is a similar tale to the Arthurian legend where a lady has a knight decapitated in-order to gain healing power. There is little wonder then that the waters of St. Clare are thought to have healing properties, even today. We also find that the patron Saint of the Sinclair's is actually St. Katherine, who is often pictured holding the sword, which severed her own head! The true healing, we are being told, is to be found in the head and in the water – both of which are the same – both enable us to enter the otherworld of our own unconscious.

There is also a real reason that the Sinclair's found their origin in this place. The legacy was theirs to take, or so they believed. But just how did the Sinclair's come to claim the legacy of the healing saint?

During this ninth century period the swift ships and navigational skills of the Vikings was making life difficult for many Europeans. They were able to swoop down onto a village or town – and although outnumbered by the townsfolk – it was by their speed and surprise that they were able to pillage the area. No sooner had the people realised what had occurred than their attackers were off, back to sea.

What helped them of course was also a difference of religion. The Christians would not attack churches. The Vikings on the other hand seemed to relish the prospect, as they were themselves pagans – their religion based around many gods, including the large element of dragon lore.

However, one of these Viking rulers supposedly became Christian, Rollo, the first Duke of Normandy, and it is he who became the first in a long line of Sinclair's, right down to, and beyond, the builder of Rosslyn Chapel. This place is linked so deeply with the story of the Holy Grail, that it is therefore no surprise to see it linked-in with the initial stages to the 'cult of the head' – as if to see the Sinclair's associate themselves with it, and then later to hide it.

Rollo, as the first Sinclair, became known as *Sanctus Clarus*, the 'Shining Light' and it is this shining light, which was to become one of the biggest clues in the search for the real Holy Grail. The book, *Head of God* by Keith Laidler claims that the head of Jesus is in Rosslyn, however I checked with the Rosslyn Templars in-order get their opinion on the matter, the response very kindly came back:

"The official position regarding the possibility of the embalmed head of Jesus Christ being at Rosslyn Chapel is that no one knows what is below the chapel. The other 'official' position, from the Roman Catholic Church in Scotland, is that the head of Christ is not at Rosslyn Chapel." (Email received on 23rd May 2003.)

Well, there's a surprise. Even though there have been several attempts to find something at Rosslyn, to date, nothing like the Grail or the Head of Christ has been found. One of the objects implicitly linked with both Rosslyn and the Sinclair's is of course the Holy Grail.

CHALICE

The chalice or Holy Grail is the first and principle sacred vessel in our minds. It has been sought for hundreds of years and been used in various guises for thousands.

Just because there are Christian overtones to the modern legend of the Grail, does not necessarily mean that it is originally a Christian vessel.

Like all things Christian, it was stolen from various sources. Even if it were purely a Christian vessel, then it would be nothing at all like the various 'true' Grails being claimed today such as the Sacro Catino. As St. Chrysostom said, "*The table was not of silver, the chalice was not of gold in which Christ gave His blood to His disciples to drink, and yet every-thing there was precious and truly fit to inspire awe.*"

As far as vessels from the time are concerned, the likelihood of them being made of gold is slim. Instead we are looking for an object made of glass, wood, ivory or even clay. The miracle performed by Mark as revealed by St. Irenaeus – where Mark turns white wine into red and shows the contents, may reveal it to be glass, and therefore see-through.

Of course, the very idea of white turning to red is of Alchemical tradition and is a work upon the self – a clue to the reality of the Grail.

Tertullian also informs us that glass was used for the Eucharist chalice. (*The Hidden Church of the Holy Graal* by Arthur Edward Waite.) There may have been additions however, which transform the Grail or chalice into something materially precious. As for shape, our primary informa-tion comes from ancient sarcophagi, mosaics and other such monuments, which depict Eucharist chalices. It seems that the best shape for the early Christian period would be a vase shape, with no stem and possibly two handles.

The real chalice of course cannot be found – the Last Supper never hap-pened and a man named Christ was never crucified on a cross – at least not in the way told in the Bible. It is all a symbol, a representation of inner esoteric truths. So, again, we are looking for the original and sym-bolic chalice. It is an addition, stolen by the Christians much later on. But it WAS stolen from somewhere and proof of this comes from 'Peredur' a Welsh version of Chretien de Troyes, 'Perceval' – where the Mass Wafer is replaced with a severed head "*swimming in blood*" on a platter.

The question is whether the head or the platter is the Grail?

This severed head is also found in many other Grail romances. What this does show, is that the idea of the severed head as the Grail or at least associated with it existed in the minds of the medieval writers and that this came from somewhere. The Mass Wafer was the Corpus Christi – the 'body of Christ' – and to replace it with a severed head implied other secret knowledge.

These secrets are from a time before the ideas of the earliest Christian cults, which followed the Gnostic Christ as a 'good serpent.' Christ was crucified as the serpent and his blood – the 'blood of the serpent,' flowed in salvation – that is immortality for the world. In the Gospel of Thomas found at the end of the Second World War in Nag Hammadi, we read that, "*From me did the All come forth, and unto Me did the All extend. Split a piece of wood, and I am there. Lift up the stone, and you will find Me there.*" (46:25.) This wonderfully telling and Gnostic saying is an obvious allusion to the serpent-like features of this Son of God, who is both imaged as a literal serpent and said to be everywhere. We shall find soon that this concept will be linked inextricably to modern quantum theory and will reveal a deeper and more intuitive aspect of ancient belief.

Of course in our going after the Grail, we somewhat lose sight that the contents are more important. According to the codex of the Lesser Holy Graal, it was the content of the Vessel, which was called the Holy Grail anyway. (*The Hidden Church of the Holy Graal*, by Arthur Edward Waite.) And, according to Waite the second element of the Eucharist – that is, 'the blood' – is distilled from the Lance.

Distillation is a method of removing impurities and knowing that all things spoken of in the high church of the Grail are symbolic then the Lance should take the original French form of 'tooth.' This would then mean that the Elixir of the Grail is taken from the tooth and all the impurities removed. Could this mean that the venom is taken from the tooth of the snake?

I also had to wonder at the knowledge of a peculiar Sister Emmerich from the 19th century, when reading one of her Meditations about the

chalice.

The story goes that the chalice of Christ had found its way into Veronica's house and was recovered from there by the Apostles. The origin of the chalice had been long forgotten as it had been kept in the Temple for generations and was then used by Christ. It was brought by *Seraphia* (fiery serpent) and was used "many times" by Christ. The chalice – like the head – was stood upon a plate, (another meaning for the Grail) and it was said that a "species" of tablet could be drawn from it. It was also said to have serpents around its base – bringing to mind the Tassilo cup, which also has serpents.

Of course all of this is apocryphal and there can be no evidence taken from it. But the idea of serpents seemed to have crept in from somewhere. Incidentally St. Veronica is the very same Saint who now has a piece of cloth – a *mandelion* – named after her with the supposed "head" of Christ on it. This Veil of Veronica is kept in the St. Peters Basilica in Rome and is also strangely known as the *Seraphia* – the fiery serpent.

Hans Memling in the 15th century, painted Veronica as holding the veiled head – and on the same set of panels, is an image of a chalice and a serpent. On a trip to Paris I visited Notre Dame where I also found a remarkable gold cross with Veronica's Veil at the foot near a skull (indicative of Calvary – place of the skull) and a large serpent hissing at the veil. It was a memorable visit, as I closed in on the cross to take a close up picture the whole of Notre Dame's alarms went off with a deafening screech and I sheepishly walked away with a red face.

This saint with the fiery serpentine name, St. Seraphia, was born in Antioch and died around 126 AD. Her parents took her to Italy because of the persecution of the Christians by Adrian in Antioch.

Here, propaganda points out that she was said to have led a holy life. She never married, instead preferring to devote her life to God and in-order to fulfil this, she gave away all of her possessions and sold herself into slavery, as any normal person would. She was discovered as a Christian and

was burned, but the flames failed and so she was beheaded. Then along came Sabina who took away the body and was herself beheaded. Although not a martyred Christian, Sabina was buried in the same tomb as Seraphia. I had to note the fact that Sabina (sabine) and Seraphia were both etymologically linked to serpent worship.

Not much of this peculiar tale can be true. There are obvious elements of a Christian 'cover story.' Seraphia loved God and sold herself into slavery. Hardly likely, no matter how holy you think you are. 'Seraphia' in etymology reverts into 'fiery serpent' and now we know why the flames would not kill her – she was immortal and the only way to 'kill' an 'immortal' is to chop off their heads. Seraphia was in fact putting herself symbolically through an alchemical transformation – being reduced in the flames and separated from the body, implying separation from worldly desires.

The Sabines were an ancient people living in Italy. They were indigenous to an extent and were related to the Etruscan serpent worshippers. In Arabic, Sabeen means 'follower of another religion.' The name 'Seraphia' was then altered to 'Veronica' to cover the idea that this woman was a 'serpent-cult' leader. Basically the Serpent Sibillia were still active and the Christians did not like it, so they wrote them out of history and took their Seraphia or Sophia deity and transformed her into a Christian saint.

So, our tale has taken us from Norway to Normandy, from Scotland to Italy and what have we found? We have discovered that the secret of Rosslyn and the Sinclair's is perfectly related to the Holy Grail and serpent worship. There has been no "bloodline" crop up anywhere or any white powdered gold. Instead what we have seen is the importance of the head and the blood, the serpent and wisdom. All of these things are indeed related. The blood is the essence of ourselves, known to the Sufi as baraka. From this essence all life and soul flows. The head is the cave of wisdom, the Golgotha or Calvary of our own Christ. This worldly Christ must die and be reborn at this place of the skull – within the head. The serpent is the symbol of ultimate wisdom, of knowledge, which

grows truth and freedom from lies. All these symbolic elements taken together form the basis of the ultimate truth that Sinclair tried to hide from the literal Church authorities at Rosslyn. All these things form the basis of the mystical and mythical, seen in texts and in great stone cathedrals. All these great mysteries point back to one place if only we were capable of understanding it – our self.

And so in the second half of this book I intend to move like the slithering serpent into the world of wisdom. Our Gnostic and mystic forefathers understood all these deeply psychological concepts and they left us wisdom teaching literature – the only problem is that man has forgotten how to understand it.

Fan vaulting at wells cathedral. The Masonic symbol of interconnection to the universe. *Photo P Gardiner*

THE ONE

THE SECRET AND ANCIENT TALE OF SELF-EMPOWERMENT

There is a lot of talk about the One in New Age and alternative circles. The amazing success of the film *What the Bleep!?*, brought home to many the reality of the quantum world and the unusual state of perception that we exist in. But during the whole film there was no mention of our past. There was no indication whether ancient man had ever understood such so-called realities before the 20th and 21st centuries. Is this arrogance? That only we in the modern age can understand such concepts? Or is it a lack of understanding and knowledge of the mind of our ancestors? I decided it was time to discover whether ancient man could have possibly known about the quantum realm of *Oneness*. The fact remains that man has the same mind now that he has had for hundreds of thousands of years and so he has the same psychological make-up. During induced altered states of consciousness man has also seen in the otherworld a whole host of archetypes and the most powerful of these has remained the serpent. As psychoanalyst Carl Jung and scientist Jeremy Narby have both pointed out in the past, these wave forms or DNA shapes seen inside the mind have given rise to the position of the serpent as a paramount deity. As this otherworldly realm was seen as the place of the true self, the heavens and the realm of God it was only natural to then instill in the image of the serpent a great wisdom and also a great and terrible power. Just as at Rosslyn where the serpent can be found, a division of our minds was perceived as the two entwined serpents. Only where these two serpents meet or cross is the true concept of union to be discovered.

But first we have to understand it ourselves before we can see the clues our ancestors left behind.

To our modern eyes the concept of the *One* or *Oneness* is mystical and Eastern in origin and there will be found truth in this. But we can perceive this reality with our Western eyes. Try to imagine yourself as a grain of sand. You are nestled upon the beach, one of trillions and trillions of grains of sand. You are quite separate and yet also part of and similar to the whole. All you see around you are other grains of sand. But whilst you concentrate on those, you neglect to see the sky from which falls the rays of the sun that contain life and the drops of rain that feed

the ocean that formed you. You do not see that those other grains of sand were formed in the same way as you and that they too come from the same rocks; you are all the same. And one day, in millions of years you will form as ancient sedimentary rock once again.

In this way, we are all formed by the same methods, with the same energy. We all eat the same produce of the earth and drink the same water. We shall all return to this same earth from where we came and the earth shall one day return to the universe from whence it came. Ultimately it shall all 'roll-up' in the Big Crash and all be one again. In truth, it is all one anyway. It is all interconnected and via quantum entanglement every piece of information is everywhere from all time in one place and in every particle. Imagine that! It's like a hologram plate. When we look at it the picture placed there by light energy is three dimensional. When we smash the picture into a thousand pieces, every piece has the picture of the whole! This is what the holographic universe is like, but this time we have more dimensions such as time itself. So imagine, you as an individual are really part of a multi-dimensional holographic universe where you are everywhere in all-time!

Well, that's kind of what the *One* concept is about in a really simple way. So did ancient man understand this principle and what lessons for us can we draw? Well of course he did and he actually left us a great many lessons too. If we could lose our modern arrogance and understand these teachings as great psychological treaties then we would be truly on the road to union within ourselves. As discussed previously Rosslyn Chapel itself is a distinct example of the esoteric and Gnostic truth, formed from within the mind of man. It was as an image of Eden on the inside that the Sinclair's and Masons formed that place. This special garden in the Bible was where the first man, formed in the image of God, was divided into male and female elements and thereby lost all knowledge of the true self as well as his own knowledge of his immortality. To build or form this place on earth was a grand statement of unity or Oneness, called *Ahad* (Oneness) or *Tawhid* (Divine Unity) by the Sufi's. And it will be to the Sufi's that I shall now turn for they are truly modern mystics and Gnostics, built upon the ancient serpent worshippers of wisdom from our

ancient past. Gathering knowledge from across the world the Sufi's did not emerge suddenly and unexpectedly from nowhere. In fact they were the accumulation of many wisdom teaching systems, not least of which were the Hindu's. Later these same Sufi's would pass on their knowledge to the Christians who ventured into the Holy Land, creating in the mind-set of the Christian Gnostics a division between the West's literal inter-pretations of God and the East's metaphysical understanding. Wonderful tales were passed down throughout time, which enveloped and kept safe the esoteric knowledge and these tales slowly moved into Western litera-ture becoming popular stories such as King Arthur and Robin Hood.

But there is a tale told by the 19th century Sufi master Ghuath Ali Shah and today re-told by Sufi masters across the world, which will outline the concepts of the One clearly for all to see. To many the teachings mean nothing. They are just nice stories re-told again and again and have in the re-telling lost their value. But this is not true. Those with the eyes to see can understand the many meanings behind the tales and in this respect my years listening to and learning from various 'teachers' of the Gnostic loop, including Sufi's, has seen me in good stead. The tale I speak of is known as *The Four Travellers* and I will now myself in all humility to the ancient masters, re-tell the tale and offer some explanation for our modern eyes. Understand of course, that in each tale, there are many lev-els of understanding and so you can find truths within for yourself.

There was a forest, black as midnight and thicker than thieves. It was a favourite route for many, but suffered from highwaymen and robbers and so it was that four travellers found themselves needing to rest for the night, but fearful for their lives and possessions. They were good friends and had three of them had been so for many years and so after discussion they decided to take turns to watch around the campfire. They settled down and the first watch went to a carpenter and wood sculptor. He sat for a while and then noticed a small length of wood and so decided to pass the time carving a beautiful image of a woman. By the time he had finished it was time for the next watch and so he placed the wooden lady down and woke his friend.

His friend was a tailor and after a while he too noticed the piece of wood and decided to make some clothes for the image of the woman. He produced a dress of silk and finished off with small leather sandals. Now it was time for him to sleep and he woke the next man who was a jeweller. Again to pass the time the jeweller decided to adorn the little figure with beautiful jewels. The final watch was summoned, but this time the man, a new friend the others had met on the journey, had no skills at all and so felt very ashamed of himself. He saw the wooden lady and admired the art and craft of his new friends. He wanted to show that he too was capable of improving upon the wood. He decided the only thing he could do was to seek the help of God and so he prayed:

"Oh, Almighty and Merciful Lord, give us some portion of your glory and as the Giver of Life bestow upon this humble figure the gift of life."

The fire finally went out and all was dark, all was one black place. Then the sun rose and crept across the landscape, revealing the countless forms that had been part of the darkness. One of these forms was now new to human life – the wooden woman was a living, breathing creature. The four men now awake were aghast and in awe at their creation. The wood carver admired the contours; the tailor was gushing with pride at the serene silken dress and the jeweller thought the fine gems were full of inspiration. And yet the fourth man claimed the upper hand for himself, because it was he who had asked God to provide the life force. In truth, the four men, who just the night before had been friends, were now sworn enemies, each one claiming ownership of this thing of beauty.

And so, because they could not decide who owned the stunningly mute female they made for the nearest town where they sought out the judge. Unfortunately the judge and the towns people simply thought they were fools and so sent then to see the king. Again, the king, thinking them to be fools sent them to the Sufi master who this time took all five out to see the Tree of Knowledge and with an assembled audience began to ask the tree for its wisdom. No sooner had the Sufi begun to speak than the tree opened up before them and as if by magic the young lady walked towards it and was swallowed whole. They never saw her again.

This marvellous tale reveals many 'truths', but I wish to concentrate on just two of them here. The fact is that the woman had come from wood and would therefore go back to wood. She returned to the place from whence she came, just as we all shall. This is the concept of the *One*. It is the unity of the cycle itself. Not only are we part of the whole whilst in this part of the cycle or that part of the cycle; we are the *One* before and after and always shall be. As cosmic dust, solar rays and universal energy feed our planet and us, so too shall we ourselves return to cosmic dust, solar rays and universal energy one day. We shall return to the place from whence we came, we are part of a great unified universe. There is no tomorrow, no yesterday, neither exist. The only place in time and space that exists is now and that is a slice through the whole.

There is no god but God, as the Muslims say. There is no me but the true self and the true self is intuitive and that intuitive aspect is the natural knowing part of ourselves. It is the link into nature, the connection point or plug into the true One of all. We need no ruler or priest to do this, we just need to know.

But there is much more to this tale and for me there is a strong personal lesson for each and every one of us that can only be learned truly if we understand our 'place' in the greater whole. We are no different to that wooden woman. We came from the *One* into the *One* and so we are the *One*. Who is it that thinks they can form us, dress us and then give us life? Nobody owns us. To *own* is an anagram of *now* and in the now we exist. Whether your family, your town, your school or your employer or even your political or religious leaders – they all claim ownership at one time or another. And yet not one of them owns you just because they taught you, gave you life, gave you reason, clothed you or employed you. No ruler rules you. You are the same as everybody and everything else and no matter what another gives you it does not empower them above you.

You may be a small piece of the holographic universe, but within you is the whole picture right now.

My Sufi friend told me of a trainee who once visited him and said that the Sufi was empty and worthless. The Sufi simply replied that he was thankful for the information as he had been unaware of it. The trainee went off for the afternoon and prayed and returned in the evening full of remorse, begging the Sufi for forgiveness. The Sufi simply replied that he needed no forgiveness, because nothing had changed. The Sufi was the same now as he had been before.

The moral of the tale is simple; do not worry about what people say of you, for their words change nothing in the *Oneness* of which you and they are part. Knowledge of the *One*, the *ahad*, is above all else, because it is a knowledge of the self in its rightful place and no words or actions shall ever alter that, whether you live or die.

SACRED WISDOM

So we can see that ancient Sufi wisdom literature and teaching is derived from the knowledge of the self and our part in the whole. The truth is that Sufi traditions did not suddenly emerge from nowhere, they were in fact the result of a mixing of traditions from across the known world. From the 7th century Islam spread across Asia, India, Indonesia, North Africa and Spain. Regardless of Christian propaganda that has permeated our history books, the Islamic faith was very mystical in origin and certainly much more peaceful in its lively exchange and debate with other faiths than Christianity. The influences upon it were wide and ranged from Zoroastrianism to Hinduism and Buddhism and this is why the sacred literature of the Sufi's is so accessible and also why it is so close to the original *ophite* teachings.

Whatever we discover in Sufi teachings we shall also discover in Christian, Druid and especially Hindu cultures. And it is for this reason that I intend to investigate their sacred and secretive tales a little closer.

We speak of the secrets of the serpent and the secrets of the many societies that have spawned the globe, but what are these really? In truth even when we ask the high adepts of these secretive bodies as I did recently on a television documentary, we find that they simply hope to find out one day. This itself reveals what these secrets are, none existent! The truths are before their very eyes and so few comprehend them and so they search on. Producers, journalists and even mad conspiracy theorists claim all-manner of weird and wonderful concepts, some of which are true by the very nature of man. However, the true esoteric concepts at the heart

of all these rainbow coloured groups is simple – the mind. We find that the myriad tales of deities; of dragons and serpents; of ordinary folk; are all based upon ancient concepts of psychology. The truth is truly inside your own mind. To prove this point I wanted to look at a few of the teachings of the Sufi's, which have also crossed into Western tales such as the Grail lore via the Templars and others, and to see this ancient psychology at play. There is a great deal of relevance in this uncovering of the sacred stories of our past, for in it we shall hopefully discover our selves.

tHE JEWELLEr

There was once a great jeweller who had lived his life in peace and tranquillity. He was a wise man and he left symbols of his wisdom in a box. On his death bed his son came to him and the jeweller said to his son:

"In this box are two stones, symbols of my gift to you. One is ordinary and has no worth, the other is a valuable gem. They both appear to be exactly the same and so you must take this box to an expert and gain the knowledge to decide which is of value and which is not."

The son assured his father that he would not rest until he had discovered the valuable gem and so he took the box to a gem expert and asked him to identify the true gem. The expert looked into the box and then at the son and said that if he entered his service for five years he would tell him which was valuable and which was not. The son agreed and spent five long years learning the trade and gaining knowledge of gems. Many precious stones crossed his path and gradually he learned how to distinguish between a true gem and an imitation.

At the end of the five years the son went to the expert and asked him to keep his promise.

"I kept you in my service for five years for a good reason, because I

wanted you to gain the 'gnosis' of which gem was true for yourself. Had I told you which one was of value you may not have believed me and even if you had you may have sold it for a price less than its true value. Now you have the gnosis for yourself and what you do with the gem is up to you."

The moral of this story is about the knowledge or gnosis. The son was given a truly powerful gift by his father. It was of great value, but not just in monetary terms. The son was to find knowledge for and of himself and to not worry about the opinions of others. When we listen to other people our decisions on life are altered, but how valuable is their opinion? Can we seriously trust everything we are told to do? In fact should we even do what we are told to do? At the end of the day, all decisions are our own and we should only make these decisions when we understand our true self through gnosis. This gnosis is knowledge of our place. It is knowledge that we are the truest gem of all and to not be an imitation that is what others wish us to be.

The question of course on many people's lips is how do I do this? I have been asked many times about the altered states of consciousness that our ancestors speak of. It is often the impetus for the mystical experience and can be accessed in many ways. One of these has often been through drugs and in mankind's urgency to know all things he has turned to these drugs unprepared. In fact man also comes to the knowledge unprepared and that is why the tales of our ancients are more often than not misunderstood. We need no drugs and we need not rush. In fact to rush is to defeat the object.

THE EMPTY POTS

There is a Sufi path known as the path of the *faqir*. The word simply means 'poverty' and this does not necessarily mean to live in poverty. Instead it means to have no burdens of this world in the psychological context. I could visit many people this week and listen to all their gossip,

what the Beatle, George Harrison, termed the 'Devil's Radio.' Gradually my mind would be full of their gossip and eventually I would be rich in it. But is this the kind of wealth I desire? This is an extreme way of looking at the situation, but it is nevertheless a caricature of what we all go through on a daily basis. We listen to the radio, watch the television, read the newspapers and converse with people who know no better than to spread malicious rumours. All of this is drip fed into our psyche until we are swamped with the world's rubbish. How can you see yourself through this morass?

There was man who had two empty pots. They had previously held oil and were dirty inside. The man needed them cleaning of the dirt that they had built up and so he took them to market one day and saw two stalls both claiming to clean dirty pots. The first stall said that it would take forty days to clean the pots. The second said he could do it in a day. The man pondered this for a while and because he was lucky to have two pots he decided to give one to each of the stall holders.

The first cleaner took the pot and took great care to scrape the grime from the inside and to wash it with clean water, gently heated to the right temperature. He repeated this process again and again for forty days until the pot was clean.

The second cleaner took the pot and using the hottest flames began to burn the dirt from inside the pot until it too looked as clean as the first.

The man paid the stall holders and took his pots and was pleased that they both looked clean. He proceeded to fill them both again with new oil. The first pot was filled and placed in storage. The second was filled but before it could be placed beside the first it cracked and opened up, wasting the oil.

We are like these pots. We fill ourselves with new oil but eventually as we use it we become dirty and so need cleansing. We look around for somebody to help and we have a decision to make. It is like seeking spiritual guidance and the market place is where the various churches and

spiritually minded are to be found. There will be some that offer immediate cleansing and initially we will appear clean, but we will soon break down again. There will be others that say only through repeated and gentle cleansing can we truly be clean and because of the gradual process of learning we will be stronger. Taking drugs to achieve so-called enlightenment will break us into a thousand pieces, but learning over a lifetime will make us strong.

There is another illustration used to make this point.

THE BAKER

There was once a great man who mastered the art of concentration, a skill required for any great Sufi. A local baker was so intrigued by this man that he would visit him regularly. One day the great man had visitors but nothing to feed them and so the baker rushed out and brought them all food. The great man was so pleased that he asked the baker if there was anything he desired, to which the baker replied:

"Make me as you."

The great man took the baker and stared at him intently and eventually nobody could distinguish between them. After three days the baker died.

Why would the baker die? Because he had gained a lifetimes knowledge in an instant and so had used up his own life.

When we go to one of these masters we are told that we shall not become wise and knowledgeable in an instant. We are told to purify ourselves of all bad thought and desires. We must repeat this process again and again, just as the Western concept of alchemy informs us to do. The reason we must repeat this is simple; it is because the world will make us dirty as we remain in it. This is why we see Buddhist monks and Hindu sages seated for many hours in a world of their own. They are cleaning and

purifying their minds of the nonsense of the world. How dirty are we while we are so engrossed in the world of capitalism and commercial greed?

Only in true poverty, we are told, will we be as gods and who was it that promised such a thing? The serpent on the tree of knowledge of good and evil.

"The serpent is true to the principle of wisdom, for it tempts man to the knowledge of himself. Therefore the knowledge of self resulted from man's disobedience to the Demiurgus, Jehovah. How the serpent came to be in the garden of the Lord after God had declared that all creatures which He had made during the six days of creation were good has not been satisfactorily answered by the interpreters of Scripture. The tree that grows in the garden is the spinal fire; the knowledge of the use of that spinal fire is the gift of the great serpent. Notwithstanding statements to the contrary, the serpent is the symbol and prototype of the Universal Saviour, who redeems the worlds by giving creation the knowledge of itself and the realisation of good and evil." The Secret Teachings of All Ages, Manly P. Hall, Tarcher Penguin. p273.

The serpent and the mirror into the self. *Photo P Gardiner*

THE PHYSICAL SELF & THE 5TH ELEMENT

It seems then that the wisdom of this serpent on the tree in the Garden of Eden was nothing more complicated than the ability to point us to our own soul. Through the very nature of the snake as a threat, both physically and in the Garden, emotionally, we have to take a look at our own lives. We have seen how the subsequent wisdom teachings of the Sufi's, derived over time from the esoteric and Gnostic loop that also included the ophites, Templars and most early Christian heretics, does in fact teach us elements of profound psychological wisdom. But, there are sacred traditions, also pointing to the self, that hold yet more incredible secrets of our ancients.

Man believed that if the true inner self mirrored the nature of the outer world then so too would the physical man. It is the oldest and most amazing of universal symbols – the human body. In fact, to many cultures the knowledge and philosophy of the human body and its relationship to the universe was of paramount importance. The very power of the universe was in every fibre of the human form. Because of this connection to the greater universe our ancestors believed that processes such as the kundalini – the serpent fire – would enable the higher connection to this power of the universe and make man a god. Albeit brief, this so-called higher state of consciousness gave man an insight into the heart of himself and thereby also into the universe itself.

This process was ineffable, man could not speak of it in rational terms and so the language developed into mystical form, analogy and symbolism. God – this Oneness that permeates the fabric of existence – needed expression and so He became the Great or Grand Man or Architect. He was the perfect man, the one who was expressed not just in divine beauty, but also in mathematical perfection. He was in harmony and relationship with the mathematical equations of the universe. In this way too, man himself was in fact the mirror of this Great Man and thereby a little part of the One. We were created in His likeness, or more properly, we created the image of God in our likeness.

So in truth, the universe as a wonderful image of order from chaos was the physical manifestation of God and so we too were miniature manifestations of the universe. Suddenly unique and marvellous correspondences between our structure and that of the universe were being discovered and then trapped in secrecy – only to be used and known by the adepts. This is the often spoken of knowledge of the Hermetic Philosophers with the grand statement, 'as above, so below', revealing the macrocosm and the microcosm. And this was the process of teaching within secret orders for centuries – revealing to the initiate the divine proportions and relationships between himself and his God. This is the very nature and secret of Freemasonry – that it forms this wonderful mathematical relationship on earth in its buildings and structures, and of course now in its rituals and texts.

Through this unique understanding man now studied the form of his physical self for clues to the mysteries of life. These early Mystery schools would in fact give rise to our modern physicians and medical schools, just as alchemy gave rise to chemistry. In our modern quest we have dropped the need for the spiritual nature of man in medicine and in chemistry we simply pollute ourselves and have forgotten the psychological processes that were underlying the alchemical principles. Our ancestors did not do this, instead they saw all things in balance. In alchemy they did discover incredible chemical substances and invent new ones, but they also developed their own spiritual nature. It has often been called a 'work on the self' and so it is, for by working on ones own balance one is better prepared to discover new things and to understand the nature of nature. Just as our ancestors said we could understand the universe through our own unique form, so too alchemy said we could discover new things through constantly improving our own mind. Understanding the physical form would therefore help man better understand the invisible.

The same was true of the link to the medical and the spiritual elements and this is why for instance the tales of Jesus include those of healing and why there are links with him and the medical groups of the time. We may think that we have discovered holistic medicine, whereby we look into the thought processes of the mind as well as the body for a cure, but we have not. The Hippocratic Oath was much more than just a medical oath, it was in fact based upon the mind and spirit too, for ancient man saw a connection between his health and his thoughts.

And so, what could be more important than understanding the relationship of the human form and the human mind with the Greater Universal Man? Well in truth there was nothing more important and as a bridge for this knowledge the symbol of the serpent was used. It was the emblem of the serpent fire or process of escaping lower thought processes; it was seen within during altered states of consciousness – i.e. in the other world; and it also gave a medical method of healing. It was a perfect symbol and this is the secret of the serpent – that it was the most amazing all-rounder. And so we find the symbol of the serpent across the world in

places where man was yearning to cure himself and understand himself. So what did our ancestors discover and what did they try to keep secret?

One thing man seems to have done almost immediately is to split the element of the human into three distinct parts, in the same way that mirrors how the gods and goddesses were split into three parts. Just as Isis was the Mother, Sister and Wife so too was Mary in the Bible. She is mirrored in this 'human' relationship with the three phases of the moon, full, waxing and waning. This reveals how the relationship between the human form and the greater universe works. The male too has three relationships – brother, father, son – and in this mirrors the sun god which has balance, strength and weakness or spring, summer and winter, or morning, midday and evening. The human form, whether man or woman, was also attributed three elements – birth, life, death. But the sacred secret at the heart of the spiritual delving was to discover the 4th process of re-birth and this was the divine intervention. It was brought about in Egypt through the sacred mysteries of resurrection for the sun. Each day was a new day, a new creation and in this process the ancient Egyptians were not just interested in resurrecting the sun for physical life to continue but were accessing a sacred mystery of union of the human soul with the solar father in the sky – resurrect the sun and one resurrects the self. This triad concept was mirrored in the soul (*ba*), spirit (*ka*) and sun or energy (*ra*) and gave us the later Sufi term of life essence *baraka*. The soul was the individual person. It was his life, his desires, his dreams and his experiences in this existence. The spirit was the life force within each individual but was the same for all and was derived from the sun – it was the inner sun, the inner energy. This energy was empowered through thought, through meditation and became the serpent or solar fire. Energising this inner sun was to be in union with the universal power and to give new life to the soul.

This three level concept had many methods of expression and would later emerge as the three degrees in Freemasonry. The origin of this is in the Temple which itself was a mirror of the human form on the earth and its relationship to the divine order of the universe. There was the body and the feet were the entrance. One entered upward through the legs from the

lower nature of man and one finally emerged into the sacred holy of holies, which was the centre of the self and the place of connection to the divine and was the head or mind of the human. We can therefore begin to see how everything was a sacred geometrical connection of the human form and spirit to the universal form and energy.

The first degree in the initiation was the mystery of the material form. This was the sexual union, the physical manifestation of the creative principle. It is the human mirror of the point when God created and so this is why there was always two deities – a male and a female, a Yahweh and a Matronit or Osiris and Isis. Our physical love making matched that point of creation. This was also the degree where physical thought processes were discussed. These were methods of thinking and included teachings on mathematics, language and other such material things. This aided the initiate on the next level whereby these thought processes would already be usefully awake. The next degree would take place in the chamber that corresponded to the heart of the human form. Here the initiate would be nurtured as the new creation of the union that was achieved in the first level. He or she was now the One, the son of the gods and so would need to think like a god and so this second degree involved higher levels of abstract thought. These psychological tools would raise the mind to the highest possible for a human and leave only spiritual levels for the third degree.

The paradox was that it was in the heart chamber that the highest order of the mind was achieved and yet when the initiate reached the mind or brain chamber it was the heart functions, which were expressed. This was in fact the whole point – that the initiate would learn that the mind and the heart should be in union if one was to be like God. If the heart was impure of thought, then the initiate would fail to achieve correct balance, and so too if the mind could not conceive what was in the heart. The perfection of this mind in balance would be symbolised by the world's ancient wonders and especially by the Great Pyramid which itself reveals the 5th element.

The literal world struggles with the concept of the 5th element. It has

become a mystery to most because they fail to see the simplicity of it. Beauty is in simplicity, not in confusion. The fact is that ancient man saw the human form with five extremities – the legs, arms and the head. Temples across the world mirrored this in form and mathematical structure. It was seen in abstract structure also and in the Great Pyramid the four corners represented the legs and arms and the pinnacle the head. This abstract shape imaged the perfect man in perfect balance and only in this sacred way could he become a god. It is apt now when we consider the degradation that man is in that the cap (cap means head) stone is missing. This mirrors the actions of man – for he has forgotten his sacred relationship to the greater universe and so is no longer in a perfect state. If he were to understand his place, it may be that he would replace the cap-stone as a symbol of his understanding. There is little wonder that we wander around this planet of ours searching for our head, for it is the only thing that can tell the legs and arms what to do.

The body was also divided in many other ways, just as the psyche of man is divided. The left side of the body was darkness and subjectivity; the right side that of light and objectivity. The two are on opposite sides and yet are connected to each other, for one cannot exist without the other. This symbolism also came through in the method of fighting, whereby man fought with his sword in the right or light arm. The very word sword as connotations in etymology of light. Light is right, it is just and so any good mock solar deity such as Arthur Pendragon should have a sword of light and strength. It reveals within the structure of the tale the mysteries of the ancients and the sacred concepts we are herein discussing. The sword wielder is the hero, which is a term for the solar deity (*heros*) and in Old English we actually find that the word for sword is *heoru*. It is therefore no surprise to find that Arthur's sword was also seen as a serpent.

But what relevance is there in all this for us today? Well we should by now have gathered that our ancestors were no fools and they understood both natures of man – the physical and the spiritual. They understood that a spiritual man was worthless unless he had control of his lower nature and so he gave us symbols of this. He showed us that we cannot truly be

enlightened unless we were to bring our lower nature up to a state of balance with the spiritual nature. There is little point in being holier than the Dalai Lama is one is stupid. We have to be both rational and virtuous. Illumination is not a biological function caused by some drug or energy boost that is being claimed by the New Age fraternity and linked to the kundalini. It is both this and the rationality of thought. It is the realisation of what and who we truly are and not the subjective nature of thinking we are what we are told to be. There is little point in sitting for hours meditating on raising the serpentine energy of the kundalini if we then sit for hours watching soap operas. Our ancestors saw the control of this universal energy as a great power and so maintained strict control over the knowledge of it. Fools would not be allowed to attempt the process and only those who had already gone through the degrees of initiation were allowed to know the secrets of the power. This is why the Apostles at Pentecost were allowed to access the spirit, because they had shown themselves worthy of it by following the teachings of the sage.

So do not think that we can suddenly and by spirit or single revelation become enlightened. Do not think that drugs or excessive physical conditioning will illuminate your mind. Instead gain knowledge of your place in the universe and who you are. Ignore the dark ramblings of man-made nonsense and search for the real you. Once you have discovered this true self then you have given birth to One who resides in the One, part of the One and is the One. You will then need to gradually and holistically raise the new born to its full stature in balance as the perfect man and the mirror of the universe itself.

St Paul's snake rising from the regenerative flames. Malta. *Photo P Gardiner*

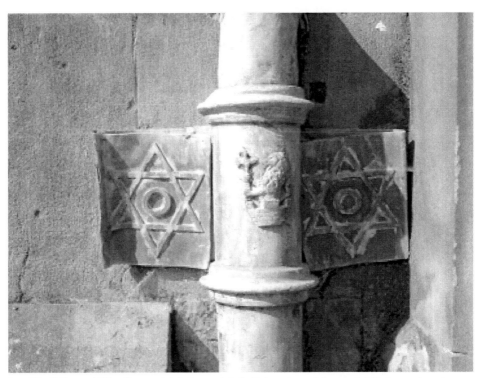

Star of David Newstead Abbey the star points both upwards to the higher nature and downwards to the lower nature – as above, so below. *Photo P Gardiner*

CONCLUSION

Enlightened Buddha, Portmeirion, Wales. *Photo P Gardiner*

"The great arcanum, the inesxpressible arcanum, the dangerous arcanum, the incomprehensible arcanum may be definitely formulated thus:

The divinity of man." The Great Secret, Eliphas Levi, Weiser.

Levi goes on to point out that the serpent said 'Eritis sicut dii', '*You will be as gods.*' And so it shall be that if we do truly come to a place of knowledge in the unity of everything, then we have the knowledge of God who is the manifestation of that knowledge.

"You will be God, for God is my Father, my Father and I are one and I intend that you and I shall be one." The words of Jesus quoted by Levi.

To be God is to have knowledge of the One. But is it sufficient to have evidence of this One? This would make the quantum scientist a God and I am sure they would be overwhelmed with joy to learn of it. However, it is not just the intellectual knowledge of the unity of all that our ancestors spoke of, they were speaking of the intuitive knowledge too.

I have spoken to many hundreds of people on this subject, from pastor to atheist and in each case there is a similar understanding. The pastor just 'knows' that God exists and fails utterly to be able to orate this sufficiently for others to understand. The same is true of the atheist, who simply 'knows' that he is a walking mass of chemicals. The term God is a very subjective one and so it cannot mean the same thing to every man and woman. People who have never come into contact with religion are still found to have an understanding of a greater deity. And so it must be a human reaction (unless animals too feel a connection) and it is a profound oddity. Why would man have such archetypal experiences of 'knowing'?

We are in effect a conscious mind walking around in a body. Our emotions and reactions are the result and product of our body, just as milk is to a cow. In truth our body is not just part of the greater universe or One, it is the result of it in the same way as a rock is the result of it. But the rock is not conscious and certainly not in the higher conscious realm that humanity can access. In this way then our consciousness is the result of the greater universe or the One and so then our consciousness is also a reflection of it. Our thoughts are the thoughts of the One, what our ancestors called God.

Think about it. Life erupted on this wonderful planet of ours through whatever means the universe, by order and chaos, came up with. Whether it was cosmic dust, a comet bringing bacteria or some underwater bubbling – the fact remains that life evolved in a magnificent way. Gradually over vast periods of time this life began to communicate and express itself. Then it became conscious of itself – it knew it existed and this knowledge eventually separated it from the thing that made it. Unconsciously this new conscious being knew that it was a walking, talk-

ing, biological copy of the universe around it. This unconscious knowledge bubbled up into the conscious world and suddenly, whether in meditation or some drug induced altered state of consciousness, we had a feeling of Oneness and called it God.

In this place of otherworldly connection man came across the mathematical world of the wave form, seen within and given life by the greatest of all crack fillers – the imagination. We see a cloud go by and our imagination completes the picture with a face. We see with the inner eye the structure of the very universe and we complete the picture of the wave with the image of the serpent. In truth the wave and the serpent are no different, because they have both by mathematical order derived the same method of movement. As man spent more and more time in this other place he grew his powers of intuition and understood more about his own connection. The snake became a symbol of this knowledge and throughout the course of history and across thousands of miles it has slithered into view again and again.

Today the relevance of it could be huge. Through the literal discovery of the existence of the serpent in all cultures and creeds it could redefine the very modern belief systems we have. Through a scientific understanding of its venom and blood structure we could have a method of fighting off disease and decay. Through a better understanding of the wisdom literature and tradition that has surrounded it for centuries we may yet find a better method of human self-improvement, rather than wishing ourselves back into the Freudian womb.

If I were to be forced to choose any one of these it would be the latter – for from true knowledge and wisdom will come the others.

We have seen throughout this book that there are many reasons for the serpent to be included in the mythology and traditions of the globe. From earth energies to venom; from the great Draco in the night sky to the energetic power of the solar orb – the serpent has formed a unique role in many civilizations. But for me the most powerful role is that of wisdom.

In the world of the Gnostics the serpent often became a symbol of Divine wisdom or Sophia. It was invoked, adored and admired for the wisdom it brought from within – especially in relation to the fact that when one entered the mystical state one would very often perceive serpents or wave-forms. The wisdom that came from this experience derived from within the self, from the unconscious world or archetypes. Note that all these words invoke the letter "s" a letter derived from the serpent in antiquity. Sophia, Self, Symbol, Sign, Serpent, Snake, Seek, Secret, Sacred – these and many more are representative of this Divine wisdom element. Indeed the letter "w" itself is the wavy serpent in glyph and this brings wisdom.

There are of course many versions of "wisdom," but to my mind the wisdom spoken of here would be archetypal – world-wide and useful throughout time. In this Appendix I have decided to discuss that wisdom in a modern way – to update and bring to light the knowledge for our age. When reading the following try to imagine that you lived 10,000 years ago, or 1,000, or 100, or now, to see that it would relate to us no matter where and when we lived. This is a kind of test that I have placed upon it, to judge the continuity and archetypal truth. It is the wisdom of the Masters, or the Messiahs, it is the Gnostic truth in modern language. I would highly recommend a book by Brian Mayne entitled *Self Mapping* for all those who wish to see this wisdom expressed in a modern world with modern methods.

Part 1 – Current Earth

Life can be short and life can be long. Often it depends upon your point

of view. To us the life of a bee seems rather short, but not to the bee. The length of life however should not be a concern, more to the point, it ought to be the way we live it that matters. The bee does exactly as it is programmed to do by nature and knows no more and desires nothing more because of it. We on the other hand are conscious beings – we know more and so paradoxically we desire more, thus causing strife and striving. Our life is a multi-faceted and intricate web of individualities, both exoteric (outside of our selves) and esoterically (within ourselves). We are many different people, affected by many different people. This complicates our life yet further, but so do other things such as fear.

In early Christian times this was incredibly important because life was much shorter and so we needed to live a good life in-order to access the "better place" in the hereafter as promulgated by the Church. This however was a fear factor causing us to look to their system instead of a more self-oriented one.

Fear is a prime mover in our lives. We may not be aware of it, but it is a fact. Until we overcome our fear we shall not be truly free – so say almost all mankind's wisdom texts. But first we must come to recognise this fear and its many faces. Fear can be as simple as worrying about how the bills are going to be paid or as complex as the subconscious notions of our position within our immediate peer group. It is a strong and subtle element of our psyche that is used against us by those who would manipulate us. The Church has for generations utilised fear in all-manner of ways to cajole the sheep into the pen. So too have governments and today we have the added bonus of the commercial world adding extra fear on top. Now individuals get stuck by their fears and run frantic on the hamster wheel of greed, envy, lust, desire and all-kinds of other "sins." The companies use slick advertising to convince us that we mustn't miss out on the next big thing and so we run off to the bank, borrow huge sums of money and spend all our lives working to pay for the things we now cannot enjoy. Nature is free, it is there waiting for us to rejoin it. Unfortunately we are too busy running away from the hell of the Church, the tax man of the State and the overdraft manager of the bank, to enjoy it. Do not think that you are reading this objectively, you know that you are subject, as we all are in one form or another. No man is free, unless he frees himself. The question is,

do we even know that we are in chains? And that is the first move we must make to find true freedom – we must look long and hard in the mirror of our life. In the end, these are our fears and they are not owned by religion, state or company.

Whether we are talking about alchemy, gnosticism or just plain spirituality the fact is that we are told again and again, sometimes in arcane language and sometimes not, that we have to burn off the bad stuff. We have to reduce ourselves down to the original core, to the seed that started it all, because most of what we think we are is really somebody else.

Once we have worked out that we are not "James Bond" or anybody else, and that we are unique individuals then we can move forward with our lives properly. Now we can look in the mirror and see who we are we must also understand that we do have connection to others, but that we must not "become" others. We are in fact natural beings, connected to nature, to the landscape, the beasts, the sea and the wind. All these things touch our lives and we touch them. It's free, it doesn't cost us anything and so we don't have to run around the hamster's wheel like a crazed rodent.

I know, there will be people mumbling to themselves saying, "But I have kids, a job, a car to pay for…." And yes, most people do these days, but the question has to be – how much "stuff" do we really need? Just because some marketing man has told you to buy something because Mr. and Mrs. Jones next door have already ordered one doesn't mean you should. That scenario is playing on our fears – that we won't be as good as our neighbours. One less thing of no worth bought is one less worry and fear. I don't need a new lawn mower, my old one still works. I don't need a television, it's full of rubbish, sells me more crap and keeps me fearful. As author Tim Wallace-Murphy said to me recently, "It's a bloody one eyed monster." I don't need a new computer, this one is good enough. I only need to know who I am, to see the glory of nature and be awe inspired by the fact that I am part of it.

A small example of how innocent our connection to nature came to me when I visited my sister on her land in Wales. She lives in an old stone

cottage in deep countryside. The lane to her home is winding, steep and perilous in winter. But it is a place of solace and a world away from the bustling streets of London or New York. I took a day out with my two small children and we ventured off for a day in the fields, woods and to picnic by her stream. I allowed the children to run wild – to know no boundaries, like the ones they have in suburbia. For the whole day they played in the stream, climbed trees, ran in the fields and fed the goats. It cost nothing and yet they were elated, well-behaved and we drove home tired and yet refreshed. On other occasions I have taken them to fun parks, which cost a lot of money, were full of people, sights, sounds and smells. We have driven home tired, but certainly not refreshed and it affected the children's psyche, causing more arguments and confusion. To my mind, this is an evolutionary connection. It is contact with the ancestral genes within us – the path of thousands upon thousands of years of man and his tuning in with nature. This contact has only in the last few hundred years been eroded, so that now we do not even realise what is wrong with us.

There is nothing of faith in this concept, it can be explained scientifically. Just as man's skin alters pigmentation in different climes, or as stature has altered according to diet, so too man's emotional and psychological state merges with his surroundings. For a longer time than we can imagine mankind has been as one with nature. He has understood her cycles, walked with the herds, swum with the schools and followed the ebb and flow of the seas and rivers. He tested the foodstuffs and found balance with his diet. All the anthropological evidence points to a distant past whereby man lived in relative harmony, hunting and gathering for a small percentage of his day. His teeth and bones were strong and there are no signs of warfare or unrest. Of course there were fewer people on Earth in those days and our success at survival knew no bounds. Mankind grew, but it was not until he began farming and claiming land and possessions that unrest seems to occur. Dairy farming brought disease. Destroying huge tracts of forests brought changes in the environment. Greed and hunger brought jealousy and the rot set in.

Now thousands of years later we live on islands too small for our population and force the natural world into our way of thinking. We destroy more than we mend. Fear drives us like never before – a fear derived in the

evolutionary world of survival.

And because we do not understand our past we ruin the future. Many times we have all heard historians say that we need to know where we came from to know where we are heading and yet this is a frightening thought, for even now in the 21st century we still do not properly comprehend. Our past, we believe, is strewn with the wreckage of human failure and some success. We have the brains to create nuclear energy and then turn it into a bomb. If this is the past we see, then the future we predict for ourselves will be ever more troublesome. Instead we should look further into our past and to the point where we were intuitive of the natural world. This past lasted for a much longer period than our relatively modern settlement scenario. Is it too late? Are there now too many people on the planet? A hundred years ago there were one billion, now there are six billion. The future looks grim for the human race unless it does something soon. Will man awaken to this understanding? Will he realise what he has done in his race to nowhere?

Even now there are growing numbers of people who feel empty and isolated, even though they live amongst thronging crowds. A city is not a community if it does not have a spirit of oneness and our cities, towns and even villages can be places of high technology, fast paced, dog eat dog styled nightmares. Many of those who recognise that something is not right about the way we live are moving back into the countryside. Some take their modern ways of living with them and so also their hamster wheel in order to pay for it. Others feel a stronger urge to understand where we came from and to reconnect. What stops us all doing the same thing? A great many things and mostly all rooted in fear.

At the end of the day, whatever our circumstances, we will be better off within ourselves if we understand that we are creatures of the planet earth and not some machine sent to do the bidding of the corporations. We should decide what we want and we can only do this if we know our own minds – our true self. For millennia man has sought this "source" and in every culture it has come to the same conclusion, that the self is the aspect of the human psyche that is intuitively in-tune with nature. To deny this aspect of ourselves is to invite division and turmoil into our lives. The

unconscious mind strives for what it has been developed over thousands of years to do – to connect, and yet the conscious mind desires all manner of things and denies its true role. Our attraction to certain colours, shapes and smells used today to entice us into plastic products and useless insurance are all within us because of evolution. Colours of fruit, shapes and smells of healthy food are all now so long forgotten that we only see, feel and smell the poison of the burger or candy bar, cleverly mocking their natural "alternative." And this word is an indication of how far we have walked away from our natural state – that we call good wholesome food "alternative" and have to label it "organic" because we genetically engineer and dose ourselves up with chemicals. Most people try not to think about it, in the same way they do not see into the beautiful dark eyes of a cow or lamb for fear of being put off their meat. It is a self-defence mechanism, in the same way that our brain turns off our muscles when we go to sleep, to stop us beating ourselves to death.

However far mankind has walked away from his Earth Mother, he has remembered many things and over the course of human history hundreds of individuals have secured their knowledge within texts, symbols, art, structures and ritual. It is to this sacred knowledge that we now turn.

PART 2 – HELP!

In Part 1 we very briefly touched upon the connection of man's inner psyche to the natural world around him. How this is part of our history and forged by our evolutionary instincts. In fact we are following patterns, mathematical equations that simply did not predict that consciousness would create a world like the one we now inhabit. In fact, it was not part of the mathematical equation to predict, but to survive and to be strong. But that does not help our conscious mind, which has to deal with the situation we find ourselves in. How can we be healed of this scar we have created?

Well, me and you are not the first people in existence to comprehend these issues. In fact in every generation there have been men and women who have grappled with the complexity of our disjointed societies. The powerful imagination of mankind has created all manner of answers to the di-

lemma. One of these is religion, but in creating these so-called sources of wisdom and spirituality man has created yet more chains. Alpha dominant individuals muscle their way into these well-meaning groups and sects and turn them into grand imperial armies that set out to destroy the weak and collect the chosen ones into the fold. Those individuals who comprehended the truths were simply not numerous and powerful enough to fight and so used intellect and cunning (from the word can, meaning serpent) to pass the word. These we know in many names and even some of these groups have been taken over by more powerful ones. Gnostics, Sufi's, mystics, underground streams, alchemists, Cathars and heretics – their names are many and widespread, but within their philosophies and texts we can discern methods of overcoming our conscious issues to life and find ways of helping even us today.

All the groups I just mentioned and several others are linked through time by a thread. This thread has been worn thin by the religious States of times past, but has nevertheless remained connected from the very earliest groups in a time before Egyptian empires, right through the rise of Christianity and into the modern world. Carl Jung the psychoanalyst was one modern writer who discovered the thread and showed how it had been kept alive during the inquisitorial periods of Catholic Europe by the alchemists. It was the thread of Gnosis – the knowledge of the connection, the Divine element of mankind within each and everyone of us. The language of the alchemists was so obscure that it wasn't seen on the whole as a threat by the Church and so they either ignored it, or even joined in with it – often hoping to be friends or have influence over the one who discovered gold. Of course, the discovery of gold is an esoteric terminology and not a literal element, but that was lost on the profane.

The alchemist, in simple terms, tells us what to do, in order to discover the Philosopher's Stone – the source stone of all, of ourselves. Once we discover this stone we can build again. This stone is the core of our true selves. We have to reduce the body and mind down in order to find it. This means that we have to get rid of all the things in our lives that do not represent who we really are. All the issues we are carrying with us, created by other people and planted in our minds awaiting a bad harvest. These seeds grow within our minds until we can no longer see ourselves

within the weeds. We have to chop down and destroy these weeds in the mind and what we shall reveal will be the seed stone of the Philosopher's. In modern terms it's like this: when we watch a television program or go to the cinema we see the modern gods of celebrity world. Whether we like it or not these stars affect us and we take on their personas as if our own weren't good enough. We are in effect trying to become a character created from within the mind of another individual – it is not even a real person we are trying to emulate. There are evolutionary reasons for this – it revolves around children copying and learning from parents – but we must grow up and realise that we are who we are and we need not become a Hollywood clone. Over the course of a lifetime and to differing degrees, we all clone other people and take on the attributes we like. We all start wearing "badges," whether this be a Rock t-shirt or a Freemasonic apron. It is as if these badges help us to become who we think we are and eventually we no longer know where we came from. Imagine if you can, all the people and influences on your life and how you have developed because of all those influences. Now imagine trying to burn them all out of your mind – what would you be left with? Does this scare you? It does most people and so you may be among good company. This is why alchemy was hard, not for the feint hearted and was seen as the Great Work. The same was true of the Cathars, some of the Gnostics and all manner of groups who understood these concepts, albeit in different form and language. To be "perfected" and "pure" meant not to have any of the impurities of this world. It is a job we must undertake if we are to discover ourselves properly and it is a job that cannot suddenly happen over night – there is no red or blue pill.

How do we go about beginning this work I hear many ask? Well, in fact we are all individuals and so there are many ways, but the truth is that we are all pretty much alike at the core too. We all have to take a serious look at the esoteric mirror – at what lies within. We have to start with the mundane and work through the layers we have built up. I often tell people to begin with actions, because they speak volumes about an individual. Think about what you do and how you react and then ask yourself if you are reacting intuitively or are you acting in a specific way that you have learned from another clone? Do you smile peacefully because you saw the Dalai Lama do it? Or do you smile because your inner psyche tells you to?

We all have many actions and reactions in life and so there will be a lot of hard work here, but do this as part of your everyday life. Put up a sticker somewhere that says, "Was that YOU?"

Eventually and with effort you will begin to understand your own mind and recognise in yourself and others when these clone-like spectres are talking. It will not be easy – that is the only certainty I can offer. But the rewards are manifest in the freedom of mind. You will obtain for yourself the freedom not to be fearful.

Once we have begun this process and stayed the course for some time there are other things we must learn. I know I keep repeating this in my work, but the truth is, it is of such profound importance that I will probably still be repeating it on my death bed. We must learn, on every level of our inner and outer lives the art of balance. Only once we have discovered that balance is important will we understand the truth of this statement. If I try to walk into a Temple by walking into one of the entrance pillars I will hurt myself. If I walk in the centre, between the pillars, which hold up the Temple, then I shall enter the holy place. The pillars are male (positive) and female (negative) aspects of ourselves and the Temple's holy place holds the stone that fell from heaven – the Philosopher's Stone – the source – ourselves. Balance out our lives and much more will follow.

The symbol of the dual serpents rising towards the great orb with outstretched wings is a symbol of this perfect state. That we have managed to balance the duality, the logic and emotion, the left and right brain, and we have therefore set ourselves free, realized the oneness, the orb, and we can truly fly.

ANKH

The Ankh is the Crux Ansata. A simple T-Cross, surmounted by an oval – called the RU, which is, simply put, the gateway to enlightenment.

This enigmatic symbol of Egypt represents quite simply 'eternal life' and was often found in the names of Pharaoh's such as Tut-ankh-amun. The symbol is often depicted being held by a god to a Pharaoh, giving him life, or held by a Pharaoh to his people, giving them life – this basically set aside the immortals, from the mortals, for anyone wearing or carrying the Ankh had gained or hoped to gain immortality – from the gods of the Otherworld.

It is the loop (the RU or gateway) of the Ankh, which is held by the immortals to the nostrils (as in the Biblical god breathing life into the nostrils of Adam.) It outlived Egyptian domination and was widely used by the Christians as their first cross, but in this symbol holds a clue to the secret of the serpent.

Thoth was said to have symbolised the four elements with a simple cross, which originated from the oldest Phoenician alphabet as the curling serpent. Indeed Philo adds that the Phoenician alphabet, "are those formed by means of serpents . . . and adored them as the supreme gods, the rulers of the universe." Thus bringing to mind the god Thoth, who again is related to the worship of serpents and who created the alphabet.

Bunsen in the 19th century thought, "The forms and movements of serpents were employed in the invention of the oldest letters, which represent gods." This symbol of the four elements was altered slightly and became the Egyptian Taut, the same as the Greek Tau, which is where we get the name Tau Cross from – a simple T.

The T or Tau cross has been a symbol of eternal life in many cultures and

gives its name to the Bull in the Astrological sign of Taurus – note here the two elements of the Tau and the RU being brought together. In fact the Druids (or "adders" after the snake) venerated the tree and the snake by scrawling the Tau cross into tree bark – opening up the gateway.

In the Middle Ages the Tau cross was used in amulets to protect the wearer against disease.

Amongst the modern Freemasons the Tau has many meanings. Some say that it stands for Templus Hierosolyma or the Temple of Jerusalem, others that it signifies hidden treasure or means Clavis ad Thesaurum, "A key to treasure" or Theca ubi res pretiosa, "A place where the precious thing is concealed."

It is especially important in Royal Arch Masonry where it becomes the "Companions Jewel" with a serpent as a circle above the cross bar – forming the Ankh with the Hebrew word for "serpent" engraved on the upright and also including the Triple Tau – a symbol for hidden treasure.

It was also the symbol for St. Anthony – later to become the symbol for the Knights Templar of St. Anthony of Leith in Scotland. St. Anthony lived in the 4th century AD and is credited with establishing Monasticism in Egypt, and generally the story goes that he sold all his possessions after hearing from the Lord and marched off into the wilderness to become a hermit. On his travels he learned much from various sages in Egypt and grew for himself a large following. He was sorely tempted by the devil in the form of "creeping things" and serpents. In one episode he follows a trail of gold to a temple, which is infested with serpents and takes up residence, needing little food for sustenance other than bread and water. He is said to have lived 105 years and due to this longevity he is credited with protective powers.

The Order of the Hospitalers of St. Anthony, who would later take much of the Templar wealth, brought many of Anthony's relics to France in the 11th century, although they were said to have been secretly deposited somewhere in Egypt just after his death and then later to have found their way to Alexandria.

The Taut or Tau symbolises creating four elements of the universe. Next the symbol of the sun / serpent was added, a simple circle or the oval RU. This loop above the T cross-created the Ankh, the symbol of eternity. The snake in a circle eating its own tale is symbolical of the sun and immortality.

The symbol of the moon was added to this, turning it into the sign for Hermes/Mercury and showing the Caduceus/Serpent origin. No wonder that this, the most perfect and simple of symbolic devices became the symbol of the early Christians; no wonder that, even though there were no cross-beam crucifixions, Christ was never the less symbolically crucified on a symbol of eternal life, a symbol of the serpent and access to life eternal.

This symbol became the mark or sign, which would set the believer aside for saving. In Ezekiel this is the mark that god will know, the mark on the forehead. As Deane points out the *Ezekiel* passage (9:4) should read, "Set a Tau upon their foreheads," or "Mark with the letter Tau the foreheads." The early Christians baptised with the term "crucis thaumate notare." They baptised with the symbol of the snake. And St. Paul himself in *Galatians* 6: 17 states, "Let no-one cause me trouble, for I bear on my body the marks of Jesus."

Is this the original mark of Cain, who we have found to be of the serpent tribe?

The idea of this sign or mark is widespread once discovered. In Job 31:35 we read in our modern Bibles, "I sign now my defense – let the Almighty answer me," which should properly read, "Behold, here is my Tau, let the Almighty answer me." He then goes on and says, "Surely I would take it upon my shoulder, and bind it as a crown to me."

This remarkable idea of wearing the Tau cross on the shoulder as a sign would later become part and parcel of the crusader Templars markings, the very same Templars who are instigated in the worship of serpents. (See Templars.) Also the Merovingians (said by some to be descended from Jesus and a sea serpent or fish god – the Quinotaur or Quino-Tau-r)

were supposedly born with a red cross between their shoulder blades. The Tau cross is also strangely used by those practicing sacred geometry as a "marker" for buried treasure, whether physical or spiritual. This "buried" treasure is the Gateway and the Tau cross as a symbol of the serpent and eternal life was the method of access – the symbolic tree.

In shape, the Ankh is very similar to the Egyptian musical instrument, which is shaped like the oval RU – the Sistrum (see Sistrum.)

BEL/BAAL

Solar god, thought by John Bathurst Deane in his, *Worship of the Serpent Traced Throughout the World*, to be an abbreviation of Ob-El – the serpent god or shining serpent.

Bryant remarked that the Greeks called him Beliar, which was interpreted by Hesychius to mean, "a dragon or great serpent." Bel is the Assyrio-Babylonian version of the gods Enlil and Marduk – being the same as Baal – the same Baal seen throughout the Bible.

Could it be that Beltane should be rendered Bel-Tan, both words signifying the dragon/serpent? – And showing again, a cross-continent link to Europe.

In fact "Tan-it" or Tanit was the patron goddess of Carthage in Northern Africa, who was also associated with the "Tree of Life" like Ishtar and Astarte.

Often the Tree is depicted with wavy lines said to represent serpents – a merging in symbolic form. The name Tanit means "Serpent Lady" and she is found on many coins in Carthage associated with the Caduceus and symbolizing the role of Tanit in life, death and rebirth. She is basically the same as the "Queen of Heaven" – Astarte/Isis/Mary.

BIRDS

The association between birds or wings and the serpent seems to go back

in time many thousands of years and across the world. To quote John Bathurst Deane from *Worship of the Serpent Traced Throughout the World*:

"The hierogram of the circle, wings, and serpent, is one of the most curios emblems of Ophiolatreia, and is recognised, with some modifications, in almost every country where serpent worship prevailed . . . It may be alleged that all these cannot be resolved into the single-winged serpent once coiled. Under their present form, certainly not; but it is possible that these may be corruption's of the original emblem which was only preserved accurately in the neighbourhood of the country where the cause of serpent-worship existed; namely, in Persia, which bordered upon Babylonia and Media, the rival loci of the Garden of Eden."

Deane relates these many thousands of images of the "winged serpent" to the Seraphim of the Bible, the "fiery" and "flying serpents."

These could also be the origins for the flying dragons and why Quetzal-coatl was the "feathered" or "plumed serpent" amongst others. The reason given by Deane for this symbolism is for proof of deity and consecration of a given Temple. If this is the case, then it was certainly believed that the ancient serpent had consecrated Temples across the world.

The real reason for the wings is that the serpent enlightenment aspect gave the adherent wings, symbolically making him/her higher in aspect and part of the "heavenly" chorus. The serpent of wisdom allowed the access for the original shaman to the Otherworld – hence the shamanic ability to fly.

The hawk, like the eagle, is of particular interest and is found throughout the world. It is widely associated with the solar deities such as Ra and even Horus and in Greek myth it was the bird associated with Apollo.

BUDDHA

According to Albert Churchward in *The Origin and Evolution of Religion*:

"The first Buddha was called Hermias, and can be traced back to Set of the

Egyptians; he originated in the Stellar Cult. Later, however, the Solar Cult was carried to India, and the Buddha is there representative of Ptah of the Egyptians."

So, we have a non-historical god-man. He follows certain patterns, which can be seen to relate entirely to the idea of Jesus Christ, because these patterns are the same the world over and follow a distinct astrotheological perspective. It is interesting to note that Buddha is seen as emerging from Set or Ptah of Egypt, especially when we consider the serpentine relationships of both deities.

The serpent was an emblem of Buddha the messiah (*Squire, Serpent Symbol,* p 195). According to Hindu oral tradition and legend, Gautama "himself had a serpent lineage." Not surprisingly trees are sacred to Buddhists, as Gautama was "enlightened" beneath the Bo Tree. In Ophiolatreia, Hargrave Jennings quotes Captain Chapman who was one of the first to see the ruins of Anarajapura in India "At this time the only remaining traces of the city consist of nine temples . . . groups of pillars . . . still held in great reverence by the Buddhists. They consist first of an enclosure, in which are the sacred trees called Bogaha" or Trees of Buddha.

The basis of the Tibetan healing arts comes from Bhaisajya-guru, Lapis Lazuli Radiance Buddha – the "master of healing." The begging bowl is made of lapis lazuli and contains the very elixir of life.

An indication of what this Elixir is that resides in this bowl is found in a story related about the Buddha when he passes the night away at the hermitage of Uruvela.

The leader, Kashyapa, warned Buddha that there was only one hut available, and that a malevolent Naga occupied it. Buddha was not phased by this and went to the hut regardless. However, a terrific struggle ensued culminating in the hut bursting into flames. The onlookers drenched the flames, but they had to wait until morning to find that Buddha had survived. The Buddha emerged with his begging bowl in his arms and inside was a peaceful, coiled snake. The Buddha had slain the dragon of its fiery notions and emerged with a beneficial result. In truth, Buddha had sub-

dued the power of the serpent energy and was a master shaman – disappearing into the night and re-emerging once again with beneficial advice and healing.

Now, to invoke the healing power of the snake, it is thought to be sufficient to simply call on the medicine Buddha. The serpent and Buddha are associated in symbolism because Buddha turned himself into a Naga (cobra) in-order to heal.

The coming Buddha is said to currently reside near, under or even in the Naga tree, where he learns wisdom from the Nagas.

Buddha as the god-man:

Born December 25th to the virgin Maya – announced by a star, wise men and angels.

Pronounced ruler of the world at birth and presented with costly gifts.
He "crushed the serpents head" and was tempted by the "evil one."
He was baptised in water with the Holy Ghost present.
He fed the poor, healed the sick and walked on water.
According to some traditions he even died on a cross and was ascended physically to heaven (Nirvana).

BULL

In the mysteries of Ceres and Proserpine the great secret is communicated to the initiates "Taurus Draconem genuit, et Taurum Draco." Meaning, "The bull has begotten a serpent and the serpent a bull."

The bull is a symbol of the "generative force," - the power. It is a symbol of the sun, both external and internal. As the Quinotaur he supposedly spawned the Merovingian bloodline with his son being called Merovech, after the sacred bull of Heliopolis, Meroe.

It was King Merovee, the first in the line of Merovingian kings, who was said, to have been spawned by the Quinotaur. This is a giant sea monster

with a bull or goats head. So the mer part of Merovee becomes obvious in that mer means "sea" – born of the sea. The word "Quinotaur," if broken down, resolves into Taur for Bull, and Quin/Kin for King. He is the "King Bull" of the sea. This "bull king" goes back a very long way in history – right back to the days of Mesopotamia and kings such as Sargon and Menes. But this goes back yet further to an association between these kings and their legendary genesis from ancient sea-born gods such as Oannes and Dagon who we can see are serpent gods.

The sun as a serpent would sink beneath the horizon and become a fish. Dag means "fish" and On means "sun," Dagon is therefore the "night-time serpent sun" – otherwise known as the "Black Sun" in various esoteric traditions. The "black sun" is a symbol of the Underworld and the Unconscious – the "Collective Unconscious" attributed to psychologist, Carl Jung. Could it be that these legendary creatures are archetypes from the unconscious – or represent man's "collective unconscious?"

These myths are those of invading "serpent worshippers" or migrating snake cults, coming into the land; bringing with them all the skills associated with the coming of these ancient gods such as metallurgy, architecture and medicine – not to mention a distinctive psychology. These deities are half bull, half fish or serpent figures, revealing their belief systems in their strange images - not what they were physically. It reveals a belief system of a duality between the sun (bull) and the snake (dragon/dagon.) Oannes is Dagon and from this we get our word for dragon. This god is the Biblical Leviathan, the great serpent of ages past who encircles the world as the Ouroborus, the symbol of immortality and eternity. This is the same symbol, which attracts the phrase, "My end is my beginning," like the words placed into the mouth of Christ, "I am the beginning and the end . . . the Alpha and Omega." In fact the Christians of later times went on to use the image of the Ouroborus as a symbol for the Alpha and Omega elements of their Christian faith. The Levites of course derive their name from this Leviathan, their name meaning "Sons of the Leviathan." Oannes is also the same as the Hindu Vishnu whom we know is linked with the serpent.

Heracles wrestled with the snake, which transformed itself into a bull.

Heracles tore off one of the horns, which the nymphs tossed into the river where it turned into the Cornucopia or "horn of plenty."

In Scotland there are hundreds of Pictish symbols found on rocks and ancient Neolithic monuments. There are many that are in the image of the snake and also with the snake in association with the bull – thus revealing the widespread nature of the bull/serpent association.

CELTIC KNOTWORK

Due to the prevalence of the serpent in the Celtic world and surrounding cultures, it could be that Celtic Knotwork is derived from the images of the snake.

We can see influences of this in the spirals and other serpent shapes seen upon many of the world's ancient monuments. In Scandinavian literature and stone art we can also see how the serpent appears, looking remarkably like Celtic Knotwork. In Roman and Greek wall paintings there are running spirals thought to be symbolic of the protective snake.

A Neolithic vessel, now in the museum of Henan in China, shows a distinct correlation between the idea of the snake and the Knotwork. The idea of the Knotwork coming from the snake was probably discontinued due to Christian influence.

Other symbols that are related to the snake include the Ivy leaf, a symbol of Bacchus/Dionysius and a symbol of immortality. The reasoning behind this symbol is simply that the leaf is similar to the snake's head and it entwines around pillars and trees as the snake is shown to do in images across the world.

Related to this Ivy leaf image is the shape of the heart and we can see in two Japanese clay statuettes from the Jomon period that they have these snake-heart heads.

Many images of the Buddha also incorporate this Ivy/Heart shape head – a softening and hiding of the earlier images of Naga deities who had snakes

heads. These Ivy and Heart shapes were thought to protect the person wearing them or the building adorned with them, and they are therefore no different to the concept of the protecting or guarding snake from folklore and legend. They are just basically symbolic of the original snake – and remaining so until Christianity demonised them. Of course the Ivy, along with that other serpentine symbol, the grapevine, are to be seen across the world's Christian buildings, as Jesus claimed that we should be grafted onto the vine. Did Jesus really mean that we should be part of the serpent cult? Part of the family, which he was himself a creation of?

The drawing or carving of the serpentine path upon sacred rocks and trees (wood) is surely an indication of the serpent access to the Otherworld.

CHRISHNA

One of the earliest shaman-gods and linked here with Horus, Jesus and others. Chrishna, Christna or Krishna is Vishnu in human form, like Christ is Yahweh in human form. And as all other healers, saviours and preserving gods, he was represented as a serpent. The orthodox and post Christian position of his death is that he was shot in the foot while under a tree. However, as always with Hindu gods there are many variances. One states that the body of this "god-man" was suspended on the branches of a tree. The disciple, Arjuna (John), came to take the body away, but it had already disappeared. The use of many arrows to "pin" him to the tree is reminiscent of the crucifixion of Christ.

As Doane points out in *Bible Myths and Their Parallels in Other Religions*, "The Vishnu Purana speaks of Chrishna being shot in the foot with an arrow, and states that this was the cause of his death. Other accounts, however, state that he was suspended on a tree, or in other words, crucified…. The death of Chrishna is very differently related. One remarkable and convincing tradition makes him perish on a tree, to which he was nailed by the stroke of an arrow…. We find that Chrishna is represented hanging on a cross, and we know that a cross was frequently called, "so cursed tree." It was an ancient custom to use trees as gibbets for crucifixion, or, if artificial, to call the cross a tree . . . In earlier copies of Moor's *Hindu Pantheon*, is to be seen representations of Chrishna (as Wittoba),

with marks of holes in both feet, and in others, of holes in the hands.

Many of the images of Chrishna have been destroyed or removed by Christians. In the 19th century the British Parliament sent a Christian Bishop to find out about the Hindu religion. The result was forwarded back to England for investigation and was found to be "horribly mutilated" and to be "scarcely recognisable." The crucifixion was completely removed. Indeed the Reverend Simpson, an erudite religionist noted that the "subject, a crucifix, is omitted in the present edition, for very obvious reasons." These obvious reasons were the Christian sensibilities, who, when they discovered such instances came up with the excuse that, "These crucifixes have been introduced into India, I suppose, by Christian missionaries, and are, perhaps, used in Popish churches and societies." (Moors *Pantheon*)

There were several other points of discussion, which startled many; namely the Coronet, which was probably of Ethiopian or Parthian descent and looked incredibly similar to the crown of thorns and even the halo's seen around the gods. The fact however remains that India had its crucified victim long before Christianity.

With the travels of people such as Apollonius of Tyana into the mysteries of India, there is little wonder that the idea of a crucified god got back to Greece, Italy and the pre-Christian world. Indeed Apollonius is connected with bringing back the ideas of Chrishna. Yet again we have a line drawn back towards the serpent worship of antiquity directly from Christianity. Christianity has "borrowed" extensively from the numerous, but singular, serpent cults and pagan beliefs of the ages. The relation of Chrishna in his various forms (Vishnu) as a serpent deity, and being hung upon the cross, has remarkable similarities to the "Brazen Serpent" of Moses, which according to the Christian writer Barnabas, was set up on a cross, which Lundy says was a simple sign of salvation; and Moses himself makes the sign of the cross at Exodus 17:12. It is basically the Ankh, the serpent upon the T or Tau cross. It is life, immortality and rebirth from the Otherworld; a universal image seen across the Atlantic even with Quetzalcoatl.

There is wide usage of the crucified form, being seen even in Assyrian

Monuments of Nineveh, which predate and were the progenitors of the Christian cross. They were symbols of the resurrected serpent god; the serpent god entering a ritualistic rebirth on the sun symbol of the cross; a symbol, which would take on the symbolism of the serpent because of this very fact. The fact that, according to Tertullian, the Christians were accused of worshipping an ass-headed god points simply to Set or Seth, the Egyptian god, who is the twin to Horus, as Christ is the same as John the Baptist.

The Brahmans represented Chrishna as a crucified god-man; the Romans revered Sol crucified on December 25th; Zoroaster was born by immaculate conception and his soul suspended "a lingo" or from the wood or tree of knowledge; Prometheus was crucified, even nailed to a cross; Tammuz was crucified around 1160 BC according to Graves; and Julius Firmicus said that Tammuz was raised from the dead for the salvation of the world, the same Tammuz who is represented by the Tau cross; and the Assyrians had their sun god Baal with outstretched arms in the cruciform. The fact that this "sign" of the god-man or serpent on a cross was a symbol of salvation, which is basically "immortality," is seen even by Christians such as Reverend Cox who said, "[to] the Egyptian, the cross . . . became the symbol of immortality, and the god himself was crucified to the tree which denoted fructifying power." The snake brings immortality and the tree, as the vegetation or solar power gives it "life." This Egyptian god crucified was none other than the twin of Set, Horus (Osiris too.) In fact Horus was even seen crucified between two thieves, just as Jesus was to be in the New Testament – the neutral in-between state.

DIONYSIAC ARCHITECTS

These are said by Masonic historians to be the prime originators of their guilds. A secretive group or secret society with doctrines said by Manly P. Hall (in *Masonic, Hermetic, Quabbalistic & Rosicrucian Symbolical Philosophy*) to be similar to the Freemasons. They are thought to have been great builders, reminiscent of the idea of the great builders who escaped India. The great builders of course were esteemed, because it was this guild of men that could divine the land and open up the portal to the Otherworld with their sacred geometric knowledge.

It was supposedly this secret society, under Hiram Abiff, that built the Temple of Solomon and erected the great brass pillars now seen as Boaz and Joachim in Masonry. They were also known as the Roman Collegia and were said to have wandered around like the Medieval Masons, building such fantastic places as the Temple of Diana at Ephesus (John Weisse, *The Obelisk and Freemasonry*.)

Weisse also points out that the Collegia influenced the Islamic building efforts, which were later to become a turning point in Western European architecture after the crusades and possibly via the Collegia's influence over the Templars amongst others.

These Collegia were also thought to have been known before the Romans in Greece and were said to have worshipped Bacchus. Some even believe that Jesus, when he mentions that he will rebuild the Temple, is pointing out that he too is of the Collegia. Also, considering the Masonic fascination with the Druids, there is little wonder that William Stukely believed them to have been the builders of Stonehenge and other ancient monuments. Many Masonic writers love to associate themselves with the Druids and that they, "had a high veneration for the Serpent. Their great god Hu, was typified by that reptile." George Oliver, *Signs and Symbols* (Macoy Publishing, New York.)

If it is true that the Dionysiac Architects and the Bacchus/Dionysius-worshipping Greek and Roman Collegia, were among the originators of the Freemasons, then it is highly likely that they were linked also with the serpent-worshipping Druids. They were all in fact a later showing of the world-wide serpent cult – the same as those in India, Egypt and elsewhere who all had fantastic building skills and held secrets of the Gateway. Today we can still see a remnant of this great architectural, serpent-worshipping and secretive cult in the Masons. As George Oliver points out, "The Serpent is universally esteemed a legitimate symbol of Freemasonry."

EIGHT

To quote from Tim Wallace-Murphy and Marilyn Hopkins in *Rosslyn*, "A number of great importance to the ancient Egyptians and the Knights

Templar." Including the preparatory Temple at Buhen, there are eight sacred sites in the Egyptian system. There are eight doors depicted in the allegorical symbolism of the Temple of Philae. Eight occurs frequently in European esoteric symbolism, especially that associated with the Templars. There are eight steps on the scala philosophorum, or "philosopher's ladder," depicted at Notre-Dame de Paris; there are eight points to the croix patte, the main badge of the Templar Order; the octagon is the basis for much of the geometry used to construct the round Templar churches as well as playing a significant role in the sacred geometry of Gothic architecture. Eight is also the symbolic number for resurrection, an important concept for initiation.

Without doubt the secret knowledge of the early Christian (and Islamic) and oriental Gnosticism took root within the Templars, as well as other Christian monastic orders. The number 8, therefore becoming of paramount importance to the sacred geometry and architectural structures that erupted around Europe. The Dome of the Rock, built by the Islamist's had eight equal walls within the boundary of the dome, holding it aloft. The Templars guarded this sacred building for ninety years and simply must have been influenced by Islamic Gnostic beliefs. From here, the Templars went back to Europe and built. They influenced thousands of buildings incorporating the number eight. These buildings were erected by compagnonnages (Les Compagnons des Devoirs du Tour de France) or early Masons, who would later on become the Freemasons and in Provence actually erected many of the Templar churches.

Tim Wallace-Murphy and Marilyn Hopkins in *Rosslyn* state that these "Children of Solomon" were instructed in sacred geometry by the Cistercian Monks – the same Cistercians who helped set up the Templars in the first place. Many, including the great Fulcanelli, believed that the Gothic architecture which came with these "new" Templar and Cistercian inspired building techniques, actually contained a three dimensional language known as "la langue verte" or the "green language." Green, as we have seen before is the 'special' colour of the serpent world. It is the Emerald Tablet and the Green Man; it is the language of initiation. No wonder then that Rosslyn Chapel has this green language from top to bottom. No

wonder that Rosslyn also has the language of immortality in the symbol of eight and the snake.

According to Hargrave Jennings in *Ophiolatreia*, the Egg is used as the phonetic sign for 8 and, "When combined with T, is the determinative of the female gender… placed close to a serpent in hieroglyphical legends."

LADY OF THE LAKE

There are various names attributed to the "Lady of the Lake;" Nimue and Vivienne are the two most used and most amazingly also as "White Serpent." Nimue is probably Mneme or Mnemosyne, who is one of the Muses or "water nymphs" from Roman and Greek mythology that gave out weapons as gifts from the Otherworld. Vivienne in all likelihood comes from Vi-Vianna or Co-Vianna the "water goddess" or Coventina of Celtic origin ("Coventina's Well" also had a skull offering discovered.) These water deities are strongly related to the story here of serpent worship, and united with the tale of the sword or weaponry, it introduces the duality of peace and war so well known in the serpent myths. The sword pierces and strikes and involves contemporaneously, the image of the serpent upon the blade via the unique metallurgy employed.

The water nymphs were universally seen as controlling the essential essence of life via their relationship with the healing waters, springs and lakes and their unique access to the treasures of the Otherworld.

Coventina was worshipped widely and it is highly likely that Morgan Le Fay is associated with her, as her name implies water nymph. There are also elements, which introduce her into the "Triple Goddess" of the Celtic religion and therefore relating her to Bridgid. She was a great goddess of healing; linked strongly with water nymphs – and in relation to the sword she was also a great smith.

She also owned an apple orchard, which relates nicely to Avalon. Her day is called Imbolc – 2nd February – but it is also known as Oimelc, Candlemas and in the USA as "Groundhog Day." This special event in the Amer-

ican calendar involves of course the mass killing of snakes, and relates to the tale of Bridgid's snake, which comes out of the mound from which it had been hibernating.

At Oimelc it is said that the singers cry, "The day of Bride, the birthday of spring, The serpent emerges from the knoll." And in winter, Scottish folk poems still speak of the serpent that dwells in the hillside (see Serpent Mound.)

As the "Lady of the Lake" forged Arthur's sword, so too the various parts of these ancient goddesses simply must have been collated together in the form of this Arthurian water goddess – a new deity forged.

These goddesses, all basically the same, are also related to Sibyl or the Sibillia who presides over witches; and in the Ukraine one of the names for "witch" actually means "snake," and in Russia it was believed that witches had snake tails. This sheds more light on the idea that witches mixed their famous brews and elixirs in their cauldrons, very much like the cauldron such as Gundestrup.

Sibillia has the "power over life' and touches baskets and bottles with her wand to restore them afresh. Sibillia taught magical arts in her serpent grotto where shape-shifting fairies reminiscent of the naginis (female serpents) of India emerge and dance around. These fairies are said to turn into snakes each Saturday. Anyone who wished to enter this Sybil Cave must love snakes or suffer the consequences. Sibillia is also seen in the Life of Robin Goodfellow as Sib, who speaks for the fairies. She says that they live in, "some great hill, and from thence we do lend money to any poore man or woman that hath need." In the 15th century, Perceforest has her as the "Lady of the Lake."

In Scottish myth one of these fairies lived inside a tree and often appeared holding a limpet shell containing the "milk of wisdom" which was called the "copan Moire" or "Cup of Mary" in her hands – an obvious allusion to the "life-giving" element of these snake, shape-shifters remembered in legend.

There are many other tales, which link these European snake shape-shifters to the Nagas of India. Like Melusine and Sibillia the Tante Arie loved to plunge into cool pools in her caverns of Milandre where she changed into a vouivre or serpent; bringing to mind the concept that the shapeshifting Nagas of India are said to reside in the underwater realms. Surely these ladies of ancient lore are folk memories of serpent worshipping leaders from the past. The Nagas were also said to have jewels in their foreheads, like many other serpents from legend. As if knowing this, the vouivre too wears a jewel in the middle of her forehead. The Nagas are also said to protect great treasure, so too do the ladies of European lore.

We know that the Scythians were great worshippers of the serpent from many sources – as in the bracelets found, which the women wore as symbols of fertility. The Scythians were intimately linked with the Naga, serpent worshippers of India via trade and war. They came to Europe via several means – one of them as hired hands of the Romans. Herodotus tells us of an account of the Scythian snake goddess who was mistress of the land where the Dniepr flowed into the Black Sea. This Scythian serpent goddess was also a cave dweller.

The xana serpent goddesses of Asturias even had a sacred and valuable chalice stolen by a human, only to eventually deposit the famed cup in a Church. These xana's kept their treasures in a "serpent cave" immersed in pools, remarkably like the Patala of the Nagas.

In Wales the serpents were said to emerge and congregate on Midsummer's Eve to blow into the Serpent Stones / Eggs or Glain Neidr which is reminiscent of Pliny's tale of this activity amongst the Gauls. The snakes are said to create eggs or alternatively "new life." In Wales these serpent stones were said to be coloured pebbles, which gave "second sight" and healing.

Midsummer's Eve was the night when the serpents would role themselves into hissing balls and create the glain egg, also known as "snake stone" or "Druid's egg." In Welsh myth even Merlin himself went in search of them.

163

Victor H. Mair of the University of Pennsylvania also points to the association between the Scythian and the Arthurian tales: "The Nart sagas [repositories of Scythian traditions] contain parallels with Arthurian legend so numerous and so uncannily close that it is impossible they are unrelated."

Interestingly, remains of these Scythians have been found on the Silk Road to China. Remains here of Caucasians dates back even before that and at present stand somewhere in the region of 3,000 years BC, with female Shaman being buried in full regalia, tattoos of spirals and zig zags and long finger nails. This in itself shows the widespread travel of these Scythians or those like them and the transport of ideas, possible many thousands of years ago.

MASONS

Freemasonry is a massive subject in its own right and no minor inclusion such as this can do it justice. However, I am always conscious of the proven link between the Templars, the Catholic Church and the origin of this secret society. Remember that the Templars did actually "escape" to Scotland and were well cared for there and so it is no surprise to find the Scottish Rite being of such profound importance.

In the symbolism of the regalia of the 25-degree of the Scottish Rite there are several images, which go back thousands of years and are related to the trail of the serpent. On the flap of the Apron is a serpent, coiled up in a circle and holding its tail in its mouth – a 4,000 year old Ouroborus. This is the symbol of immortality and enlightenment. As if to prove this point, the Scarab beetle is within the circle – the Scarab was an Egyptian symbol, also of immortality – and is often seen in the centre of serpentine circles in ancient Egypt.

The Jewel of the degree is an Ankh (the sign of Life) and originally the Aprons were tied so as to form an Ankh from the knot.

The cross bar on the Ankh has the word Nakhus or Nehushtan – the very word used for the "Brazen Serpent" of Moses. The circle of the Ankh is a serpent.

164

The 25-degree is all about the story of Moses and his Brazen Serpent from Exodus, as well as various other dying and reborn gods not necessarily with overtones of Christianity.

In some Masonic aprons (according to Wor. H. Mejj, a Mason in the USA,) the old fashion was to have a hook to tie it in the form of a snake.

It is also of interest to note that the Italian Fascists of history who hated the Masons actually called them "Serpente Verte" or "green snakes" as they were said to wear a green band on their arm in memory of the philosophical story, *The Green Snake* by Goethe; a story about a king who enters a mysterious temple to learn the truth of existence and life. This is a cloaked story of access to the Otherworld via the power of serpent energy.

Within the initiation rituals of the Freemasons, and Knights Templars, there is a peculiar ritual, which is linked with the use of the skull:

The Mason kisses a skull seven times and takes an oath requesting that the spirit that inhabits the skull should testify against his own wrong doings. Indeed, should the Mason ever do anything wrong then he is supposed to have his skull lopped off so that his brain is exposed to the sun. This is reminiscent of the myth that Set lopped off the great serpent, Apep's head with a knife – an astronomical statement of the sun defeating the moon, good over evil. Apep is the serpent, and it is his head, which is sliced off to save the world.

In Rosslyn, above the most important place where the Altar would normally be (which is not there in the case of Rosslyn) there is an image of a man's head, with the skull lopped off. The position at the Altar place indicates the importance of the head – was this somebody who had sinned?

MESSIAH – COMPARISONS

There are many similarities between the various "messiahs" that the world has known and it is my view that they all emanate from one original and serpent cult source and are all depicting the true position of enlightenment that we can all attain – we can all be son's of god.

Buddha was born of the virgin Maya who was known as the "Queen of Heaven" on December 25th.

Jesus was born of the Virgin Mary, also known as the "Queen of Heaven," on December 25th in a cave or manger.

Horus was born of the virgin Isis-Meri on December 25th. Isis-Meri is also known as Mata-Meri or Mother Mary.

Mithra was born to a virgin on December 25th and in a cave or manger; also announced by a star and three wise men.

Chrishna was born of the virgin, Devaki. This goddess or 'Queen of Heaven' is known as Isis, Astarte, Asherah, Marratu, Marah, Mariham. In fact the Semites knew her as Mari-El or Mary God or indeed shining Mary. Chrishna's most beloved disciple was known as Arjuna or Ar-jouan (John.) Anup or Aan (John) the Baptizer baptized Horus, and John baptized Jesus. Both Anup and John the Baptist were decapitated.

Buddha performed miracles and healed the sick, as did most of the others. Horus had twelve disciples like Christ and Mithra. Buddha was transfigured on a mountain like Christ and Horus. They all ascended into heaven. Buddha was sacrificed for three days and was then resurrected like Jesus. Horus was crucified, buried in a tomb and then resurrected.

Mithra (buried in a tomb and then resurrected three days later.)

Chrishna (crucified between two thieves on a tree, then rose from the dead and ascended to heaven) – as did Prometheus.

The idea of being resurrected after three days has strong links to astronomy. The stone monuments of the world are also linked to astronomy and the serpent. The 12 disciples are the 12 zodiac signs and months and of course, the snake, seen as the Ouroboros is in control of the signs – just like Christ, who controls and guides the disciples. But the snake is seen, not just in control of the stars, but also as the sun and the moon – basi-

cally, the serpent is seen as the most powerful of the cosmic entities.

In December the sun makes a descent southward until 21st or 22nd December, which is then termed the "Winter Solstice." It stops then for three days and begins to move back again northwards – it is resurrected. As the serpent and the sun are linked together in symbolism of new and regenerative power then there is no surprise to find this correlation.

Being born of a virgin implies the knowledge that the calendar began whilst in the constellation of Virgo. As the sun, the various messiahs are the "sun" of god and are the "light of the world." The Hindi word "Kris" actually means sun and it is from this root that the word Chrishna and Christ are derived. In fact Chrishna was known as "Jezeus" or "pure essence" and centuries before Jesus Christ.

The sun has a corona or horned crown, like the horns and the crown of thorns of Jesus and Chrishna. Most of these remarkable and ritualistic "sons of god" are come of age at 30 and there is no surprise to find that the sun enters into each zodiacal sign at 30 degrees.

Even the language barrier is overcome when we find that Buddha was considered the good shepherd, carpenter, savior and light of the world. Horus was known as "the way, the truth and the light" – again, like Jesus. Also as God's anointed, "the messiah," the "lamb of god," "the word," "the good shepherd," "the fisher," "the son of god" – Horus was also known as the "KRST" or Christ. (There are in fact many depictions of Horus at his virginal mother's breast, looking exactly like Jesus and Mary. Horus also raised "El-Azar-us" or "El-Osiris" from the dead, just as Christ was to raise "Lazarus." This story in itself is an allegory of the sun god Osiris being reborn.

There are others who match those similarities seen above. Dionysius for instance, rode on a triumphant ass. He was sacrificed as the Dendrites or Young man on the tree and eaten in a sacred Eucharist. He turned water into wine; given the title king of kings and rose from the dead. His cult actually entered Jerusalem around the time of Christ and was indeed thought

to have been worshipped by the Jews. His symbol was IHS, a symbol still used by Christians. He was called Iasius in Crete, which is an equivalent to Iesu or Jesus.

Mithra, like Jesus, has his principal festival at Easter when he was resurrected and he had a Eucharist like Jesus.

In Phrygia the god Attis was crucified on a tree – a day known as "Black Friday." He was born on December 25th to a virgin named Nana. He had a Eucharist of bread as his body and was called the Son of God. After three days in the "underworld" of hell he ascended as god.

They are all basically descended from royal lineage and were generally wealthy. We know from looking around the folklore as well as these religious similarities that this royal lineage generally meant that they were descended from serpents or dragons. Jesus was of the line of David; Buddha the son of a Raj, and Chrishna descended of royal stock. They all are involved in some kind of trinity, as are many other faiths.

Chrishna, Buddha and Jesus all are "dragon slayers" – they all "crush the head of the serpent." To all, the serpent is an emblem symbolical of 'wisdom.' To all, the serpent is intricately linked to their entire myth as a symbol of healing and is highly beneficent. And to all, yet again, the serpent is linked to the Elixir.

The Christian Church who has destroyed much of it over the past 1,500 years jealously guarded most of this information. The very messiahs of the globe were written over. Even Buddha became a Christian saint as St. Josaphat, taken from the Buddhist title, Bodhisat.

Christianity as a literal truth is now so heavily entrenched in the culture of the west that there is almost no attempt made to put the record straight. Recent television documentaries prove that the idea of the Christian story is still seen today as being literally true, and these are documentaries made by Journalists on the BBC! The fact remains that the story is widespread and is an astronomical, serpent-oriented device for symbolical immortality

– the knowledge of ones own immortality through access of the Other-world.

SERPENT MOUNDS

The evidences of serpent worship in the Americas can largely be shown via the many serpent mounds that appear across the continent. The most famous by a long way is the "Serpent Mound" of Ohio, Adams County. However, most people are not aware that similar mounds also appear elsewhere.

In 1871 at the meeting of the British Association in Edinburgh, a certain Mr. Phene gave an account of his discovery in Argyllshire of a similar mound, "several hundred feet long, fifteen feet high and thirty feet broad."

The tail tapered away, while a circular cairn, which he presumed to be the solar disk above the head of the "Egyptian uraeus", surmounted the head. Indeed this is not a "one off," In the Zend Avesta one of the heroes takes a rest on what he thinks is a bank – only to find out that it was a green snake. Iphicrates related that in Mauritania, "There were dragons of such extent that grass grew up on their backs." Thus showing the highly, likely chance that tales of massive dragons in far-off lands could easily be Serpent Mounds. Again, the Egg becomes important in these mounds as a symbol of "new life."

Other instances of Serpent Mounds are found mentioned by Strabo (*Lib xv.* P.1022) where two dragons are said to have resided in the mountains of India, one eighty cubits long and the other one hundred and forty.

Posidonius also tells of one in Syria, which was so large that horse riders on either side could not see each other. Each "scale" was as big as a shield, so that a man "might ride into his mouth." Bryant concurs with the belief that these must be ruins of Ophite temples, Syria with Hivites or Ophite influence, and India with Naga. And what were these Temples used for?

In ancient Egyptian papyri and in the Mesoamerican, codex borgia there are instances of the King entering the serpent and going through it in-order

to be resurrected – much like those we find in the myth of Osiris.

A book said to have been written by Votan (*Quetzalcoatl*) in the language of the Quiches and thought to have been in the possession of Nunez de la Vega, the Bishop of Chiapas, has some revealing elements – so revealing that the Bishop tried to burn it. Votan says he left Valum Chivim (chivim is a Hebrew word, meaning "sons of the female serpent" (or Eve) and may imply a greater knowledge of this journey from a Judaic perspective) and came to the New World to apportion land among seven families who came with him and were said to be culebra or of serpent origin. These chivim could possibly be the Nephilim of the Bible. Passing the "land of thirteen snakes" he arrived in Valum Votan, founding the city of Nachan (City of Snakes), thought to be Palenque, and possibly around 15 BC or even earlier. Votan is said to have made four trips to the east and even to have visited Solomon.

Interesting to Serpent Mounds however is the description of a subterranean passage, which is said to terminate at the root of "heaven." This was called a "snake's hole" and Votan was only allowed in because he was the son of a snake. Surely this can only mean that Votan was an initiate in the serpent cult and that there was a ritualised Serpent Mound or pyramid which led to snake heaven or Patala.

Upon his return, Votan built temples according to the style. He built a temple called the "house of darkness" at Huehueta and placed in there a great treasure. This treasure was said to consist of jars closed with covers of clay. What was in these jars nobody knows, but interestingly Egyptian canopic jars were known to have heads on them.

The Fenian heroes of ancient Ireland are recorded orally in song and one of them, Fionn, was their "dragon slayer." One of the legends tells us that: "It resembles a great mound, its jaws were yawning wide; There might lie concealed, though great its fury, A hundred champions in its eye-pits. Taller in height than eight men, Was its tail, which was erect above its back; Thicker was the most slender part of its tail, Than the forest oak which was sunk by the flood."

Fionn asked where this great monster had come from and was told, "From Greece, to demand battle from the Fenians." It seems that the serpent worshippers had come to Ireland, believed to be from Greece, and had fought the ancient inhabitants, leaving behind such terror of them that they became symbolized as this great "dragon mound." Fionn, it is said, opened the side of the dragon and released the men, going on to kill it. It may be that there is a mixture of wartime fact built in with ritualistic truth in this legend. Emerging from the side of the dragon, as in other myths, gives new life.

The Serpent mound at Ach-na-Goul near to Inverary proves the spread of the Irish serpent worshippers into Scotland.

SISTRUM

An Egyptian musical instrument closely associated with female gods – especially Hathor the serpent/cow goddess and Isis – the consort of Osiris.

In form, very much like the Ankh (see Ankh) with a loop at the top – also representing the egg – and three serpents striking through the loop with small square pieces of metal, which rattle. It's possible these three serpents represent the two serpent channels and the central axis of the spine to create the divine spark (or in this case music) in the centre of the skull.

During the ascent of these serpent energies up the spine to the centre of the head, the individual while going through this enlightenment process, will hear sounds similar to the sounds the Sistrum makes – i.e., rattle sounds like tambourine bells and sounds like a bell-tree being stroked. One will also hear sounds like a "rattle snake" and also whistles and flute-like instruments.

Underlying these sounds is a very low and strong rumbling sound which fades-in at first and gets louder and louder as the process proceeds culminating in the bright, white light explosion in the centre of the head. The Sistrum then may have been a symbol of this experience.

The Sistrum was used in pictures and carvings to show the various gods and Pharaohs subduing the power of a particular god – and mostly because the god holding the Sistrum had the "power" and "energy" to do so through having had the enlightenment experience.

SPIRALS AND ROCK ART

Spirals and carvings of snake energy are seen all over the world, much like the cult of the serpent. And, it is always found to be in association with the serpent worship. According to J.C. Cooper in *An Illustrated Encyclopedia of Traditional Symbols*, the spiral "typifies the androgyne and is connected with the caduceus symbolism" which is of course the symbol of serpent healing. In Australia Robert Layton in *Australian Rock Art: a New Synthesis,* (Cambridge University Press) points out the serpent origins of these images; images, which are always seen with other serpentine shapes. Figure three in Layton's book shows these images clearly as "a snake entering a hole," "a snake leaving a hole."

Remembering that the Ouroborus, the circular image of the snake eating its own tail, is an image of immortality, we should also remember the antiquity of the device. Along side spirals are circles like the Ouroborus, called often cup and ring marks. There are also zigzags, thought by many to be the fiery aspect of the serpent, and waves, showing the fluidity of the serpent - something also related to the symbolism of Water. It is no surprise that such images of the snake, in all its relative forms should be seen on the most ancient of rock art. In the cup and ring marks there are many images of what appears to be a serpent entering the cup and rings. Some have put this down to a serpent entering a hole, others that it is eating an egg; nobody is sure. What it does show is a serpent head towards a cup or an opening. This "opening" is at the centre of concentric circles, much akin to the tales of Atlantis or images of meditation devices created on the ground by aboriginal peoples in New Zealand and Australia.

The spirals have also been associated with astronomical alignments. This can especially be seen in the work of N L Thomas in *Irish Symbols of 3500 BC* where the spiral running right to left is seen as the winter sun; the spiral running left to right is the summer sun and the double spiral as

the spring and autumn equinox. There is little doubt from the work carried out by Thomas that this is true, but the fact remains that the ancients were using symbols of the serpent in their astronomical alignments. This is matched by the fact that the serpent was seen in the sky, in various constellations and by the serpent encompassing the heavens. The two elements cannot be split apart – this was a unified theory of life and it was created by, given life by and kept fertile by the snake.

In Eurasia and Japan there are definite images of snakes as spirals. In earthenware from the middle Jomon period (approx 2000 BC) of Japan these can be seen quite clearly, and are said to be there to protect the contents of the jar from harm; something important was obviously in them. Clay figures from the same period also show wound snakes on the heads. These spirals became part of family crests and transformed over time into the Yin and Yang symbol of duality so popular today. These family symbols are called Kamon and one class of them particularly is called Janome, which basically means eye of the snake. Characters for snakes in Chinese became part of the alphabet over 3000 years ago. Another interesting point about the snake in China is that the Rainbow is said to be the snake elevated into the sky much like the Australian Rainbow Serpent. Indeed, the Chinese character for Rainbow reflects this position as it has the symbol of the snake within it.

In Peru there is pottery with spirals ending in snakes heads. In Taiwan there is a sculptured door with spirals ending in snakes heads. In many Celtic stone monuments there are similar images – all leading to the now beautiful and ornate Celtic Knot-work.

WATER

Geoffrey Ashe in *The Ancient Wisdom* says:

"According to one theory, all primordial serpents of myth are derived from a Sumerian Arch-Serpent in Subterranean waters, whose name was Zu."

"Water" – as we have seen – is the home of the serpent spirit. And water serpents are generally healers. For instance in a lagoon near Gimbo Am-

buri in Africa there was a serpent, which would cure "madness," and in an Algerian well there was a serpent deity taken over by a Muslim Saint, which was said to cure sore eyes. This links with the ideas once prevalent in Palestine and Syria that the waters were often associated with the annual Rajab festivals, which honour the serpent that resides in the holy waters.

The Naga of India were also said to live beneath the waters in Patala, and they were expert healers. And springs such as Ephca in Palmyra were named after the serpent deity residing there. In Greek myth, the serpentine god Poseidon, and the serpent Typhon, were water and spring deities with many watery places taking on their names. Even in the Temples of Aesculapius we find the pools of healing; a healing which is directly associated with the serpent.

This element of the "healing serpent within the water" simply crossed over into the water itself, and thereafter the water became the healing element. Added to this the concept that water was seen as the portal (hence Patala and Atlantis) to the otherworld and we have an association of the "water of the gods" healing mankind.

Beneath the Temple in Jerusalem there is the "Serpent Pool" or "Dragon Pool." What it was for? Nobody is quite sure. It may be that here lay the Hebrew secret of the "healing water" in the name "serpent." This is the "upper pool," called today, the Birket-el-Mamilla. It is the "dragon well" of Nehemiah 2:13 and the "serpent pool" of Josephus War V. 3 & 2.

This pool, which lies in the north west of the city (although the exact location is heavily debated,) was later renamed the "pool of Hezekiah" by the serpent-bashing king himself.

The Essene, were said to have used pools to heal and they are connected to the healing serpent in many ways. It may indeed be that Baptism has its root in this idea of the serpent healer – being "born again" to new and eternal life by being submerged into the waters of the serpentine Otherworld. An indication that this may be true is found in the fact that baptism

has its roots in other ancient societies such as India. Here, the initiate was dipped three times (like the "three day death of the sun" – see Messiah Comparisons) into the sacred waters. The dove aids baptism as well as it comes down on the hierophant and adds the regenerative aspect as the Holy Spirit. Where "full submersion" was impossible due to arid climates, then sprinkling of either water or blood would suffice.

In Greece they even kept a Holy Vessel, which carried the sacred waters of the healing serpent.

The Egyptian Horus was baptised by Anu the Baptizer and so the origin of Baptism is much older than we previously understood. And as we can see it is firmly rooted in civilisations, which are central to the development of the serpent-worshipping cult – namely Egypt and India.

A larger version of this basic "truth" is seen in the story of the flood.

In Indian lore the many-headed serpent, Vishnu, tells Manu about the coming deluge and so saves mankind from certain death – only to be symbolically reborn again after the deluge and from the waters. It is the serpent, which has the powers to create the chaos of the flood, and the serpent, which can save – in the same way that it has the venom to kill, and the venom to cure.

Surely, associating the serpent upon sarcophagi and funeral items brings the idea out, that it is the power of the serpent, which will once again bring new life, whether in this world or the next and to the person contained within.

In Bali the Naga serpent worshippers even burn a serpent with their dead to give him or her new life after death. The place that many great legendary figures go to after or near death is often across the waters to a place where the fairies or "serpent spirits" reside. They are given life eternal via the snake. It is only after the power of the snake has left you that your life ends, as Porphyry related that when Plotinus died, a snake emerged from beneath his bed – the snake had left and taken his protection away.

Abdalqadir as-Sufi, Shaykh, The Return of the Kalifate, Madinah Press, 1996

Ableson, J., Jewish Mysticism, G Bell and Sons Ltd.

Andrews, R., and Schellenberger, P., The Tomb of God, Little, Brown and Co, 1996

Appollodorus, The Library – Greek Mythography 2nd Century BC.

Ashe, Geoffrey, The Quest for Arthur's Britain, Paladin, 1971

Bacher, Wilhelm & Blau, Ludwig, Shamir, Publisher unknown.

Baigent, Ancient Traces, Viking, 1998.

Baigent, Leigh, The Elixir and the Stone, Viking, 1997.

Baigent, Leigh, Lincoln, The Holy Blood and the Holy Grail, Jonathan Cape, 1982.

Baigent, Leigh, Lincoln, The Messianic Legacy, Arrow, 1996.

Baigent, Michael, Leigh, Richard, The Dead Sea Scrolls Deception, Arrow, 2001.

Baigent, Michael, Leigh, Richard, The Temple and the Lodge, Arrow, 1998.

Balfour, Mark, The Sign of the Serpent, Prism, 1990.

Balfour, Michael, Megalithic Mysteries, Parkgate Books, 1992.

Barber, Malcolm, The Trial of the Templars, Cambridge University Press, 1978.

Barrett, David V., Sects, Cults and Alternative Religions, Blandford, 1996.

Barrow, John D., Theories of Everything, Virgin. 1990.

Basham, A.L., The Wonder that was India, Fontana Collins, 1954.

Bayley, H., The Lost Language of Symbolism, Bracken Books, 1996.

Bauval, R., The Orion Mystery, Heinemann.

Beatty, Longfield, The Garden of the Golden Flower, Senate, 1996.

Begg, E., The Cult of the Black Virgin, Arkana, 1985.

Begg, E. & Begg. D., In Search of the Holy Grail and the Precious Blood, Thorsons, 1985

Blaire, Lawrence, Rhythms of Vision, Warner Books, New York, 1975.

Blavatsky, H.P., Theosophical Glossary, R. A. Kessinger Publishing Ltd, 1918

Borchant, Bruno, Mysticism, Weisner, 1994.

Bord, Janet and Colin, Earth Rites: Fertility Practices in Pre-Industrial Britain, Granada Publishing, London.

Bouquet A.C., Comparative Religion, Pelican, 1942

Boyle, Veolita Parke, The Fundamental Principles of Yi-King, Tao: The Cabbalas of Egypt and the Hebrews, W & G Foyle, 1934.

Brine, Lindsey, The Ancient Earthworks and Temples of the American Indians, Oracle, 1996.

Broadhurst, Paul, and Miller, Hamish, The Dance of the Dragon, Mythos, 2000.

Bryant, N., The High Book of the Grail, D S Brewer, 1985.

Bryden, R., Rosslyn – a History of the Guilds, the Masons and the Rosy Cross, Rosslyn Chapel Trust, 1994.

Budge, E. A. Wallis, An Egyptian Hieroglyphic Dictionary Volume 1, Dover Publications, 1978.

Butler, E.M., The Myth of the Magus, CUP.

Callahan, Philip, S., Paramagnetism: Rediscovering Nature's Secret Force of Growth, Acres, USA 1995.

Callahan, Philip, S., Ancient Mysteries Modern Visions: The Magnetic Life of Agriculture, Acres, USA, 2001.

Callahan, Philip, S., Nature's Silent Music, Acres, USA, 1992

Ceram, C. W., Gods Graves and Scholars: The Story of Archaeology, Victor Gollancz & Sidgwick and Jackson, 1954.

Coles, John, Field Archaeology in Britain, Methuen, 1972.

Campbell, Joseph, Transformations of Myth Through Time, Harper and Row, 1990

Cantor, N.F., The Sacred Chain, Harper Collins, 1994.

Carr-Gomm, Sarah, Dictionary of Symbols in Art, Duncan Baird Publishers, 1995.

Cavendish, Richard, Mythology, Tiger, 1998.

Carpenter, Edward, Pagan and Christian Creeds: Their Origin and Meaning, Allen and Unwin Ltd, 1920.

Castaneda, Carlos, The Teaching of Don Juan, Arkana.

Childress, David (Editor), Anti-Gravity & The World Grid, Adventures Unlimited Press, 1987

Chadwick, N., The Druids, University of Wales Press.

Churchward, Albert, The Origin and Evolution of Religion. Publisher unknown.

Churton, Tobias, The Golden Builders, Signal Publishing, 2002.

Cicero, De Senectute. Publisher unknown.

Clarke, Hyde and Wake, C. Staniland, Serpent and Siva Worship, R. A. Kessinger Publishing Ltd, 1877.

Collins, Andrew, Twenty-First Century Grail: The Quest for a Legend, Virgin, 2004.

Collins, Andrew, From the Ashes of Angles, The Forbidden Legacy of a Fallen Race, Signet Books.

Collins, Andrew, Gods of Eden, Headline, 1998

Collins, Andrew, Gateway to Atlantis, Headline, 2000.

Cooper, J.C., An Illustrated Encyclopaedia of Traditional Symbols, Thames and Hudson, 1978.

Croker, Thomas Crofton, Legend of the Lakes, out of print and publisher unknown.

Crooke, W., The Popular Religion and Folk-lore of Northern India, R. A. Kessinger Publishing Ltd.

Cumont, F., The Mysteries of Mithra, Dover Publications.

Currer-Briggs, N., The Shroud and the Grail; a modern quest for the true grail, St Martins Press.

David-Neel, Alexandria, Magic and Mystery in Tibet, Dover Publications.

Davidson, H. R. Ellis, Myths and Symbols of Pagan Europe, Syracuse University Press.

Davidson, John, The Secret of the Creative Vacuum, The C. W. Daniel Company Ltd, 1989

De Martino, Ernesto, Primitive Magic, Prism Unity, 1972.

Devereux, Paul, Secrets of Ancient and Sacred Places: The World's Mysterious Heritage, Beckhampton Press, 1995.

Devereux, Paul, Shamanism and the Mystery Lines, Quantum, 1992.

Devereux, Paul, Symbolic Landscapes, Gothic Image, 1992.

Dinwiddie, John, Revelations – the Golden Elixir, Writers Club Press, 2001.

Dodd, C.H., Historical Tradition of the Fourth Gospel, Cambridge.

Doel, Fran and Geoff, Robin Hood: Outlaw of Greenwood Myth,

Temous, 2000.

Duckett, Shipley, Eleanor, The Gateway to the Middle Ages, Monasticism, Ann Arbor Paperbacks – the University of Michigan Press, 1961.

Dunstan, V., Did the Virgin Mary Live and Die in England?, Megiddo Press.

Davies, Rev. Edward, The Mythology and Rites of the British Druids, publisher unknown.

Devereux, Paul, Places of Power: measuring the secret energy of ancient sites, Blandford

Devereux, Paul, Thompson, Ian, Ley Guide: The Mystery of Aligned Ancient Sites, Empress

Dunford, Barry, The Holy Land of Scotland: Jesus in Scotland and the Gospel of the Grail, Sacred Connections, 2001.

Eliade, Mircea, Shamanism: Archaic Techniques of Ecstasy, Princeton University Press.

Ellis, Ralph, Jesus, Last of the Pharaohs, Edfu Books, 2001

Epstein, Perle, Kabbalah: The Way of the Jewish Mystic, Shambhala Classics, 2001

Ernst, Carl H., Venomous Reptiles of North America, Smithsonian Books.

Evans, Lorraine, Kingdom of the Ark, Simon and Schuster, 2000.

Feather, Robert, The Copper Scroll Decoded, Thorsons, 1999.

Fedder, Kenneth L., Park, Michael Alan, Human Antiquity: An Introduction to Physical Anthropology and Archaeology, Mayfield Publishing Company, 1993.

Ferguson, Diana, Tales of the Plumed Serpent, Collins and Brown, 2000.

Fergusson, Malcolm, Rambles in Breadalbane, 1891 publisher unknown

Fontana, David, The Secret Language of Symbols, Piatkus, 1997.

Ford, Patrick K, The Mabinogi and other Medieval Welsh Tales, University of California Press.

Fortune, Dion, The Mystical Qabalah, Weiser Books, 2000

Foss, Michael, People of the First Crusade, Michael O'Mara Books, 1997.

Frazer, Sir James, The Golden Bough, Wordsworth, 1993.

Freke, Timothy, Gandy, Peter, Jesus and the Goddess, Thorsons, 2001.

Gardner, Laurence, Bloodline of the Holy Grail, Element, 1996.

Gardiner, Philip, The Shining Ones, www.radikalbooks.com, 2002.

Gardiner, Philip, Proof – Does God Exist? www.radikalbooks.com, 2001.

Gardiner, Samuel R., History of England, Longmans, Green and Co., 1904.

Gascoigne, Bamber, The Christians, Jonathan Cape, 1977.

Gerber, Richard, Vibrational Medicine, Bear & Company, 2001

Gilbert, Adrian, Magi, Bloomsbury, 1996.

Goldberg, Carl, Speaking With The Devil, Viking, 1996.

Gould, Charles: Mythical Monsters, Senate, 1995.

Graves, Robert, The Greek Myths: 2, Pelican, 1964.

Gray Hulse, Tristan, The Holy Shroud, Weidenfeld and Nicolson, 1997.

Guenther, Johannes Von, Cagliostro, William Heinemann, 1928.

Hagger, Nicholas, The Fire and the Stones, Element, 1991.

Hanauer, J.E., The Holy Land, Senate, 1996.

Hancock, Graham, The Sign and the Seal, Arrow, 2001

Halifax, Joan, Shaman: the Wounded Healer, Crossroad, Thames and Hudson.

Harbison, Peter, Pre-Christian Ireland, Thames and Hudson, 1988.

Harrington, E., The Meaning of English Place Names, The Black Staff Press.

Hartmann, Franz, The Life of Jehoshua The Prophet of Nazareth: an occult study and a key to the Bible, Kegan, Trench, Trubner & Co, London, 1909.

Harvey, Clesson, The Great Pyramid Texts, (website article – www.pyramidtexts.com)

Heathcote-James, Emma, They Walk Among Us, Metro, 2004.

Hedsel, Mark, The Zelator, Century, 1998.

Howard, M., The Occult Conspiracy, Hutchinson.

Howard, Michael, a paper entitled The Womb of Ceridwen.

James, E.O., The Ancient Gods, Weidenfeld and Nicolson, 1962.

Jennings, Hargrave, Ophiolatreia. Kessinger Publishing. Year unknown.

Johnson, Buffie, Lady of the Beast: the Goddess and Her Sacred Animals, publisher unknown, 1988

Jones, Alison, Dictionary of World Folklore, Larousse, 1995.

Josephus, Antiquities, Indypublish.com

Kauffeld, Carl, Snakes: The Keeper and the Kept, Doubleday and Co., 1969

Kendrick, T. D., The Druids, Methuen and Co., 1927.

King, Serge Kahili, Instant Healing: Mastering the Way of the Hawaiian Shaman Using Words, Images, Touch, and Energy, Renaissance Books, 2000

Knight, Christopher, Lomas, Robert, Uriel's Machine: Reconstructing the Disaster Behind Human History, Arrow, 2004.

Knight, Christopher, Lomas, Robert, The Second Messiah, Arrow, 1997.

Laidler, Keith, The Head of God, Orion, 1999.

Laidler, Keith, The Divine Deception, Headline, 2000.

Lapatin, Kenneth, Mysteries of the Snake Goddess, Houghton Mifflin Company, 2002.

Layton, Robert, Australian Rock Art: a new synthesis, Cambridge University Press.

Larson, Martin A., The Story of Christian Origins, Village, 1977.

Leakey, Richard and Lewin, Roger, Origins Reconsidered, TSP.

Le Goff, Jacques, The Medieval World, Parkgate Books, 1997.

Lemesurier, Peter, The Great Pyramid Decoded, Element, 1977.

Leone, Al, The Totality of God and the Izunome Cross – Unlocking the Secret Riddle of the Ages, unpublished at time of writing this but can be read in full at www.gizapyramid.com/Leone1.htm

Levi, Eliphas, Transcendental Magic, Tiger Books, 1995.

Lincoln, Henry, Key to the Sacred Pattern, The Windrush Press, 1997.

Loye, David, An Arrow Through Chaos: how we see into the future, Inner Traditions International, 1983.

Lyall, Neil and Chapman, Robert, The Secret of Staying Young, Pan, 1976.

MacCana, Proinsias, Celtic Mythology, Hamlyn

Mack, B.L., The Lost Gospel, Element, 1993.

Maclellan, Alec, The Lost World of Agharti, Souvenir Press, 1982.

Magin, U. The Christianisation of Pagan Landscapes, in The Ley Hunter No. 116, 1992.

Mann, A.T., Sacred Architecture, Element.

Maraini, Fosco, Secret Tibet, Hutchinson, 1954.

Matthews, John, Sources of the Grail, Floris Books, 1996.

Matthews, John, The Quest for the Green Man, Godsfield Press, 2001.

Maby, J. C., Franklin, T. Bedford, The Physics of the Divining Rod, Bell, 1977

McDermott, Bridget, Decoding Egyptian Hieroglyphs, Duncan Baird Publishers, 2001.

Meij, Harold, The Tau and the Triple Tau, H.P. Tokyo Chapter 1, 2000.

Michell, John, Rhone, Christine, Twelve-Tribes and the Science of Enchanting the Landscape, Phanes PR

Milgrom, Jacob, The JPS Torah Commentary: Numbers New York: Jewish Publication Society, 1990

Moncrieff, A. R. Hope, Romance & Legend of Chivalry, Senate, 1994.

Morgan, Gerald, Nanteos: A Welsh House and its Families, Gomer, 2001.

Morton, Chris, and Thomas, Ceri louise, The Mystery of the Crystal Skulls, Element, 2003.

Muggeridge, Malcolm, Jesus, Collins, 1975.

Newton. Janet, Ancient Board Games (web article 2001)

Nilsson, M. P., The Minoan-Mycenaean Religion and Its Survival in Greek Religion, Lund, 1950.

Oliver, George, Signs and Symbols, Macoy Publishing .

O'Brien, Christian and Barbara Joy, The Shining Ones, Dianthus Publishing Ltd.

Oliver, Rev. George, The History of Initiation, R. A. Kessinger Publishing Co, 1841

O'Neill, John, Nights of the Gods, publisher unknown.

Opponheimer, Stephen, Eden in the East, Phoenix Mass Market Publications.

Orofino, Giacomella, Sacred Tibetan Teachings on Death and Liberation, Prism-Unity, 1990.

Pagels, E., The Gnostic Gospels, Weidenfeld and Nicolson.

Paterson Smyth, J. How We Got our Bible, Sampson Low.

Pennick, N, Sacred Geometry, Wellingborough, 1994

Picknett, Lynn, Prince, Clive, The Templar Revelation, Corgi, 1998.

Piggot, Stuart, The Druids, Thames and Hudson

Pike, Albert, The Morals and Dogma of Scottish Rite Freemasonry, L.H. Jenkins, 1928.

Plichta, Peter, God's Secret Formula, Element, 1997.

Plunket, Emmeline, Calendars and Constellations of the Ancient World, John Murray, 1903.

Powell, T.G.E., The Celts, Thames and Hudson

Rabten, Geshe, Echoes of Voidness, Wisdom Publications, 1983.

Radin, Dean, The Conscious Universe, Harper Collins, 1997.

Randles , Jenny and Hough, Peter, Encyclodepia of the Unexplained, Brockhampton Press. 1995

Read, Piers Paul, The Templars, Phoenix, 1999.

Rees, Alwyn and Brynley, Celtic Heritage, Thames and Hudson

Reid, Howard, Arthur - The Dragon King, Headline, 2001.

Reid, Howard, In Search of the Immortals: Mummies, Death and the Afterlife, Headline, 1999.

Richet, C., Thirty Years of Psychic Research, 1923 (publisher unknown).

Rinbochay, Lati, Rinbochay, Locho, Zahler, Leah, Hopkins, Jeffrey, Meditative States in Tibetan Buddhism, Wisdom Publications, 1983.

Rohl, David, A Test of Time: The Bible – from Myth to History, Arrow, 1995.

Roberts, Alison, Hathor Rising: The Serpent Power of Ancient Egypt, Northgate, 1995.

Roberts, J.M., The Mythology of the Secret Societies, Granada.

Roberts, J.M. Esq,. Antiquity Unveiled, Health Research, 1970

Robertson, J. M., Pagan Christs, Watts, 1903.

Rolleston, T. W., Myths and Legends of the Celtic Race, Mystic P, 1986.

Russell, Peter, The Brain Book, Routledge, 1980

S, Acharya, The Christ Conspiracy: the greatest story ever sold, AVP, 2003.

Schaya, Leo, The Universal Meaning of the Kabbalah, University Books, 1987.

Schele, Linda, Miller, Mary Ellen, The Blood of Kings: Dynasty and Ritual in Maya Art, George Braziller, 1992.

Scholem, Gershom G., On the Kabbalah and It's Symbolism, Routledge & Kegan, London, 1965.

Schonfield, Hugh, Essene Odyssey, Element, 1984.

Schonfield, Hugh, The Passover Plot, Hutchinson, 1965.

Schwartz, Gary, Russek, Linda, The Living Energy Universe, Hampton Roads Publishing, 1999

Scott, Ernest, The People of the Secret, The Octagon Press, 1983.

Seife, Charles, Zero: The Biography of a Dangerous Idea, Souvenir Press, 2000

Seligmann, Kurt, The History of Magic, Quality Paperback Book Club, New York, 1997.

Signs, Symbols and Ciphers, New Horizons.

Simpsonb, Jacqueline, British Dragons, B. T. Batsford and Co, 1980.

Sinclair, Andrew, The Secret Scroll, Birlinn, 2001.

Sharper Knowlson, T., The Origins of Popular Superstitions and Customs, Senate, 1994.

Smith, M., The Secret Gospel, Victor Gollancz.

Snyder, Louis L., Encyclopaedia of the Third Reich, Wordsworth, 1998.

Spence, Lewis, Introduction to Mythology, Senate, 1994.

Spence, Lewis, Myths and Legends of Egypt, George Harrap and Sons, 1915.

Stephen, Alexander M., The Journal of American Folklore, January/March, 1929.

Stone, Nathan, Names of God, Moody, 1944.

Sullivan, Danny, Ley Lines, Piaktus, 1999.

Talbot, Michael, The Holographic Universe, Harper Collins, 1991/1996.

Taylor, Richard, How to Read a Church, Random House, 2003.

Temple, Robert, The Crystal Sun, Arrow, London.

Temple, Robert, Netherworld: Discovering the Oracle of the Dead and Ancient Techniques of Foretelling the Future, Century, 2002.

Thiering, Barbara, Jesus The Man, Doubleday, 1992.

Thiering, Barbara, Jesus of the Apocalypse, Doubleday, 1996.

Thomson, Ahmad, Dajjal the Anti-Christ, Ta-Ha Publishers Ltd, 1993.

Thomson, Oliver, Easily Led: A history of Propaganda, Sutton Publishing, 1999.

Toland, John, Hitler, Wordsworth, 1997.

Tolstoy, Nikolai, The Quest for Merlin, Little, Brown and Co.

Tull, George F., Traces of the Templars, The Kings England Press, 2000

Vadillo, Umar Ibrahim, The Return of the Gold Dinar, Madinah Press, 1996.

Villars, de, Abbe N. de Montfaucon, Comte de Gabalis: discourses on the Secret Sciences and Mysteries in accordnace with the principles of the

Ancient Magi and the Wisdom of the Kabalistic Philosophers, 17th century. Kessinger Publishing.

Villanueva, Dr J. L. , Phoenician Ireland, Dublin, 1833 publisher unknown

Vulliamy, C. E., Immortality: Funerary Rites & Customs, Senate, 1997. Previously Immortal Man published by Methuen 1926.

Waite, Arthur Edward, The Hidden Church of the Holy Grail, Fredonia Books, Amsterdam, 2002.

Wake, C. Staniland, The Origin of Serpent Worship, R. A. Kessinger Publishing Ltd, 1877.

Walker, B., Gnosticism, Aquarian Press.

Wallace-Murphy, Hopkins, Rosslyn, Element, 2000.

Waters, Frank, The Book of the Hopi, Ballantine.

Watson, Lyall, Dark Nature, Harper Collins, 1995.

Weber, Renee, Dialogues with Scientists and Sages: Search for Unity in Science and Mysticism, Arkana, 1990

Weisse, John, The Obelisk and Freemasonry, R. A. Kessinger Publishing Ltd.

Wheless, Joseph, Forgery in Christianity, Health Research, 1990

Williamson, A., Living in the Sky, Oklahoma Press, 1984

Wilson, Colin, The Atlas of Holy Places and Sacred Sites, Doring Kindersley, 1996.

Wilson, Colin, Beyond the Occult, Caxton Editions, 2002

Wilson, Colin, Frankenstein's Castle: The Double Brain – Door to Wisdom, Ashgrove Press, 1980.

Wilson, Hilary, Understanding Hieroglyphs, Brockhampton Press, 1993.

Wise, Michael, Abegg, Martin, Cook, Edward, The Dead Sea Scrolls, Harper Collins, 1999.

Within, Enquire, Trail of the Serpent, Publisher, author and date kept a secret.

Wood, David, Genisis, Baton Wicks Publications.

Woods, George, Henry, Herodotus Book II, Rivingtons, London, 1897

Woolley, Benjamin, The Queens's Conjuror, Harper Collins, 2001.

Wylie, Rev. J. A., History of the Scottish Nation, Volume 1, 1886, publisher unknown

Dr G.K Zollschan, Dr J.F Schumaker and Dr G.F. Walsh, Exploring the

Paranormal, Prism Unity, 1989.

Other Sources
Dictionary of Beliefs and Religions, Wordsworth. 1995.
Dictionary of Phrase and Fable, Wordsworth. 1995.
Dictionary of Science and Technology, Wordsworth Edition. 1995.
Dictionary of the Bible, Collins. 1974.
Dictionary of the Occult, Geddes and Grosset. 1997.
Dictionary of World Folklore, Larousse. 1995

The Apocrypha, Talmud, Koran, Bible, Dead Sea Scrolls - Damascus
Document, The Community Rule, War of the Sons of Light with the Sons
of Darkness, Messianic Rule of the Congregation, Temple Scroll.
Writings of Pliny the Younger, Flavius Josephus, Pythagoras, Plato,
Hippolytus of Rome, Ephraim the Syrian, Carl Jung, Jeremiah Creedon
(Guardian), Foundation for the Study of Cycles, The I Ching (Richard
Wilhelm Translation), New Scientist, Nag Hammadi Gospel of Truth,
Gospel of Mary, Gospel of the Egyptians, On Baptism. Documents
received from the following and used by their permission, Scientologist's,
Jehova's Witnesses, Mormons, Jewish Pentecostal Mission, Rosicrucians,
Freemasons, Inner Light. Websters Encyclopaedia, Encarta
Encyclopaedia, The Unexplained (Focus), Encyclopaedia of history
(Dorling Kindersley), Staff at Lichfield Cathedral, New Scientist (21
March 1998 and 11 July 1998), Bible Explorer (Expert Software), Faith
in Every Footstep (The Church of Jesus Christ of Latter-Day Saints -
press Information CD-Rom). Corroborations of Occult Archaeology, The
Theosophical Society Publishing House 1935. A Guide to the Antiquities
of the Bronze Age in the Department of British and Medieval Antiquities,
printed by order of the board of Trustees, 1904, Oxford University Press.

Mythology
www.gardinersworld.com
www.serpentgrail.com
www.theshiningones.com
www.philipgardiner.net
www.radikalbooks.com

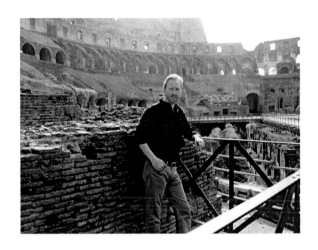

Philip Gardiner is the international best selling author of *The Shining Ones; Secrets of the Serpent* and the critically acclaimed *Gnosis, the Secret of Solomon's Temple Revealed.* He has appeared on hundreds of radio and television programs worldwide and is often referred to as the "next Graham Hancock." He has infiltrated various secret societies and been initiated into Orders many people had thought were long forgotten. Committed to his mission to uncover the real history of mankind and the unraveling of manipulative propaganda, he has come up against many obstacles and yet in his books and DVD's consistently uncovers vital information and provides insights into the mysteries of the ancients and the nature of reality. He lives in the heart of Robin Hood country in the UK and travels the world on a personal quest to uncover the truth.

To find out more information about Philip Gardiner and his work, go to www.reality-entertainment.com.

LaVergne, TN USA
21 October 2010
201841LV00004B/91/P